WEDDING PHOTOGRAPHY UNVEILED

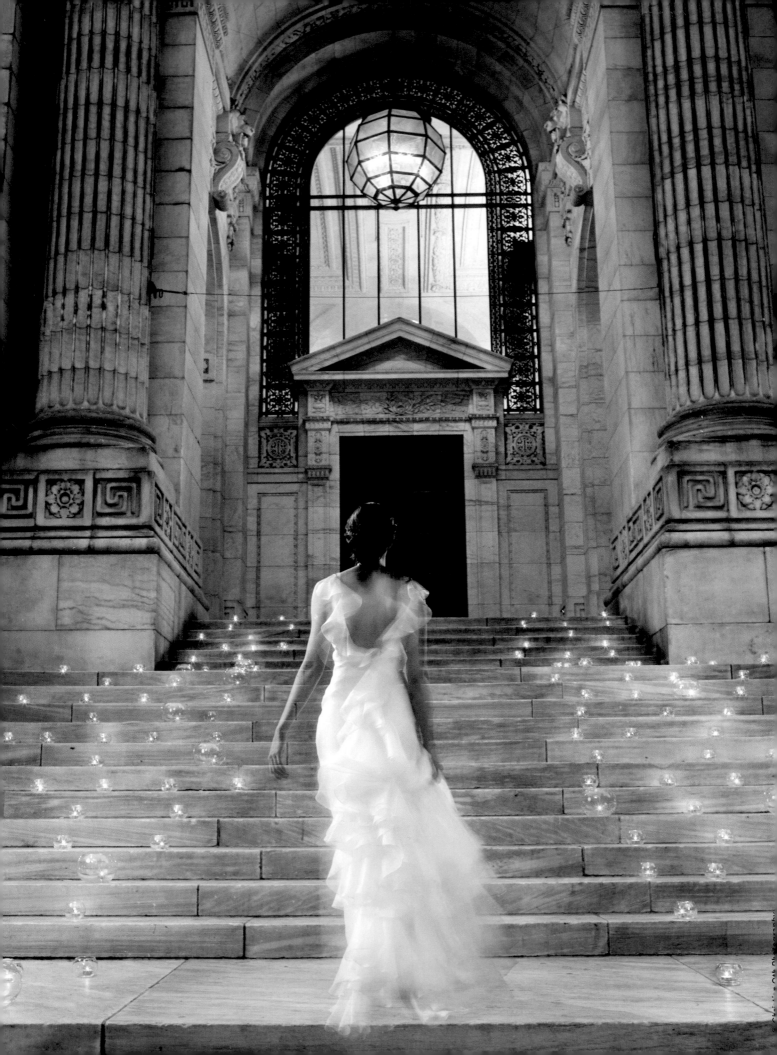

WEDDING PHOTOGRAPHY UNVEILED

INSPIRATION AND INSIGHT FROM
20 TOP PHOTOGRAPHERS

Jacqueline Tobin

AMPHOTO BOOKS
an imprint of Watson-Guptill Publications
New York

Editorial Director: Victoria Craven

Senior Editor: Julie Mazur

Project Editor: Carrie Cantor

Art Director: Jess Morphew

Designer: HSU & Associates

Production Director: Alyn Evans

Photo Editor: Jeanine Fijol

First published in 2009 by Amphoto Books

an imprint of Watson-Guptill Publications,

the Crown Publishing Group

a division of Random House, Inc., New York

www.crownpublishing.com

www.watsonguptill.com

www.amphotobooks.com

Library of Congress Control Number: 2008935968

ISBN-13: 978-0-8174-5910-9

Printed in Singapore

1 2 3 4 5 6 7 8 17 16 15 14 13 12 11 10 09

© Jose Villa

CONTENTS

ACKNOWLEDGMENTS

I want to express my deepest gratitude and affection to each and every photographer who participated in and helped guide me on this project: Liz Banfield, Virginie Blachère, Chenin Boutwell, Philippe Cheng, Suzy Clement, Mike Colón, Amy Deputy, Shannon Ho, Jesse Leake, Kathi Littwin, Charles and Jennifer Maring, Melissa Mermin, Elizabeth Messina, Melanie Nashan, Christian Oth, Parker J. Pfister, Ben Quillinan, Meg Smith, Amanda Sudimack, and Jose Villa. You are the kindest, most thoughtful, and most generous group of people I've ever had the pleasure of working with, and your images truly move me.

An especially heartfelt thank-you to Elizabeth Messina—the best research assistant a girl could ask for, a true friend, and an extraordinary talent.

Special thank-yous go to photo editor Jeanine Fijol for all her help and organizational know-how, to Jack Neubart for putting up with my endless questions and technical inquiries, and to all my colleagues and friends at *Photo District News*.

Last but not least, an enormous thank-you to my wonderful and incredibly selfless parents, who've been married for fifty-two years: Thanks, Mom, for all your endless love and support, and to you especially, Dad, for getting me interested in writing when I was just a kid stuffing story-idea suggestions for our family newsletter (the *Tobin Tattler*) into your homemade box up in the attic. You gave me direction and interest in something solid that I've held on to ever since, and I'll always love you for that.

© *Elizabeth Messina* Film-shooter Elizabeth Messina shot this wide open and relied on natural light. The image has a real fashion/editorial feel, which has become a big part of wedding photography today, especially for Messina, who publishes both real-life wedding work and editorial assignments in magazines like Elegant Bride, InStyle, and grace ormonde Wedding Style. This shot was taken with Kodak Portra 400 film, which Messina says look especially great when printed in sepia, as was done here. The brown tone, she explains, lends a warmth and old-fashioned feel to the image. **CAMERA:** Contax 645; **SHUTTER SPEED:** 1/60 sec.; **F-STOP:** f/4; **LENS:** 80mm Zeiss; **FOCAL LENGTH:** 80mm; **FILM:** Kodak Portra 400 black and white (printed in sepia)

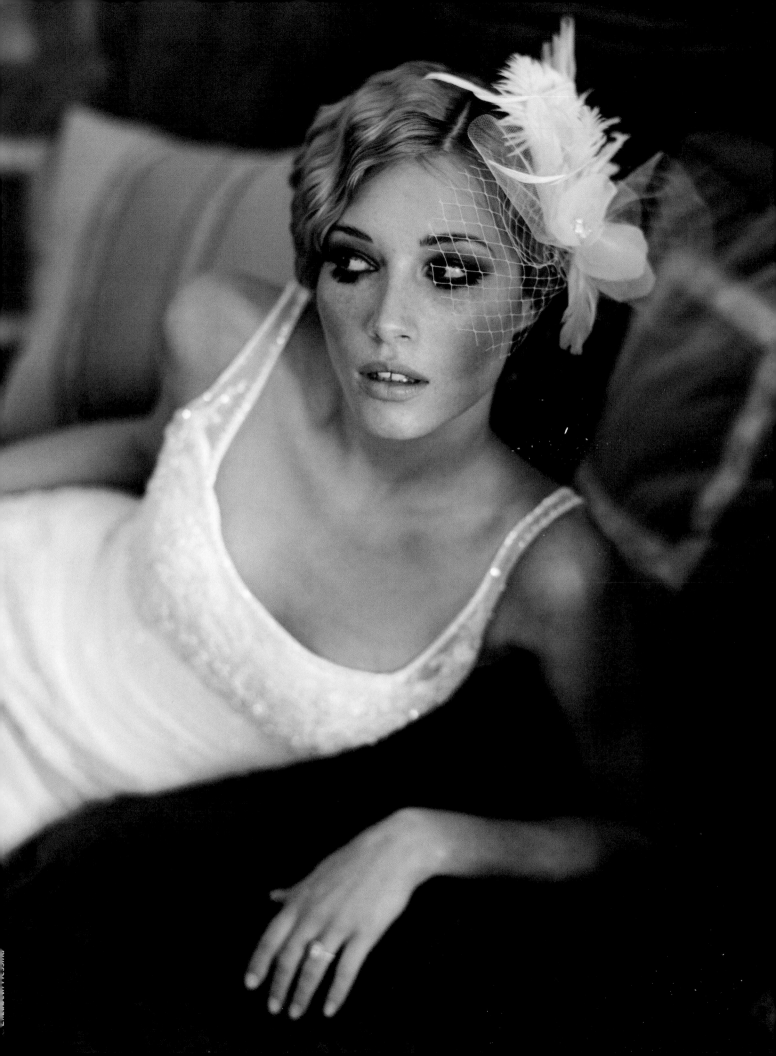

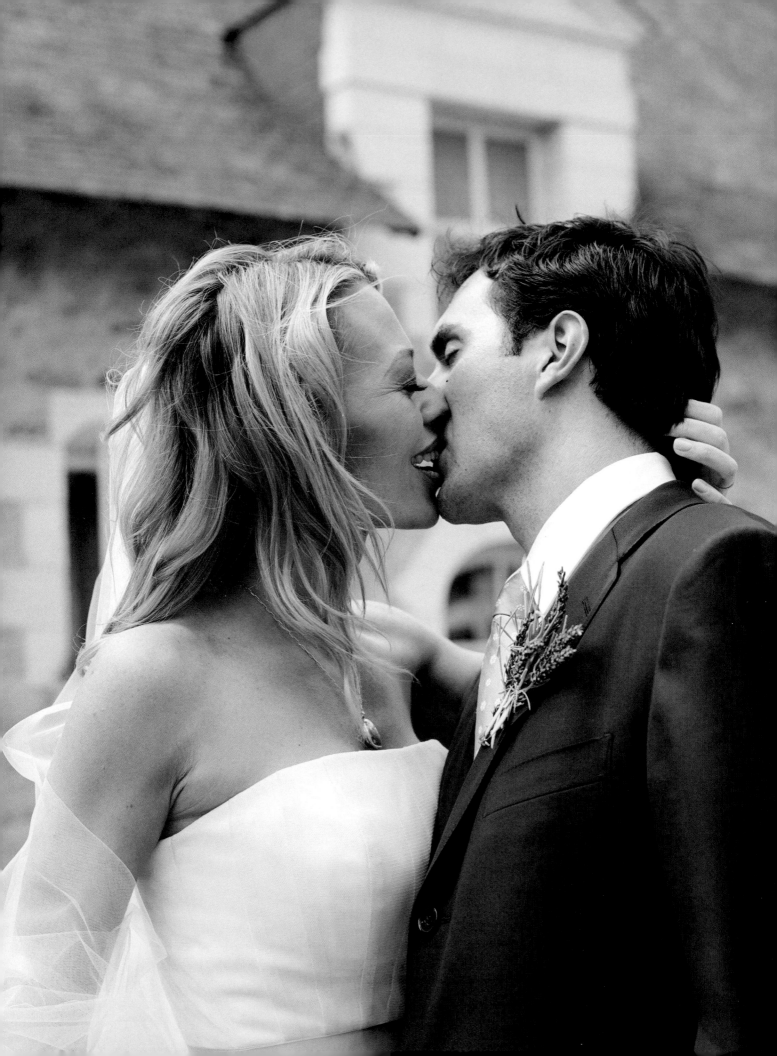

INTRODUCTION

R-E-S-P-E-C-T

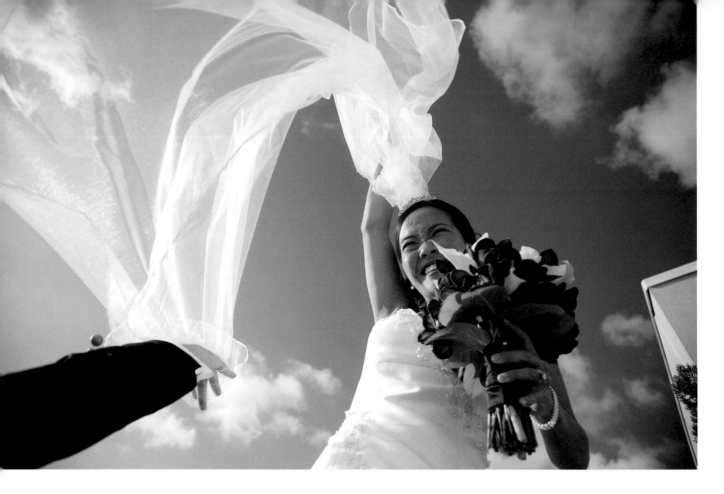

A dear friend of mine who photographed weddings back in the late eighties once described it as a thankless profession filled with long hours and backbreaking work. Back then, wedding photographers were considered the bottom-feeders of the industry, and the shared sentiment was that "no photographer worth his or her salt would touch weddings with a ten-foot pole." The idea of covering the industry in any way, shape, or form was collectively nixed by the editors—myself included—at *Photo District News*. Nevertheless, for my friend, shooting weddings was the only way he could support his family of four. So he endured the jokes and the taunts and even a recurring dream in which he would find himself on stage as funnyman Rodney Dangerfield, proclaiming to an audience of fellow photographers, "I get no respect, NO RESPECT, I tell ya!"

Unfortunately, my friend left the industry before it really took off and wedding photography evolved to become the hip, cool, respectable profession it is today. In the mid to late nineties "wedding photo-journalism" emerged to replace the carefully posed shots and tacky, over-lit portraits of traditional wedding photography with candid, intimate moments documenting the day's events as they unfolded—uninterrupted—by purist photojournalists who worked unobtrusively in the background.

Suddenly, every bride and groom wanted their wedding shot in a photo-reportage style, with no formal portraits, studio lighting setups, or cake-cutting shots allowed. Fast-forward to the early 2000s, when a more balanced mix of images came into play and wedding photographers were being asked, once again, to include certain shots in the day's lineup—including a resurgence of posed bridal portraits and group shots—only this time they were being done more creatively, drawing from other genres in the industry, like fashion and still life, among others. As a result, many buzzwords have cropped up on the photo checklists of brides, wedding planners, and bridal magazine photo editors—terms like *lifestyle, editorial, documentary, fashion-forward*, and *fine art*.

As an editor and writer with twenty-three years of experience in the photo industry, I've taken note of some of the best and brightest photographers who excel at documenting this storytelling experience that is the wedding day. With this book, I outline where wedding photography has been as a medium, its industry status today, and where it is headed—in terms of style as well as equipment. I also demonstrate the important role the photographer plays during the event itself, made clear through the visual and written records of how the day unfolds (by category)—getting ready, ceremony, portraits, and reception—in the work of twenty photographers from around the country who represent a "Who's Who" in contemporary wedding photography. The twenty are:

Liz Banfield	The Marings
Virginie Blachère	(Charles and Jennifer)
Chenin Boutwell	Melissa Mermin
Philippe Cheng	Elizabeth Messina
Suzy Clement	Melanie Nashan
Mike Colón	Christian Oth
Amy Deputy	Parker J. Pfister
Shannon Ho	Ben Quillinan
Jesse Leake	Meg Smith
Kathi Littwin	Amanda Sudimack
	Jose Villa

The most compelling images, I've discovered, are these "new school" images that focus on emotion-filled, spontaneous moments during the course of the day, woven together to highlight a couple's personality and connection. And while there's been a resurgence in the formal portrait over the past several years, especially group ones—parents and relatives, the bridal party, the groom and his groomsmen,

etc.—these photographers are putting a new spin on an old tradition, presenting the portrait in new and visually stunning ways, such as in lush, natural settings or offbeat, quirky locations.

What follows on these pages is a variety of individual talents producing high-quality images, shooting with digital, film only (which applies to four of the twenty photographers), or both (seven of the twenty). True, the benefits of going digital continue to multiply, and more wedding photographers seem to be migrating over to a more efficient workflow in which they are utilizing new techniques and software to edit and tweak their images. But all of the photographers highlighted here continue to turn out creative wedding images, both in color and black and white, shooting digitally or with film, and getting unique final images, whether done in camera or in postproduction using various software programs.

In sum, these twenty come together on these pages to graciously share not only their stunning imagery but also their business practices, techniques, philosophies, and strategies on approaching their craft. These photographers are published in top bridal magazines, conduct workshops and seminars, garner corporate sponsorships, assemble unique albums for their clients, produce multimedia slideshows accessible through online links as well as marketed on DVDs, and vigorously promote themselves through websites, forums and blogs, editorial spreads, and promotional mailers. Today, wedding photography continues to be a rapidly expanding, competitive industry, and the people behind it are constantly sought after by regular folks, high-society types, and big-name celebrities alike, all wanting them to capture that one perfect day. Now, that's what I call respect!

(page viii) © *Elizabeth Messina* Actress Jeri Ryan and her husband, Christophe Eme, were photographed by Messina right after their ceremony in France's Loire Valley. Messina works mostly with natural light and creates a signature look by using wide aperture settings, usually at *f*/2 or *f*/4. Typically, her wedding images, like this one, are both artistic and intimate. "These two are such a beautiful couple," she explains, "so in love. I really wanted to capture that feeling for them on film." Here, the couple's sweetness and playfulness comes across as they interact without being posed. **CAMERA:** Contax 645; **SHUTTER SPEED:** 1/25 sec.; **F-STOP:** *f*/4; **LENS:** 80mm Zeiss; **FOCAL LENGTH:** 80mm; film: Fuji 800 NPZ color

(opposite) © *Amy Deputy* In this image of bride and groom meeting on a hotel rooftop before their ceremony, Amy Deputy was able to add an artful spin and vibrant color to an unscripted moment. As the couple were negotiating the climb down from the roof, the bride's veil caught the wind; the groom's arm is visible as he tries to help her untangle it. **CAMERA:** Canon EOS 5D; **EXPOSURE PROGRAM:** Aperture Priority; **ISO:** 250; **SHUTTER SPEED:** 1/6400 sec.; **F-STOP:** *f*/4; **LENS:** EF24-105mm *f*/4L IS USM; **FOCAL LENGTH:** 24mm

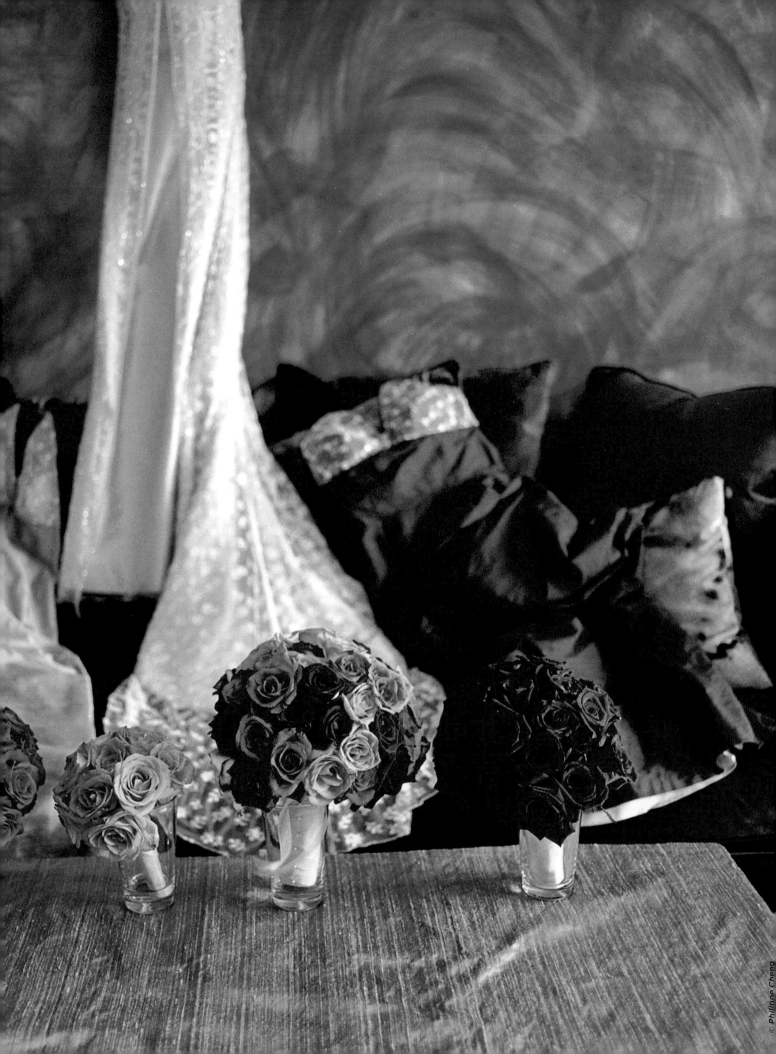

I. WEDDING PHOTOGRAPHY TODAY

Inspiration and Perspiration

"What separates good photographers from mediocre ones is being able to know and foresee our ever-changing surroundings and being able to control the lighting, focus, and composition in a split second. I know my equipment well enough to be able to make on-the-fly adjustments without taking my eye off the subject. Equally important is my personality. It helps me stand out from the pack, keeps the day flowing smoothly and allows me to connect with my brides."

—BEN QUILLINAN

A wise man once said, "Wedding photography is all about being in the moment. A good wedding photographer knows how to capture the moment and the essence of the person in those moments." Wedding photographer extraordinaire Joe Buissink is that wise man, and he was speaking to an enthralled audience of over 120 fellow photographers during *PDN*'s 2007 PhotoPlus Expo at the Javits Center in New York City. "It's an exhausting effort," he continued, "seven or eight hours of focusing in the moment and reacting instantly to what I see. I use my equipment as an extension of my eyes, my hands, and my heart, and I trust the equipment implicitly, so all I have to do really is react," he told us that day. "I have to see the moment. And often, I intuitively guess and anticipate so I'll be one split second ahead of it."

Of course, it's one thing to listen to this photography guru share his tips and techniques as his signature images flash up on the screen and be truly inspired by them; it's another thing to try and recreate them. "I'm always being asked, 'How do you get these moments? How come I can't?'" Buissink told us that day. "I've come to realize that the way I shoot a wedding is not only by looking with my eyes. I see with my heart, and it's with my heart that I photograph weddings. I impact every photograph I shoot. Why are my images so emotional? Because that's who I am: I love weddings because they are so full of emotion, and it's an honor for me to be invited into the most special day in a couple's life and to share that with them."

The photographers featured in this book echo this sentiment wholeheartedly: Each one deems it a privilege to share the day with the couples they are hired by, and each one is extremely passionate about his or her work. They photograph weddings genuinely and from their hearts and are more than willing to share their strategies and approaches with their colleagues. Like Buissink told us that day, "I'll tell you everything I know. I've got nothing to hide."

Jesse Leake, who has been photographing weddings since 2001, says he watched, listened, and learned when he attended a WPPI (Wedding and Portrait Photographers International) workshop by Buissink years ago: "When I first saw him shooting, his approach was totally different than anything I had ever seen before—the way he moved around and captured these off moments that

© *shannonho.com* This candid of a smiling bride right before her wedding ceremony is typical of the majority of Shannon Ho's signature images: black and white and documentary in nature. **CAMERA**: Canon EOS-1D Mark II; **EXPOSURE PROGRAM**: Aperture Priority; **ISO**: 400; **SHUTTER SPEED**: 1/125 sec.; **F-STOP**: f/1.8; **LENS**: 85mm; **FOCAL LENGTH**: 85mm

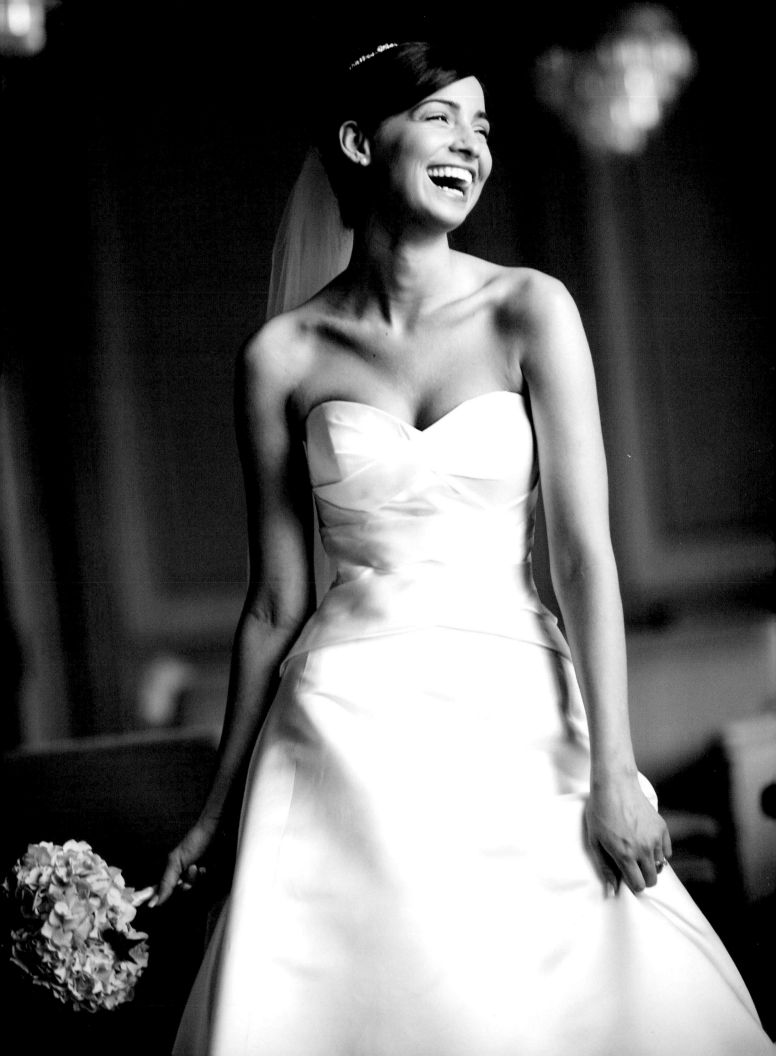

everyone else seems unaware of. He would drop to his knees, be on the floor, and shoot rapid-fire, continuous shots with the camera above his head. He doesn't try to control a wedding; he's just there waiting, observing, capturing the moment. When I got home and looked at his website, I thought 'Wow that's what I want to do.' I was totally inspired by him. He has a great attitude and great images."

But wedding photography is not just about getting that great in-the-moment shot. It involves long, hard work, with many different components involved: artistic talent in several genres, good people skills, extensive knowledge of current photographic techniques and ever-changing technology, and business savvy. It's a competitive field and a rapidly expanding one, with more photographers getting into the business than ever before. In 2007, photographer Tony Corbell, who has photographed hundreds of weddings himself, wrote the following (for *American Photo* magazine):

> *Only recently [have wedding photographers] been widely recognized for their multifaceted talent. During the course of a wedding day they serve as architectural photographer, documenting locations; as portrait photographer, flattering the day's key players; as product photographer, shooting a close-up of the rings; and as photojournalist, telling a story, under pressure, with pictures. One indication of wedding photographers' new status is that they are being asked to do more and more work outside their geographic bases. Another is that they earn more money than ever.*

Case in point: When my sister Pamela got married in 1998, she hired Martin Gardlin—one of the top Manhattan photographers at the time—and paid $2,500, which included an album of twenty-four 5 x 7-inch photos for the bride and groom as well as for their parents, and a set of 4 x 6 finished proof prints. He even threw in the negatives. Ten years later, most shooters are 100 percent digital, they offer a range of services, and their rates have doubled, even

tripled, depending on their location and the services they are offering.

For example, in 2008, Shannon Ho, based in Norman, Oklahoma, offered a basic wedding package starting at $4,795, second and third packages at $6,930 and $9,300, and a "Fourth Collection" priced at $13,800, which included up to ten hours of wedding coverage, credit toward an album, DVD slideshows of the images, an engagement session, and a bridal session. She says she gets frequent requests for the "bridals," something she describes as similar to a senior portrait. Her typical bridal session includes up to an hour at a location in Norman, as well as a guaranteed forty images proofed online on a password-protected website (for sixty days) with viewing and ordering options.

Fine-art wedding photographer Jose Villa, one of the four photographers profiled in the book who shoots film only, is based in Solvang, California (near Santa Barbara, a top wedding destination) and also offered several different shooting packages in 2008, the most basic starting at $6,500 (for five hours of his time) and expanded ones going up to as high as $13,300. A fifth package, priced at $15,000, exists, but Villa says his average wedding (in 2007–08) costs between $8,000 and $10,0000.

Then there's Liz Banfield, who lives in Minneapolis, Minnesota, and travels out of town for most of her weddings. She says that while her basic coverage begins at about $9,000, her average client spends $14,000 with wedding day coverage, travel expenses, and albums. And Mike Colón, in Newport Beach, California, shoots for a very specific clientele (mostly celebrities and high-society types) and doubled his rate almost overnight from $10,000 to $20,000 a wedding years ago. But more on that later.

The good news is that with all these changes and developments occurring within the industry year after year, there are strong foundations of support that offer wedding photographers information and advice and enable them to network with colleagues, learn how to market themselves, and so on. WPJA (the Wedding Photojournalist Association) and WPPI (Wedding and Portrait Photographers

International) offer its members seminars, conventions, and workshops, among many other benefits, as does Digital Wedding Forum (www.digital weddingforum.com), while the Internet blog Wed Shooter (www.wedshooter.com) was formed with the sole purpose of "exploring and sharing techniques of professional wedding photography." Its contributors include Joe Buissink, Bambi Cantrell, Kevin Kubota (who teaches several digital workshops and sells his own line of Photoshop actions), Mike Colón, and Jose Villa.

And other "alternative" sites are cropping up yearly as wedding photographers insist on more growth, creativity, and unique imagery, including Don't Box Us In, which presents "the other side of wedding photography," and www.trashthedress .com, a phrase coined by wedding photographer John Michael Cooper. It's become a growing trend for brides to engage in a fashion shoot of sorts in their wedding gowns after the wedding is over—rolling around in mud or romping in a mossy lake or posing in a grungy back alley, thus trashing their dresses. Apparently, it makes for an interesting, albeit unconventional, addition to the wedding album, though more conventional photographers are opting for the marketable term "day-after shoot" instead.

Either way, both photographer and bride are increasingly interested in getting "different" wedding images. In that vein, more and more wedding photographers are also posting their own blogs on their websites as a dynamic marketing tool used to keep in touch with clients and colleagues via daily and weekly posts of fresh images as well as to open up and let their personalities shine through.

Says Melanie Nashan, who is based in Livingston, Montana, "In the past decade it has become more exciting than ever to be in the field. More and more people are being creative with their shooting style, which in turn spurs more creativity," she reasons. "I think the tireless educational efforts of people like Joe Buissink have helped raise the

© *Jesse Leake* Jesse Leake took to the ground and shot upward as he photographed the bride at her reception during a carefree dance number. Like the majority of his images, this shot incorporates Leake's love of composition, color, light, and motion. **CAMERA**: Canon EOS 5D; **EXPOSURE PROGRAM**: Manual; **ISO**: 640; **SHUTTER SPEED**: 1/4 sec.; **F-STOP**: f/5.6; **LENS**: 16–35mm; **FOCAL LENGTH**: 23mm

standards, which has made wedding photography evolve into an art form."

Yes, wedding photography has indeed come a long way and continues to evolve and gain greater respect in the industry year after year. Buissink, who switched over from landscape photography to wedding photography in 1996, credits Denis Reggie with influencing his initial look of mostly photojournalistic, black-and-white imagery, a style that dominated the scene back in the nineties. It was Reggie who coined the phrase "wedding photojournalism" in 1980 and permanently transformed the look of the genre, but it wasn't until the mid-nineties that the style became more mainstream.

Gone are the days of static poses and cheesy smiles, thanks, in good part, to the important contributions over the years of veteran wedding photographers like Reggie, as well as people like Bambi Cantrell, John Dolan—who helped changed the aesthetic of wedding photography and who was a founder of the I'm Proud to Be a Wedding Photographer Club in Manhattan all the way back in 1996—and Joe Buissink, among many others. Taking it to the next level are the photographers who are featured in this book.

Perhaps New York photographer Kathi Littwin sums it up best as she recalls a time when she was just getting into the business eleven years ago, right when wedding photojournalism was really taking off. "It was replacing a style of shooting where the photographer was a ringmaster with a planned shot list," she explains, "and in its place came the quiet and introspective shooter who didn't interfere with the action whatsoever." Today, however, Littwin explains, there is a nice balance between the two. "It's wonderful to watch and record the natural progression of the day. However, today's wedding photographer is, and needs to be, more personally and visually involved. The true photojournalistic images are about freezing a moment in time where the photographer has some distance from the subject. In contrast, today's wedding photography is more colorful and cinematic. Today's wedding photography has life and it moves." Well put!

1. © *Kathi Littwin* Kathi Littwin says the couple, the destination (Tulum, Mexico), and the lighting (she used fill flash) all worked together to give the image its impact and flavor. "Technically speaking," she explains, "I needed to dial down the flash. Otherwise, it would have taken over and the background would be dark." Note: It was sunset, so she says she probably dialed down 1.5 on the flash. **CAMERA:** Nikon F100; **SHUTTER SPEED:** 1/30 sec.; **F-STOP:** *f*/5.6; **LENS:** 24–85mm; **FOCAL LENGTH:** 28mm; **FILM:** KODAC VPS 400

2. © *Melanie Nashan* Montana-based photographer Melanie Nashan took this photo of an ebullient bride right before she walked down the aisle with her father. "I just love the look her dad was giving her," Nashan says. The image also ran in *Elegant Bride*, which tends to feature weddings of brides who wear designer dresses. **CAMERA:** Canon EOS D60; **ISO:** 400; **SHUTTER SPEED:** 1/180 sec.; **F-STOP:** *f*/5.6; **LENS:** 28–105mm; **FOCAL LENGTH:** 28mm

3. © *Parker J. Pfister* Parker J. Pfister likes to take "action" to get to his final image. Most of his wedding work has a fine-art feel to it and is often tinkered with and reworked in Photoshop. This shot of a bridal party was made right before he transitioned from JPG to a RAW workflow. **CAMERA:** Canon EOS-1D Mark II N; **EXPOSURE PROGRAM:** Aperture Priority; **ISO:** 200; **SHUTTER SPEED:** 1/500 sec.; **F-STOP:** *f*/5; **LENS:** 50mm *f*/1.4; **FOCAL LENGTH:** 24mm

4. © *Maring Photography* The Marings especially love covering the reception part of the wedding because, they say, it's when everyone can relax and enjoy themselves, enabling the photographer to capture great candids. To get this shot of a couple held aloft on chairs at their Jewish wedding reception, Charles Maring held the camera over his head and used a flash bounced off the ceiling, allowing it to "just fill the room." **CAMERA:** Canon EOS 20D; **EXPOSURE PROGRAM:** Manual; **ISO:** 800; **SHUTTER SPEED:** 1/25 sec.; **F-STOP:** *f*/2.8; **LENS:** 24–70mm; **FOCAL LENGTH:** 24mm

5. © *Suzy Clement* Suzy Clement, based in San Francisco, says that when she photographs a wedding, she likes to "unobtrusively capture the myriad moments of intimacy and unstaged joy, the endless tiny details and the sweeping vistas of the event." Here, she presents an all-encompassing take on one couple's reception. **CAMERA:** Nikon F100; **SHUTTER SPEED:** 1/125 sec.; **F-STOP:** *f*/5.6; **LENS:** Nikkor 28–70mm *f*/2.8; **FOCAL LENGTH:** 28mm; **FILM:** Fuji NPH

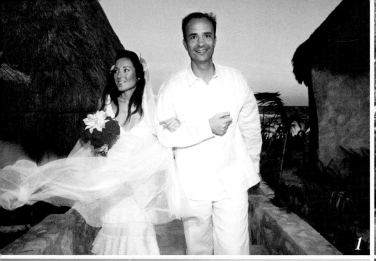

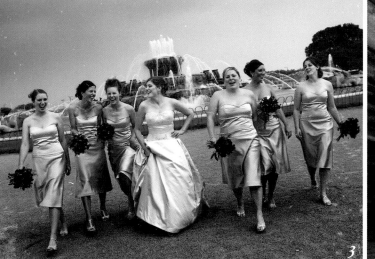

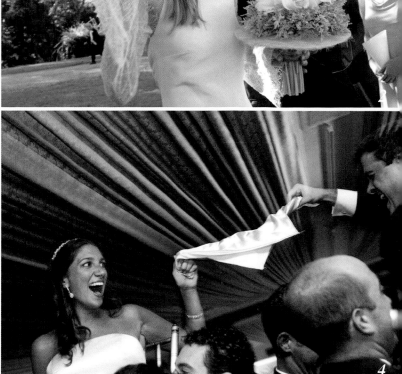

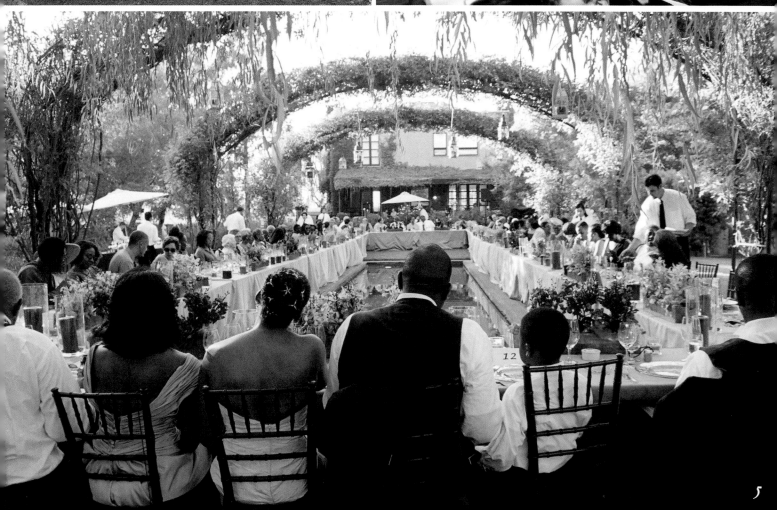

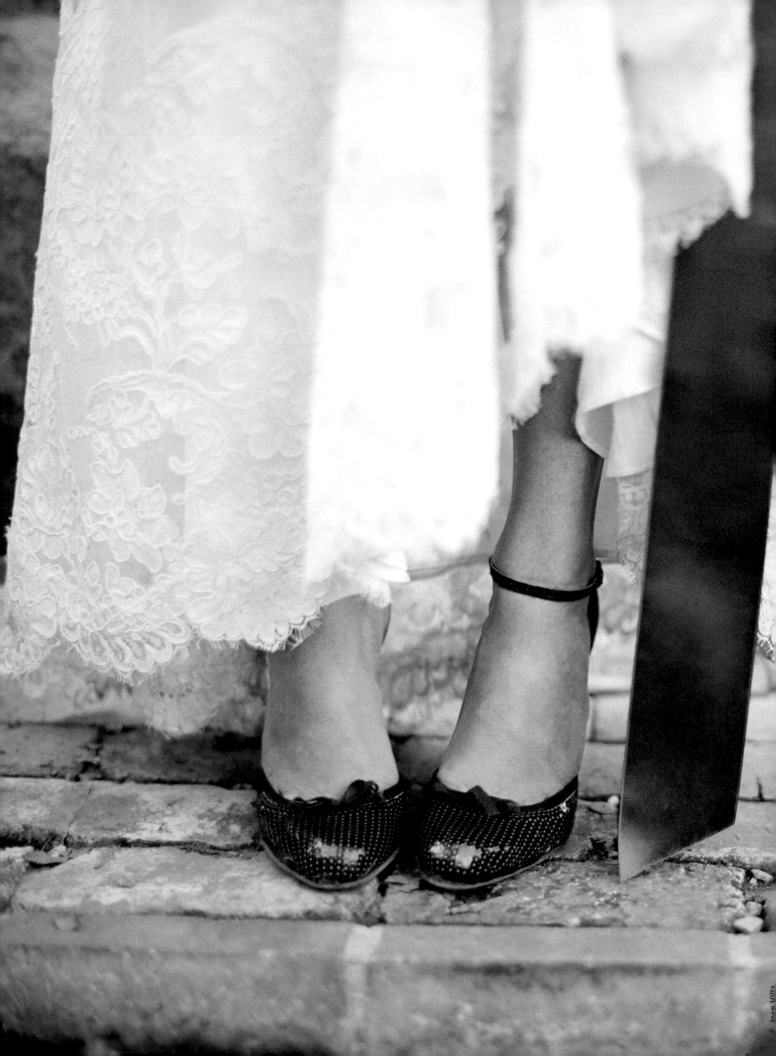

II. HERE, THERE, AND EVERYWHERE

The Role of the Photographer on Wedding Day

I n the most basic terms, the photographer is a preserver of memories, especially on the wedding day, when emotions run high and the entire event is a blur for those involved. As the years go by, the memories that last are the ones that are captured in the photographs. It is a huge responsibility, and it is part of the reason capturing the authenticity and emotional substance of each wedding is so important to the wedding photographer. Each has a unique idea of the role he or she plays that day, and each one fulfills that role in his or her own distinct way.

According to the Marings, "the main role of the wedding photographer is to make sure the couple has the time of their life and deliver on the promise you've made to them." Virginie Blachère explains, "For me, it's important to remember to have fun during the celebration while remaining respectful and discreet. I photograph from my heart. Establishing a strong relationship is a key factor." Amy Deputy takes a rather spiritual point of view: "The wedding photographer's role is to document the story as it is from a place of stillness and love. To honor the courage it takes for one person to say to another, 'I will let you witness my life. To be wholly present.'" Melanie Nashan feels that "on the day of the wedding it is imperative that you are a calming presence. As an outsider, you can gently offer guidance and diffuse situations in order to make your clients as comfortable as possible. Secondly, I think it is imperative that we be as unobtrusive as possible when we are at weddings."

In a similar vein, Liz Banfield states, "Beyond the obvious—capturing the day—I think the photographer should try to stay calm and make sure they aren't adding to the chaos and stress that surrounds most wedding days. I'm always surprised at how often people come up to me at the reception and tell me what a 'great job' I'm doing. The message is clear: People appreciate and notice professionalism."

Of course, the wedding photographer must wear many hats throughout the day: business professional, able to work under extreme pressure; keen observer, down to the minutest detail; storyteller; director; even psychologist. After all, tensions run high at weddings, and the photographer must juggle many different personalities, put out fires, and cajole stressed-out people—the bride and groom, the wedding planner, the parents of the bride and groom. These clients have entrusted you with their families, with their emotions, with their private moments, and with a wedding there is no do-over, no second take.

Couples have invested a great deal of time, money, and preparation into the day; their expectations are high, and they are counting on you to deliver the best product possible. Just how this is done depends on the level of commitment, as well as the style, of the individual photographer.

(opposite) © *Amanda Sudimack* A parking lot was not photographer Amanda Sudimack's ideal location for this image, but she says it was a perfect, cloudless day and that the bright blue sky added a dramatic contrast to the shot's overall feel. Of the groom who arrived on horseback, Sudimack says, "He was very reserved. I attribute the strength of the image to 50 percent being where I needed to be/planning and 50 percent persistence. I shot about thirty other images within a minute to get this one gesture and smile out of him, and eventually it happened."
CAMERA: FinePixS2Pro; EXPO-SURE PROGRAM: Manual; ISO: 400; SHUTTER SPEED: 1/2000 sec.; F-STOP: f/8; LENS: 17–35mm FOCAL LENGTH: 17mm

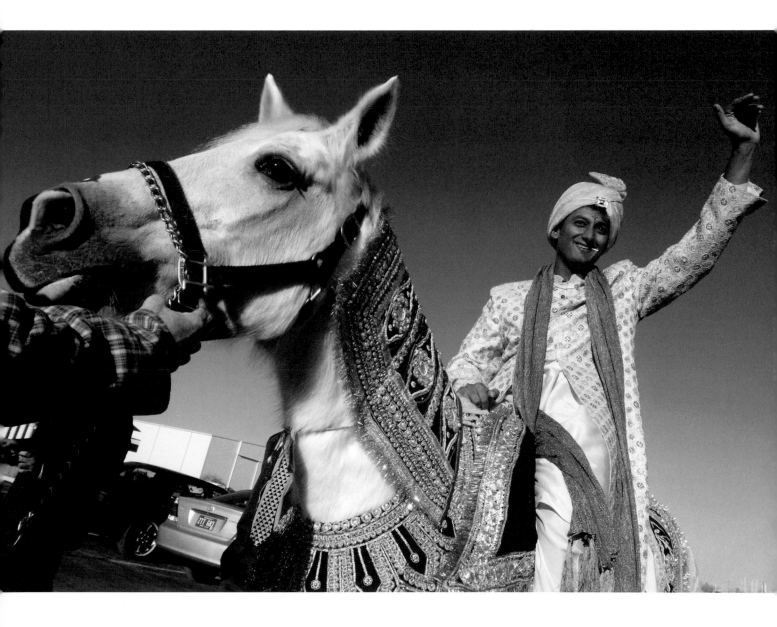

PHILIPPE CHENG

IN HIS BOOK *Forever and a Day: Wedding Moments* (Edition Stemmle, 1999), Philippe Cheng, who has been shooting weddings since 1993, presented a collection of his wedding images as a window into, he says, the more elusive aspects of the day and the feelings that arise within those moments: the joy, the intimacy, the anticipation, the celebration with family and friends.

Carley Roney, founder and editor in chief of the wedding website The Knot, wrote the following in the foreword to Cheng's book:

> *The wedding photographer's role—if he has the sensitivity and the eye to take it on—is so much more than that of an image-maker. Brought along as a scribe, he suddenly becomes a critical part of the journey. He is both confidante and supporter. Wedding photographers are required to be everywhere and yet remain unseen. But the most intriguing aspect of what they do is that they have the responsibility and the honor of seeing more clearly than anyone else in attendance."*

Ten years later, Cheng is still taking on this role and creating unique, timeless images that reflect on a couple's most personal, and most cherished, moments from their wedding: an image of newlyweds captured in their wedding finery from the waist down, walking along a cobbled path after the ceremony; the quizzical face of a young ring bearer, only his shoulders emerging from the bottom of the frame; a grainy photo of a bride as sculpture, erect and still in a corner, her face shrouded by a filmy veil. Cheng—who shoots both digital and film, and is a big fan of black and white—loves to capture the offbeat, unexpected moments of a wedding. "At first you come to a wedding with a sort of preconceived notion of what a wedding is, and when you meet everyone you think it's going to unfold a certain way, but then it unfolds in a completely different way. It happens almost without realizing it. It's the unexpected aspects of the day that I get the most energy from. You might have a very controlled situation with a very controlled family. But in that instant, when they realize the enormity of the situation and you have a father with his daughter, you can really feel the emotion in that very brief moment. That the best moment of the day."

He continues: "People who hire me know they're not going to get twenty pictures of the cake-cutting, the first dance, and the speeches. They're getting something less sure, and they really have to trust me. I'm a very subjective photographer, and on wedding day I bring a lot of my own feelings and emotions to the pictures."

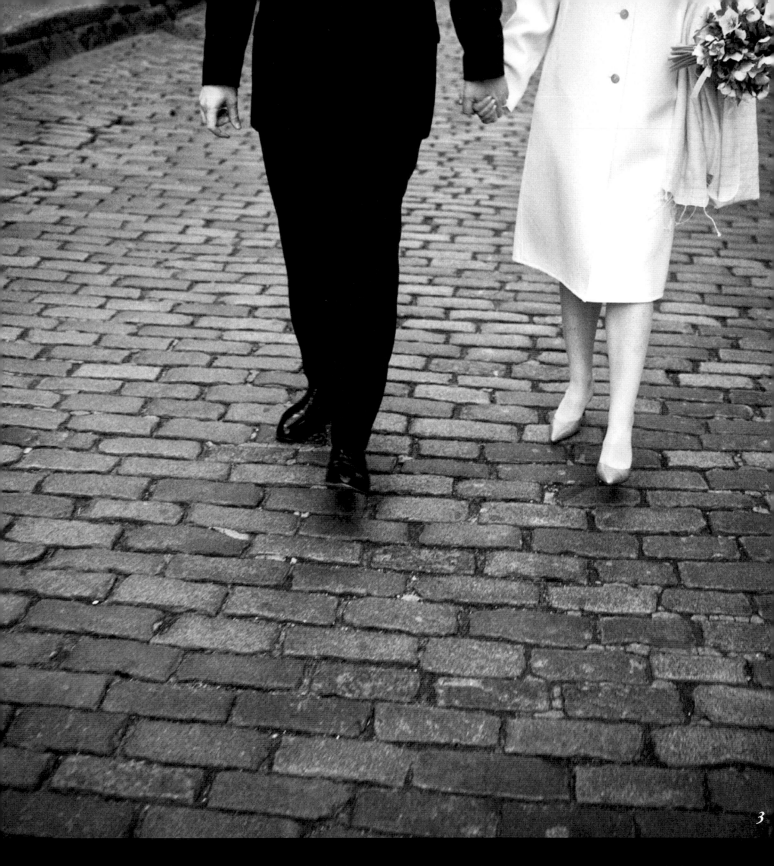

3. The cover image of Cheng's book *Forever and a Day: Wedding Moments* was taken in downtown Manhattan before the ceremony. "I've lived with this image for a long time," says Cheng, "and what makes it timeless for me is that she's not wearing a 'wedding dress.' This is what sets it apart in a way, because it almost looks like a fifties shot." It's also, he adds, what makes it unique.

CAMERA: Hasselblad; **SHUTTER SPEED:** 1/60 sec.; **F-STOP:** f/5.6; **LENS:** 60mm; **FOCAL LENGTH:** 60mm; **FILM:** Kodak Tri-X

JOSÉ VILLA

JOSE VILLA, a twenty-something phenom from Solvang, California, who shoots "all film all the time," and does roughly sixty weddings a year all over the world, defines his role on wedding day: "My approach applies fine-art photography to the living, breathing, fast-moving phenomenon that is a wedding," he says. "Yes, I do some documentary photography—you need to capture the important moments at a wedding—but I also compose and direct. For me, it is all about making something beautiful, even if I have to insert myself into the situation and recreate a moment. Ultimately, my goal is to craft vibrant, energetic fine-art images that are as unique as the people in the photographs."

Clearly, Villa doesn't play the role of purist photojournalist on wedding day, and that's just fine with the couples who hire him. "My role is to educate my clients and let them know what's what. As wedding photographers, we all capture moments. But I'm walking my clients through these moments of laughter and joy, or whatever it is unfolding at the time." During the getting ready part of the day, for instance, Villa says he has full control, and through the equipment, lighting and type of film he uses, he is creating the type of fine-art, almost painterly images his clients seek out. "I shoot with Holgas, with Rolleis, with very vintage old-school cameras. I also take a Contax 645 (that's the camera I consider to give me more of the lifestyle look that I like). It's all part of this whole fine-art feeling of the wedding day I deliver." These days, brides want the whole fashion-magazine-spread feel to their weddings, Villa explains, "very shallow depth of field, very blown-out highlights, very saturated color with soft skin tones."

When it's time to do portraits, Villa tends to "anti-pose" the bride and groom. While he's directing a couple, he explains that he's not really posing them—he gives no verbal directives, no "chin down," "look here," or "arms this way." Instead, he says, he merely talks to them as he's working. "While we're walking on a beach or scouting out a good spot for a portrait, I'm taking photos. They don't know how I'm composing my images; they don't know that talking to them and having the bride look halfway back to me, I'm actually posing them. Technically, I am, but I'm not really expressing that to them while I'm talking to them. That's what I mean by 'anti-posing.' I'm creating the photo and making them engage in certain poses without realizing it. If I say to them, 'chin up, chin down' they become aware of what I'm doing and then everything stiffens up. Instead, I anti-pose them."

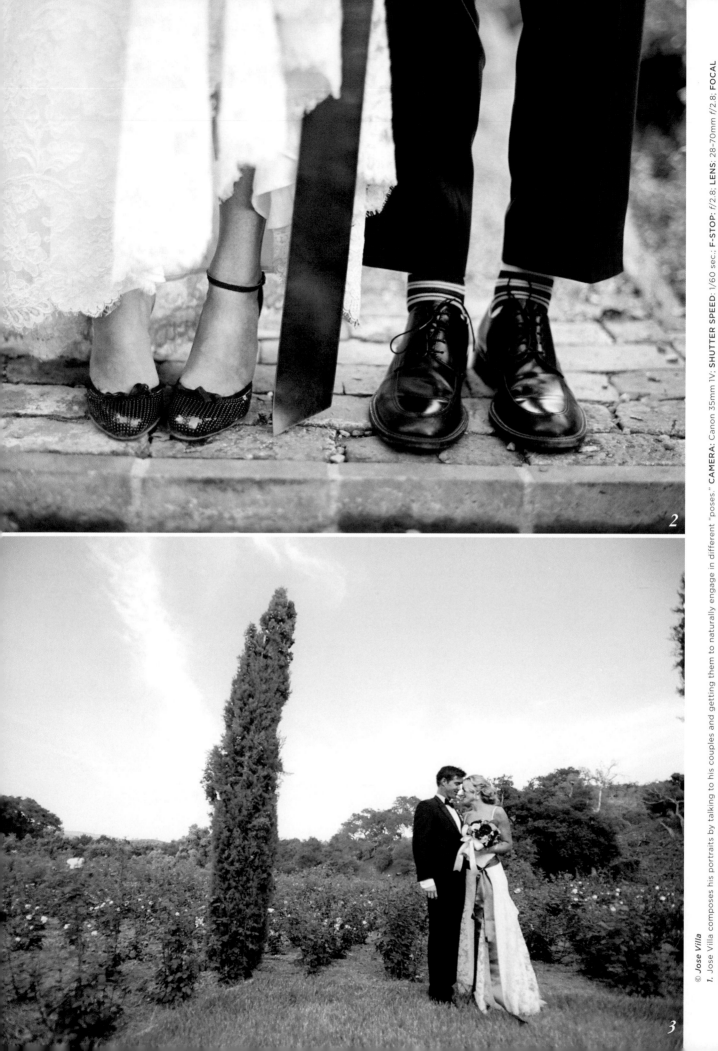

© Jose Villa

1. Jose Villa composes his portraits by talking to his couples and getting them to naturally engage in different "poses." CAMERA: Canon 35mm 1V; SHUTTER SPEED: 1/60 sec.; F-STOP: f/2.8; LENS: 28–70mm f/2.8; FOCAL LENGTH: 24mm; FILM: Fuji Neopan ISO 400 2. Quirky, offbeat images like this one are the norm for Villa, a fine-art wedding photographer with roughly sixty bookings a year. For Villa, a couple's whimsical footwear is just as telling regarding their personality as their faces. And in today's wedding photography market, where fine art is melded with fashion and lifestyle images, fancy footwear and headless torso shots are in! CAMERA: Contax 645; SHUTTER SPEED: 1/125 sec.; F-STOP: f/2; LENS: 80mm f/2.0; FOCAL LENGTH: 80mm; FILM: Fuji Pro 400 H 3. Villa's portraits of bride and groom tend to focus on lifestyle and fashion elements while emphasizing and integrating the couple's surroundings into the shot. CAMERA: Canon 35mm 1V; SHUTTER SPEED: 1/250 sec.; F-STOP: f/2.8; LENS: 16–35mm; FOCAL LENGTH: 16mm; FILM: Fuji Pro 400 H

19

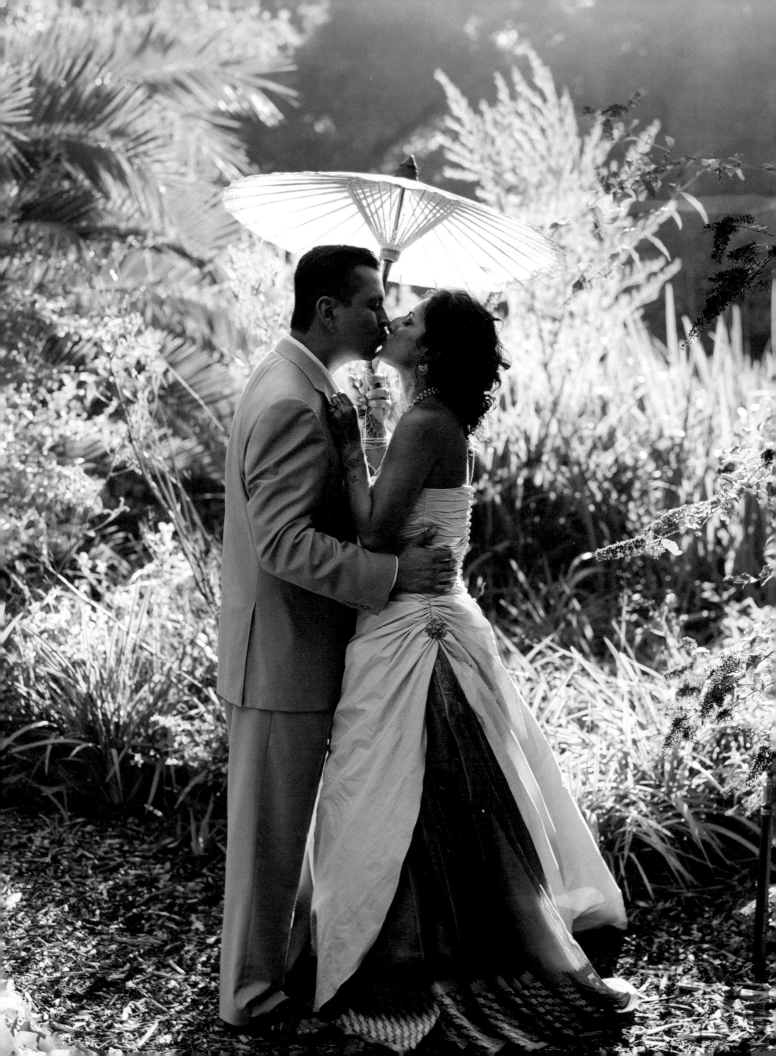

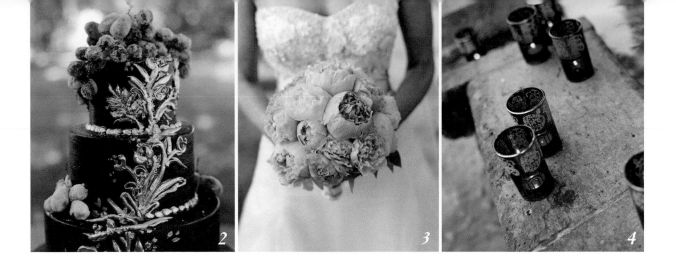

ELIZABETH MESSINA

"PHOTOGRAPHING A WEDDING is an honor, and you have to treat it as such," states Elizabeth Messina. "Every moment should be a good experience for the couple." Messina, a lifestyle-oriented photographer who shoots film and swears by her Contax 645, loves creating intimate moments and is known for her sophisticated and romantic wedding images. Jose Villa counts her as one of his "greatest inspirations," *American Photo* listed her as one of the "Top Ten Wedding Photographers in the World" in 2008, and *Modern Bride* named her one of the "Top 25 Trendsetters of 2008." Messina says she shoots for the "little moments that happen all the time," adding, "If you slow down and connect with the couple, you can effortlessly capture the moments as they unfold. I approach weddings as a fine artist and a photojournalist." And while she loves shooting candids, she also stresses the important role posed photographs play, serving as lasting memories for the family. And then, of course, there are the details.

"It's the details that define the couple and their day," she continues—from the invitations to the candles and table settings, to the shoes the bride and groom are wearing, to the wedding bouquet and embellishments on the wedding dress. "My job is to capture all of that so the couple will remember what it felt like to be there."

Once in a while, the wedding photographer has to talk a couple down off the ledge, so to speak. "I had one situation," Messina describes, "where a couple had flown out from Philadelphia to get married in Santa Barbara and they were planning a very big wedding but changed their plans when it became too overwhelming." The couple decided to elope, in style: "She had a beautiful dress, they had a cake, they hired me for the whole day, and they treated it like a real wedding, even though it was just the two of them. It was wonderful and intimate,"—up until a torrential downpour began, and the bride was beside herself. "I looked at her and said, 'This will be the memory of your day forever. It's raining on your wedding day, but it's not a bad thing—every time it rains it will remind you of this moment—it's a beautiful thing.' The bride looked at me and said, 'Oh, my God, you're right,' and after that it unfolded beautifully and the mood and energy shifted and we went outside with umbrellas and I took shots in the rain, as well as images of the windowpane with raindrops on it. These were the unique details of their day that they will always remember."

© *Elizabeth Messina*

1. Elizabeth Messina says she loves to have time to photograph a couple alone right after the ceremony because, "it's a wonderful, intimate moment." In this particular shot, Messina also wanted to highlight a detail of the bride's dress because of the special meaning attached—the bride, of Indian descent, had her mother's wedding sari (the darker pink fabric) sewn into her own couture gown to pay homage to her heritage. Messina especially loved the lushness of the surroundings of this shot, taken at the Hahn Estate in Santa Barbara, for showcasing the couple. **CAMERA:** Contax 645; **SHUTTER SPEED:** 1/25 sec.; **F-STOP:** *f*/4; **LENS:** 80mm Zeiss; **FOCAL LENGTH:** 80mm; **FILM:** Fuji 800 NPZ color

2. Messina loves to zoom in on the details because they are a reflection of a couple's style. At this reception in Malibu, she liked that the wedding cake was so unique and elegant; it also complemented the rich tones of the wedding's theme colors. **CAMERA:** Contax 645; **SHUTTER SPEED:** 1/60 sec.; **F-STOP:** *f*/2; **LENS:** 80mm Zeiss; **FOCAL LENGTH:** 80mm; **FILM:** Fuji 800 NPZ color

3. Messina puts a unique spin on a standard shot: the bridal bouquet. **CAMERA:** Contax 645; **SHUTTER SPEED:** 1/60 sec.; **F-STOP:** *f*/4; **LENS:** 80mm Zeiss; **FOCAL LENGTH:** 80mm; **FILM:** Fuji 800 NPZ color

4. These Moroccan glasses filled with candles lining a fountain at a reception are the kinds of details Messina loves to photograph. **CAMERA:** Contax 645; **SHUTTER SPEED:** 1/60 sec.; **F-STOP:** *f*/4; **LENS:** 80mm Zeiss; **FOCAL LENGTH:** 80mm; **FILM:** Fuji 800 NPZ color

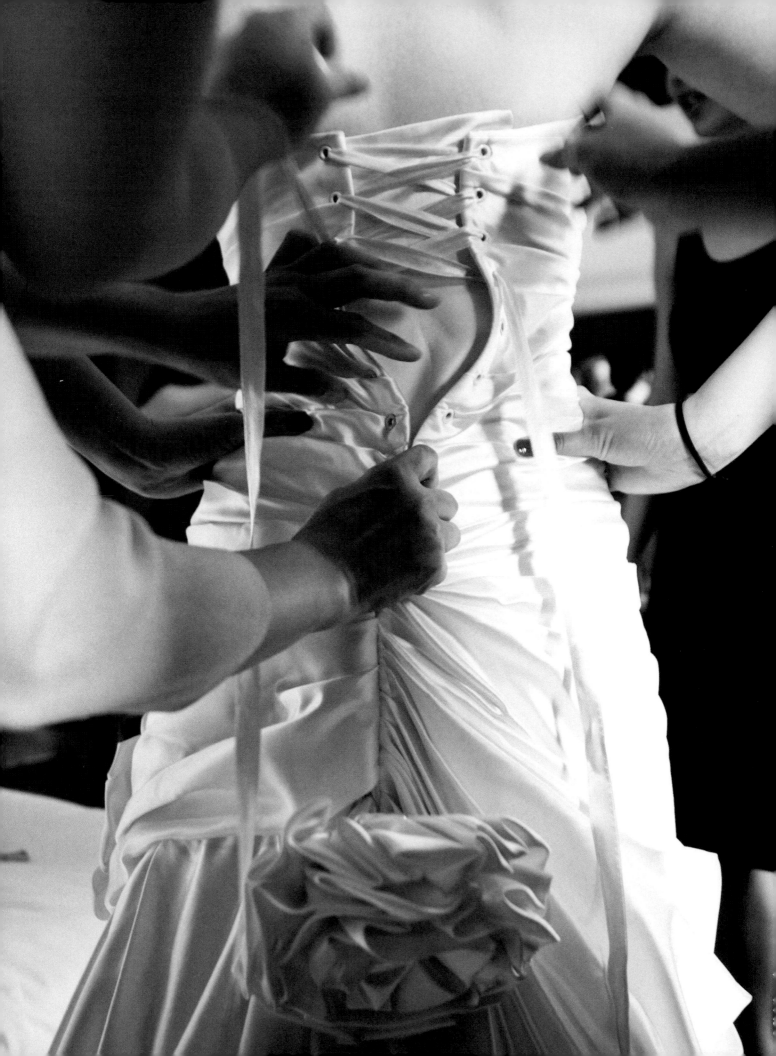

III. GETTING READY

The Day Starts Here

> "Getting ready is such an amazing time; so full of anticipation. I try to be sensitive to special moments as they unfold and capture the subtleties—whether it's through a pair of shoes or the tilt of a head—each gesture and detail is poignant and memorable. There is often a mixture of excitement and vulnerability in the air, which is so beautiful."
>
> —ELIZABETH MESSINA

W hy are "getting ready" images such an integral and frequently requested part of wedding coverage these days? They are, after all, glimpses into some of the most private and personal moments of the day. Is it really necessary to show the bride-to-be in her bra with curlers on her head running around like a crazy person? Or the groom in his socks and briefs as someone helps put his cufflinks on? The clients say yes; they want these shots.

As for the photographers taking them, they say it's not about catching someone in various states of undress but rather a way of setting the tone for the entire day. In many ways, this is where the ceremony really begins, and where intimate and inspiring images are created, be they in a grand architectural gem of a hotel, someone's bedroom, or a windowless basement. Here, Elizabeth Messina, Amy Deputy, Christian Oth, Liz Banfield, and Virginie Blachère share some of their favorites.

ELIZABETH MESSINA

"FOR ME, PHOTOGRAPHY is the language of memories," Elizabeth Messina states matter-of-factly, "and it preserves them in a way that nothing else can. Years later, a couple can look back on their wedding photographs as family heirlooms that honor and preserve the memories of that day and can be shared with generations to come."

This is why brides hire Messina, because she captures the true essence of a wedding: the joy, the love, and the candid moments as well as the essential details that convey the personal story from each couple's special day. (It's also why she is regularly sought after by photo editors—her work appears in *Elegant Bride*, *Los Angeles Weddings*, and *InStyle*, among others). "Getting ready" coverage is especially near and dear to her because, as she describes it, "It's those intimate moments before the ceremony begins—the bride's process of primping and preparing that the groom never gets to experience firsthand—that's so important for me to capture. For the bride or groom to be able to share those moments later on and say, 'This is what I was doing before I walked down the aisle,' I think that's amazing. It's the preparation, the ritual that is so full of emotion. Many brides want this intimacy documented and value the artistic aspect of the photographs, even when some of the more vulnerable shots are not for anything more than their own personal memories."

© *Elizabeth Messina*
(opposite) Messina took this beautiful, sepia-toned print of Martha Vargas a few hours before her marriage to boxer Fernando Vargas. Messina was going for the excitement and anticipation in Vargas's face and especially loved the way the light caressed her features, particularly her eyes. Messina uses as much natural light and backlighting as possible; here she made a point of shooting with the shutter wide open, something she says you need to be very conscientious of because you want to make sure you focus on the right element. In this case, she wanted Vargas's beautiful eyes to stand out, and she literally zeroed in on her eyeball; everything else in the background is out of focus.
CAMERA: Contax 645; **SHUTTER SPEED**: 1/60 sec.; **F-STOP**: f/2; **LENS**: 80mm Zeiss; **FOCAL LENGTH**: 80mm; **FILM**: Kodak Portra 400 black and white

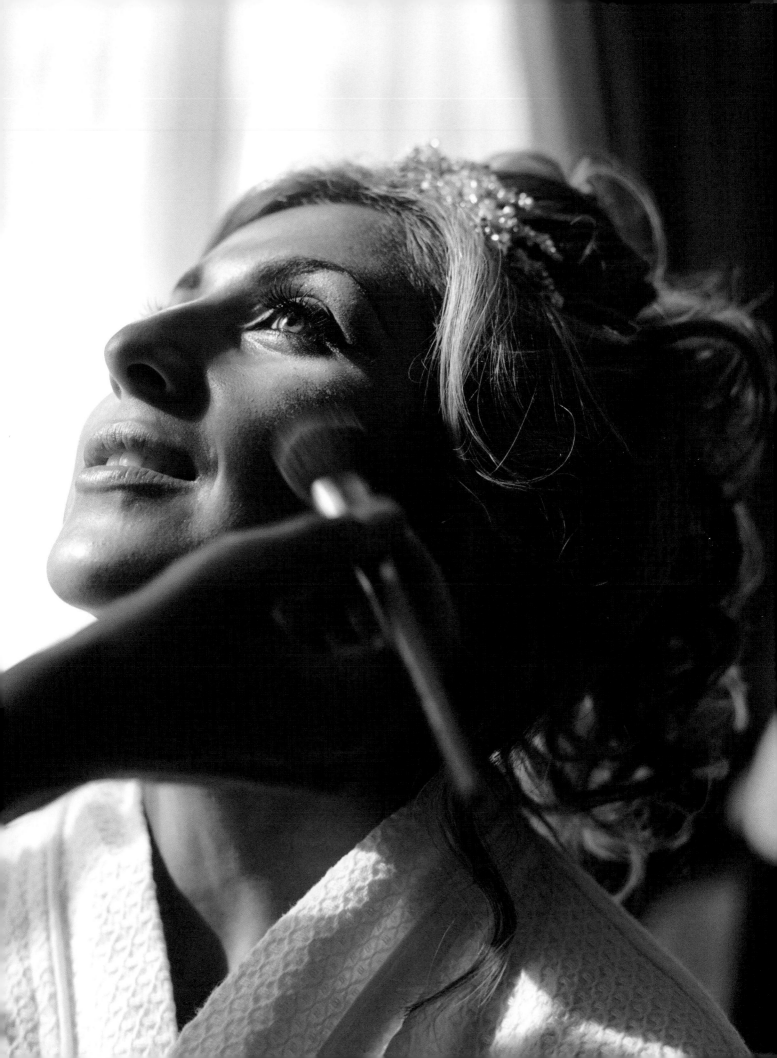

1. Here, Messina captures the bride in a quiet, sensual pose right after she's finished getting dressed. "It's like real life, but more beautiful," she says. In addition, Messina says "boudoir" photography is a huge trend right now and most brides seek out photographs of themselves in sexy, intimate poses. **CAMERA:** Contax 645; **SHUTTER SPEED:** 1/250 sec.; **F-STOP:** *f*/4; **LENS:** 80mm Zeiss; **FOCAL LENGTH:** 80mm; **FILM:** Ilford 3200 black and white

2. This is a particular favorite of Messina's. "Shoes are such a beautiful detail, one that often tells a lot about a woman's sense of style." **CAMERA:** Contax 645; **SHUTTER SPEED:** 1/125; **F-STOP:** *f*/2; **LENS:** 80mm; Zeiss; **FOCAL LENGTH:** 80mm; **FILM:** Fuji 800 NPZ color

3. "Here, the bride holds the pins that will keep her hair in place as she says her vows," says Messina. "It's a simple and meaningful image, one that is quiet and beautiful—as part of the overall coverage as well as on its own." **CAMERA:** Contax 645; **SHUTTER SPEED:** 1/250; **F-STOP:** *f*/4; **LENS:** 80mm Zeiss; **FOCAL LENGTH:** 80mm; **FILM:** Ilford 3200 black and white

4. "I look for the beauty in everything I shoot," Messina says. Here, the mirror adds a voyeuristic angle, conveying what lies ahead for the rest of the day. **CAMERA:** Contax 645; **SHUTTER SPEED:** 1/60 sec.; **F-STOP:** *f*/4; **LENS:** 80mm Zeiss; **FOCAL LENGTH:** 80mm; **FILM:** 400 NPH Fuji color

Like a grainy black-and-white image of a bride slipping into a corset, or an ambient-light shot of a bride perched on a stool wearing a robe that slides halfway down her back as a makeup artist applies powder to her face, Messina says most of her brides insist on these types of images in their albums, as well as shots of the groom getting ready for the day. "I definitely take both, it's just not as long of a process when I photograph the men getting dressed," Messina explains. "With the bride, it can take up to four or five hours." For example, when she photographed actress Jeri Ryan for her wedding in France, it was a fifteen-hour day, many of which were devoted to "getting ready" coverage.

Photographing the men usually means a shorter time frame and a different energy in the room. When Messina photographed the L.A. Clippers' Elton Brandt's wedding, she spent just an hour with him and his groomsmen as they prepared for the ceremony. Over in the bride's room, says Messina, there were beautiful flowers and soft music as the women ate lunch and slowly prepared for the day, but in the men's room, "the guys had sports on in the background, there was a barber cutting their hair, there was a stylist on hand to help Elton get dressed. The same kinds of things were taking place in both rooms but with a completely different vibe in each." And she readily admits that there are certain things she wants to photograph that are geared more to the bride at this point in the day—"iconic things that deserve their own portraits: the dress, the shoes, the rings, the hair clips, the flowers." Most of her coverage is taken with her Contax 645, but she also likes to bring a Holga or two along, to capture little details as accents to her main body of work. "I think it's a really nice way to cover this part of the day in particular . . . by mixing art with lifestyle."

No matter the equipment you choose, or whether you're photographing just the bride getting ready, the groom, or both, Messina says this is the time of day when she as a photographer is connecting with everyone—the bride and her mom, the bridesmaids, the groom and his family and friends—creating bonds that carry over for the rest of day. "It's especially important for a bride to feel comfortable with her photographer so she's at ease for the rest of the day," Messina sums up. "The more positive and relaxed the bride feels around you, the better the images are throughout the day. This comfort often begins before the ceremony, during the quite moments of preparation."

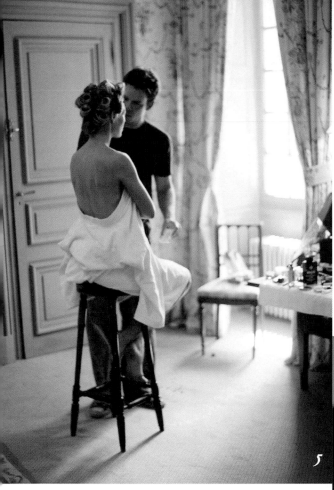

5. Shooting wide open and utilizing as much window light as possible, Messina captures actress Jeri Ryan getting made up in a fifteenth-century chateau in France.
CAMERA: Contax 645; **SHUTTER SPEED**: 1/60 sec.; **F-STOP**: *f*/2; **LENS**: 80mm Zeiss; **FOCAL LENGTH**: 80mm; **FILM**: Fuji 800 NPZ color

6. This image of Messina's father helping his father—her grandfather—get ready for his wedding was featured in an issue of *Martha Stewart Weddings*.
CAMERA: Contax 645; **SHUTTER SPEED**: 1/60 sec.; **F-STOP**: *f*/4; **LENS**: 80mm Zeiss; **FOCAL LENGTH**: 80mm; **FILM**: Kodak Portra 400 black and white (printed in sepia)

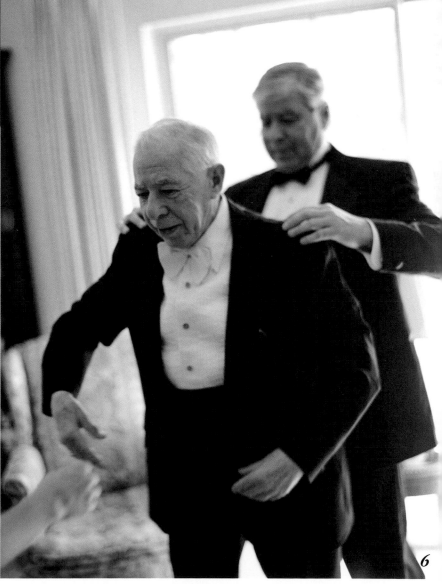

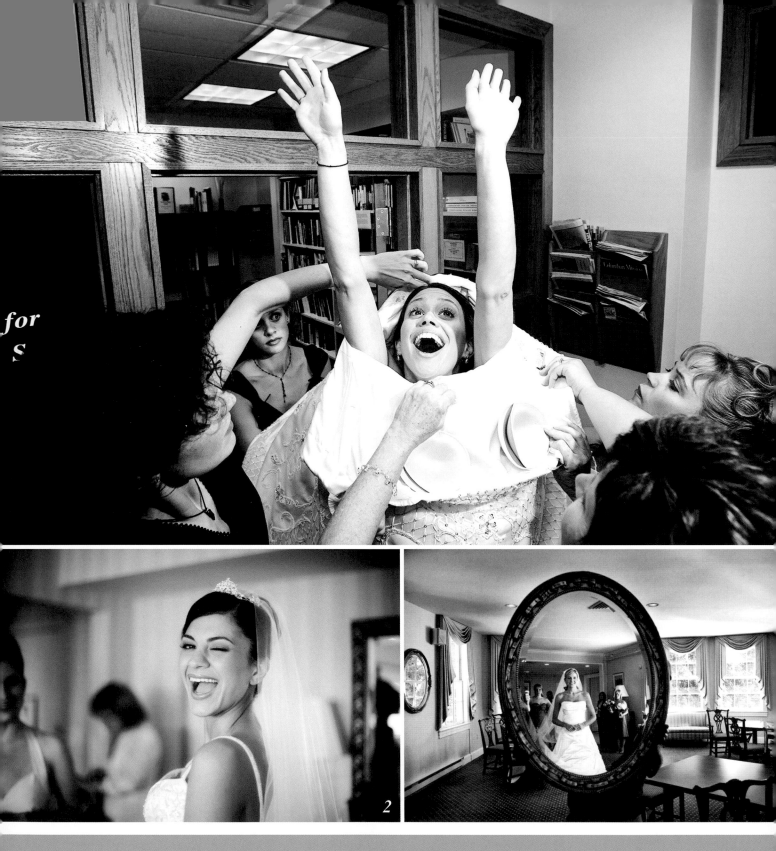

© *Amy Deputy*

1. Amy Deputy photographed this bride getting ready in a church basement in Baltimore. Deputy's assistant used a second light because the lighting in this particular room was so awful. She tries to use natural lighting as much as possible but says she occasionally will use a "teensy"' bit of fill flash or have her assistant hold a flash off to the side that she'll bounce behind her or off to the side to darken the backgrounds or just give the image a nicer feel. **CAMERA:** Canon EOS 1D Mark II; **EXPOSURE PROGRAM:** Manual; **ISO:** 400; **SHUTTER SPEED:** 1/125 sec.; **F-STOP:** *f*/4.5; **LENS:** 16–24mm **FOCAL LENGTH**: 16mm

2. Memorable moments abound during the "getting ready" coverage. Deputy was originally photographing the maid of honor in this scene as she helped the bride get dressed. Suddenly, the bride turned toward Deputy and gave her a big wink (as well as a great shot). **CAMERA:** Canon EOS-5D; **EXPOSURE PROGRAM:** Aperture Priority; **ISO:** 800; **SHUTTER SPEED:** 1/250 sec.; **F-STOP:** *f*/1.4; **LENS:** EF50mm *f*/1.4 USM; **FOCAL LENGTH:** 50mm

3. Deputy says the fact that you can see the hairdresser's arms—as well as his tool belt—holding up the mirror for the bride "adds to the quirkiness of the image and makes me like it even more." **CAMERA:** Canon EOS 5D; **EXPOSURE PROGRAM:** Aperture Priority; **ISO:** 800; **SHUTTER SPEED:** 1/80 sec.; **F-STOP:** *f*/4; **LENS:** EF 24–105mm *f*/1.4 IS USM; **FOCAL LENGTH:** 28mm

AMY DEPUTY

"WHEN PEOPLE ARE comfortable with who they are, they can look right into the camera—and there's a really powerful connection. That's a picture that tells a story," states Amy Deputy of Sparks, Maryland.

Deputy especially loves taking "getting ready" images because it's a time, she says, when "all the family and friends are there, and really sweet moments are unfolding in anticipation of the ceremony." And because there are so many things to do, her sense is that so many of the pictures have a very unguarded feel—that's what makes them so wonderful. "These particular types of images have a real sense of purpose," she explains, "when people have something to do or some place to get to . . . the "getting ready" images are a really nice way to show them in a natural state of mind, completely unaware of the photographer. It's just a beautiful time to get both the very quiet, softer images, as well as the fun ones."

As someone with a strong background in photojournalism, Deputy says that having a picture that tells a story is at the core of her wedding work, especially during this time of day. But just how did an award-winning photographer for the *Baltimore Sun* and the *Bremerton Sun* get into wedding photography in the first place? The way Deputy tells it, she accepted a wedding shoot "under duress" for a friend who needed someone in forty-eight hours—the original photographer had become ill. At that wedding, Deputy shot ten rolls of film and, after looking through it frame by frame, decided to give notice to the *Sun* that she was quitting.

Deputy has been photographing weddings ever since and has no regrets about leaving newspapers behind. She was named one of the best wedding photographers by both *Washingtonian* magazine and *Photo District News*. She is quick to point out that her background enables her to create images with a genuine documentary feel, exactly the look her clientele is after. She enjoys photographing the "getting ready" part of the day immensely but stresses that in order to take successful wedding images during all parts of the wedding day, it's important to have the following traits: You should be able to "tell a story through your images, work very fast, work with no or low light, handle stress well, shoot in several different styles of photography (still life, photo-j, editorial) and think about the type of images you'd want to have from your own wedding in twenty-five years if it were your wedding day."

She continues: "When I go to weddings, people ask me how long I've known the couple. I'm just naturally good with people because I think they are wonderful. And that's the beauty of doing weddings: I don't know all the family relationships, I don't how people react to things, I don't know their stories, so I can go in totally open with no judgment about anything, and that's really one of the best parts of my job. I don't know the backstory on anything and I don't want to. That way then I'm not trying to find the shot . . . instead everything is just presenting itself in the moment as something that's lovely."

Technically speaking, Deputy, who decided to go digital about four years ago, shoots in all RAW format because it gives her a bigger file with more information to work from. Postproduction is done in Bridge and Photoshop CS3, and she uses Photo Mechanic to do her editing. "I'll go in and enhance things, maybe on a series of photos—I have Photoshop Actions set up; I call them my little recipes— maybe to do a blue tone or more of a pinkish tone or add a little bit of blur on the edges and a burn, but for the most part I take the pictures and leave them alone, except for really nice-looking processing . . . I'm not adding anything."

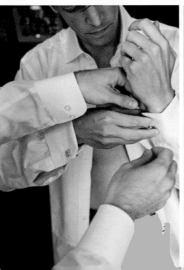

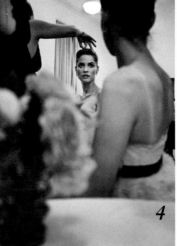

2

4

CHRISTIAN OTH

CHRISTIAN OTH—NAMED by *Photo District News* in 2003 as "one of 15 great photographers shooting weddings with creativity and flair" and named one of the "Ten Best Photographers in the World" by *American Photo* magazine in 2007—says he does some of his best work during this time of day because this is when he can "interact with the bride, become her friend and just talk." Oth makes a point of personally meeting all of his clients before their wedding and is often hired before the wedding to do engagement sessions. He especially likes being present as the bride and groom are getting prepared because, he says, it "helps ease the photographer into the day."

Does being a man photographing a woman in various states of undress add any stress to this part of the day? Oth says no. "It's never been an issue. It's just a good way to start your coverage of the wedding day, and hopefully, as the bride gets to know me a bit and feels more comfortable with my presence, it helps me shoot in a more photojournalistic manner." Oth says that as a photographer, you need to arrive at the designated spot and be professional as well as friendly and relaxed, and "ten or fifteen minutes into it the bride will forget all about you and you can just shoot all around the space and be this fly on the wall and just get your shots."

Of course, he adds, it always helps if the room is a beautiful one, in terms of architecture as well as lighting. Being based in New York City, Oth covers a lot of high-end weddings and will often find himself downtown, either in the grand suite of a chic hotel or in a hip, fashionable studio space, "which means you are already working with something that is great to begin with." And since most of his weddings run toward being larger events, he'll often work with a second photographer, so maybe while he's covering the bride, the second shooter will focus on the groom.

As for equipment, Oth, a digital shooter, favors his 24–70mm lens, and next, his 35mm *f*/1.4—the latter allows him to shoot pictures in any situation or light, say, a winter wedding in New York or a bride getting ready in a dark hotel room. "I don't need flash for that lens—or if I do, just a very light fill flash—because it allows me to shoot with natural light in most any room; it's just amazing what I can get out of it. It gives you a very shallow depth of field, and if you nail it, it becomes a very beautiful, soft picture, yet has a crisp sharpness as well." In addition to his favorite lenses, Oth says he brings a range of photographic styles to a couple's wedding day based on his varied background. "I've done photojournalism, portraits, fashion, advertising, etc. In the end, I always try to come back with unusual wedding pictures. My clients love that."

1. Christian Oth strives to get images that showcase the bride's personality as she gets ready for her wedding. This scene took place in a bedroom of the bride's mother's house. If a room is too messy, he says he'll try to clear away some of the clutter before taking the shot. **CAMERA:** EOS-1Ds Mark II; **EXPOSURE PROGRAM:** Manual; **ISO:** 400; **SHUTTER SPEED:** 1/45 sec.; **F-STOP:** *f*/4; **LENS:** 16–35mm; **FOCAL LENGTH:** 17mm

2 and 3. Oth says you can definitely get some fun shots of the groom getting ready—trying to figure out a bowtie or putting on cufflinks or getting his hair cut or washed. "It's a different dynamic from the bride's 'getting ready' moments, but most of my clients want both." **CAMERA:** Canon EOS-1DS Mark II; **EXPOSURE PROGRAM:** Manual; **ISO:** 500; **SHUTTER SPEED:** 1/90 sec.; **F-STOP:** *f*/2; **LENS:** 35mm *f*/1.4; **FOCAL LENGTH:** 35mm
2. **CAMERA:** Canon EOS-1DS Mark II; **EXPOSURE PROGRAM:** Manual; **ISO:** 500; **SHUTTER SPEED:** 1/90 sec.; **F-STOP:** *f*/2; **LENS:** 35mm *f*/1.4; **FOCAL LENGTH:** 35mm
3. **CAMERA:** Canon EOS-1DS Mark II; **EXPOSURE PROGRAM:** Manual; **ISO:** 500; **SHUTTER SPEED:** 1/90 sec.; **F-STOP:** *f*/3.5; **LENS:** 35mm *f*/1.4; **FOCAL LENGTH:** 35mm

4. Oth captured a tasteful image of actress Amanda Peet before her wedding ceremony. "As a photographer. I'm always trying to frame things," says Oth. "A lot of mirrors not only make a nice framing device, but they also give you greater distance to the subject. So when you are shooting around the room and you don't actually have access to the bride and can only see the back of her head, you can shoot her in the mirror." **CAMERA:** Canon EOS-1D Mark II; **EXPOSURE PROGRAM:** Manual; **ISO:** 400; **SHUTTER SPEED:** 1/60 sec.; **F-STOP:** *f*/2.8; **LENS:** 35mm *f*/1.4; **FOCAL LENGTH:** 35mm

LIZ BANFIELD

1. Liz Banfield calls this image a "one off," meaning a stand-alone image highlighting a detail from the wedding, for example, a closeup of a bouquet or a shot of a detail on the wedding dress. She did a lot more one-offs, she says, when she was first trying to get published in bridal magazines years ago. "A photo editor might say to me 'I need a good shot of the "getting ready" part of the day or a good image of tents.' With this shot, I was consciously thinking of something more iconic that could be applied to anyone's wedding—makeup brushes." She says that now she'd rather spend her energy on getting an entire wedding published.
CAMERA: Nikon F100; **LENS**: 50mm *f*/1.4; **FILM**: Kodak Portra 800

FILM-BASED PHOTOGRAPHER Liz Banfield gets inspired by what she calls "the trappings of the whole beauty ritual" part of the wedding day—the shoes, the makeup, the hair, choosing bracelets and necklaces to wear. "It's very unstaged at this point, filled with lots of excitement and anticipation. I get motivated to take great images based on some of those routines." She's also motivated by the medium she shoots in. "I just love the qualities of film, and, even though it's much more expensive, I prefer shooting film to digital any day." Banfield says she has her entire film batch scanned when it is processed to preserve a digital record of every shot she takes. "I think skin tones are especially better with film. And I work a lot in really low light situations where film is much more flexible and the grain can be quite beautiful."

The Minneapolis-based Banfield, whose wedding images have been published in *Martha Stewart Weddings, Town & Country*, and *InStyle*, among many others, says that photo coverage is pretty wide open at this point of the wedding day in terms of the creative opportunities available. "It's whatever I want to make it; there is no preconceived notion of how it should look. I feel very free during this time to do my thing."

And even though there are the shots every bride, and magazine editor, wants—the shoes, the hanging dress, the bride reflected in a mirror—Banfield says she feels that she has more control over variations on these images because she can change the location of the hanging bridal dress, move the shoes, or create an interesting angle for a shot, and so on. "When you shoot a wedding you are beholden to the action, to the timeline, to everything—trying to make the best of your time and the situation. But with the "getting ready" part, you have a little bit more control, which is nice. I love just rolling up my sleeves and getting started, so that's probably another reason why it's a time of day I really enjoy."

Of course, there are challenges that arise; not everyone gets ready in a light-filled space or a charming bridal room. One time, Banfield found herself photographing the preparation shots in a dark hotel room that she says was more like a bunker. "It was awful—a windowless, painted, cement-block bunker—you can't really do anything with that," she laughs. Fortunately, Banfield knew what she was going to be up against ahead of time and didn't charge the couple overtime when she met them earlier in the morning at the bride's house, "just so I could have a nice place where I could take photographs of the dress and the shoes and the invitations. Sometimes—and this is a point I make in my seminars—if you really want to get a great shot, and get it published in a bridal magazine, you have to do what it takes . . . and if that's throwing in a little bit of your own time in to start early or stay late, then you should do that, because it might make all the difference."

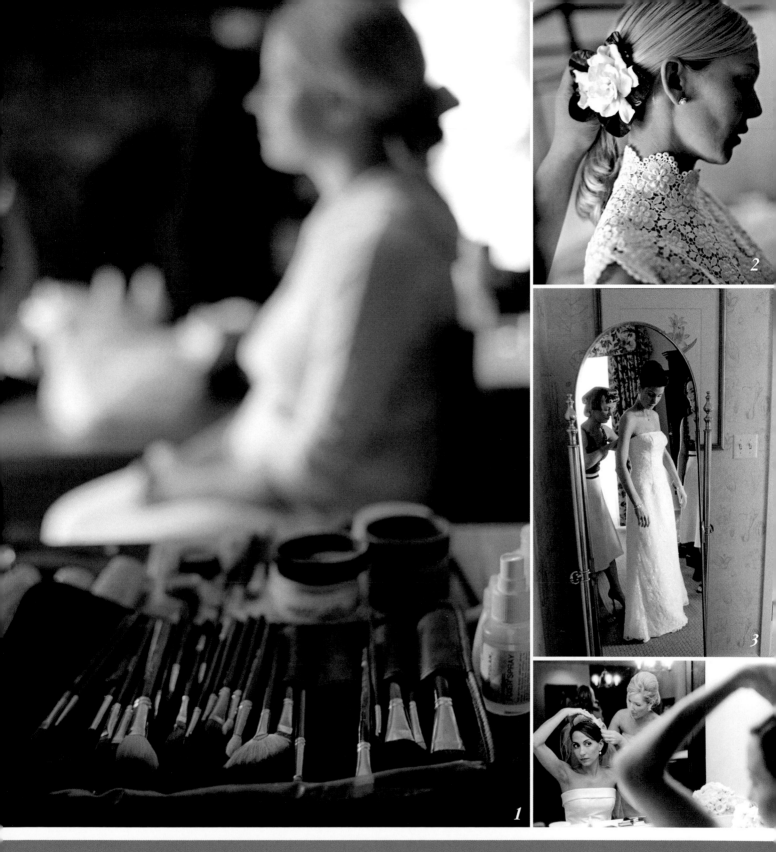

2. Banfield took this image with her 50mm lens during a destination wedding on an island off Wisconsin. She says she photographs at least half of a wedding with the 50mm. "I like using this lens in real low-light situations because I can open up to a 1.4 if necessary. It's how your eye sees the world; it's undistorted and is such a crisp, crisp lens." **CAMERA**: Nikon F100; **LENS**: 50mm *f*/1.4; **FILM**: Ilford 3200

3. With this image, Banfield goes for a unique take on the requisite "zipping up the bridal dress" shot by using a more voyeuristic approach of shooting into the mirror. Oftentimes with images like this, you might see a closeup of the back of the bride's dress or a pair of hands zipping up the dress. Here, however, the emphasis is on the interaction between bride and bridesmaids during a private moment, as well as a glimpse into their surroundings. **CAMERA**: Nikon F100; **LENS**: 35-70mm *f*/2.8; **FILM**: Ilford 3200

4. A bride gets help with a veil adjustment right before her Palm Beach ceremony. Banfield shoots mostly with 800 and 3200 film because she dislikes the look of flash. "The atmosphere you can get with those films at those ISOs is just priceless." **CAMERA**: Nikon F100; **LENS**: 50mm *f*/1.4; **FILM**: Ilford 3200

VIRGINIE BLACHÈRE

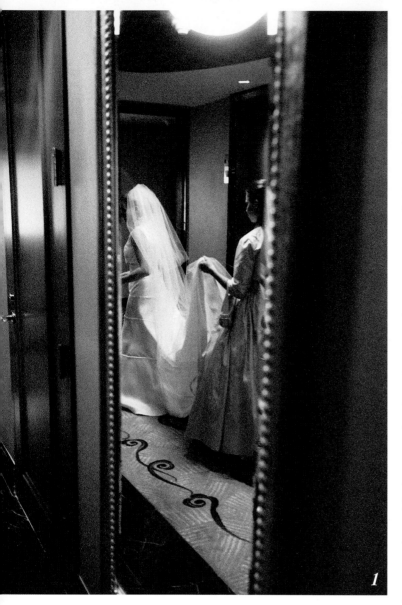

1

ON FRENCH-BORN, New York City–based Virginie Blachère's website, famed photographer Howard Schatz is quoted as saying that "her ability to capture—and beautifully compose—quiet and real feelings during the activities of a wedding ceremony is a rare and special gift. The pictures are filled with the touching, sweet and rich experiences that weddings make, and her eye and heart make her photographs glow." Exactly.

Brides see what Schatz describes, and ultimately they hire Blachère for her fresh perspective and intimate, timeless imagery—her style is sensitive and reflects the genuine feeling of a moment as it occurs. Like this (opposite, top right) quiet, thoughtful portrait of a bride right after her mother put down her veil. "I used all natural light here; you can see part of the window in back of her." She says that what she strives for most during this part of the day is to keep things simple, and, if she needs to, she'll go to a higher film speed instead of using strobe or reflectors. With this image, she pushed the film to 800.

Blachère believes that her documentary style lends itself particularly well to these kinds of "preparation" images. "It's one of my favorite times of the day. When I arrive and see where the bride is getting ready, it gives me an idea of what film I'm going to use, what camera I want, natural light availability, if I need flash or not, and types of lenses I'll need." She loves using her 24–70mm lens at this time of day, as well as her portrait lens—the 85mm—because it allows her to shoot handheld, and it opens up to 1.2, allowing her to "get all the background out of focus."

Blachère, a film shooter who will occasionally use digital during the reception, says she especially loves using her Leica for "getting ready" shots—"it's a great way to get a full range of what's happening while the bride and groom prepare for their day."

"I'm very particular on how I want my images to look," she adds. She'll use natural light as much as possible and tries to remain unobtrusive throughout the day. So much so that one bride remembered Blachère's images from a friend's wedding she had photographed nine years earlier but didn't remember the photographer being at the wedding—"she saw me at the beginning of the wedding but not after that, which she just loved; she thought the images were beautiful and ended up hiring me to shoot her own wedding. Having her not remember me there was a real compliment!"

© *Virginie Blachère*

1. Virginie Blachère shot into a hotel's lobby mirror to get this take on a bride as she was making her way over to the ceremony. "Any time I see mirrors, I play with them. I like to shoot into the mirror and get the reflection; it's really a great graphic. I also like showing doors or shooting through an open door. It adds a voyeuristic feel to an image." **CAMERA:** Leica M6; **SHUTTER SPEED:** 1/60 sec.; **F-STOP:** *f*/2.8; **LENS:** Summilux M 1:1.4/35; **FOCAL LENGTH:** 35mm; **FILM:** Kodak TMAX 3200

2. The bride was finished with her hair and headed straight for the mirror. "I'm right behind the bride in this one. You get a glimpse of the makeup artist in the corner," Blachère points out. **CAMERA:** Canon EOS 1; **SHUTTER SPEED:** 1/125 sec.; **F-STOP:** *f*/2.8; **LENS:** 24–70mm *f*/2.8; **FOCAL LENGTH:** 35mm; **FILM:** Kodak TMAX 3200 (rated at 1600 ASA)

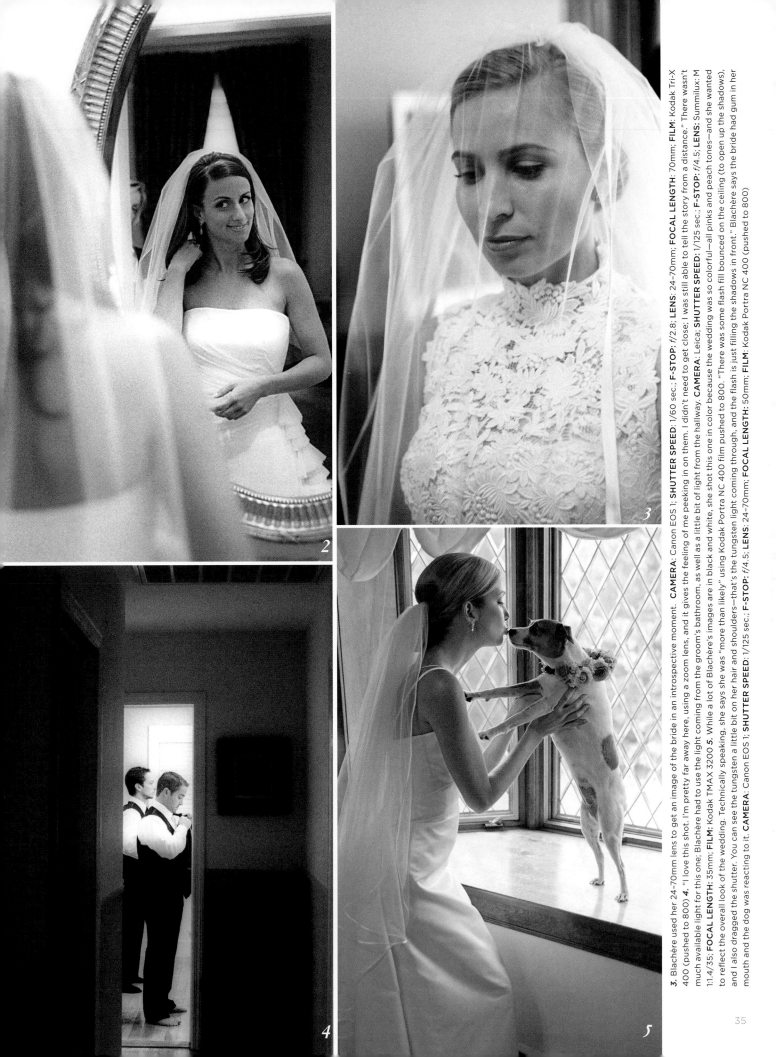

3. Blachère used her 24–70mm lens to get an image of the bride in an introspective moment. **CAMERA:** Canon EOS 1; **SHUTTER SPEED:** 1/60 sec.; **F-STOP:** f/2.8; **LENS:** 24–70mm; **FOCAL LENGTH:** 70mm; **FILM:** Kodak Tri-X 400 (pushed to 800) **4.** "I love this shot. I'm pretty far away here, using a zoom lens, and it gives the feeling of me peeking in on them. There wasn't much available light for this one; Blachère had to use the light coming from the groom's bathroom, as well as a little bit of light from the hallway. **CAMERA:** Leica; **SHUTTER SPEED:** 1/125 sec.; **F-STOP:** f/4.5; **LENS:** Summilux: M 1:1.4/35; **FOCAL LENGTH:** 35mm; **FILM:** Kodak TMAX 3200 **5.** While a lot of Blachère's images are in black and white, she shot this one in color because the wedding was so colorful—all pinks and peach tones—and she wanted to reflect the overall look of the wedding. Technically speaking, she says she was "more than likely" using Kodak Portra NC 400 film pushed to 800. "There was some flash fill bounced on the ceiling (to open up the shadows), and I also dragged the shutter. You can see the tungsten light coming through, and the flash is just filling the shadows in front." Blachère says the bride had gum in her mouth and the dog was reacting to it. **CAMERA:** Canon EOS 1; **SHUTTER SPEED:** 1/125 sec.; **F-STOP:** f/4.5; **LENS:** 24–70mm; **FOCAL LENGTH:** 50mm; **FILM:** Kodak Portra NC 400 (pushed to 800)

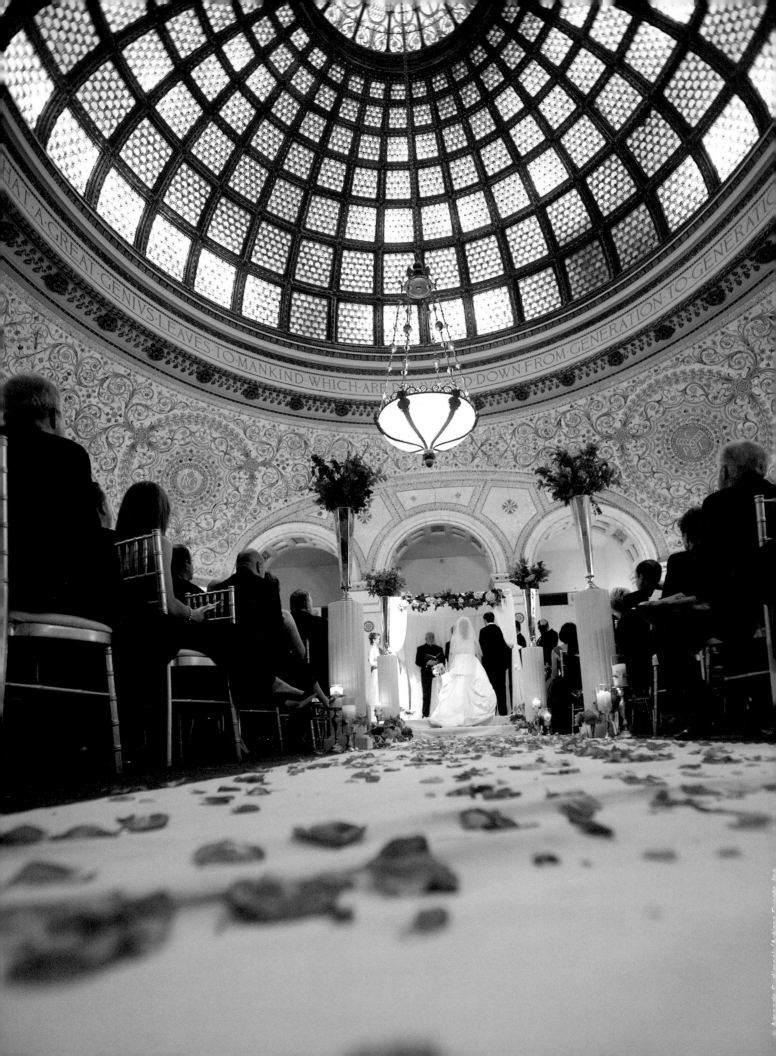

IV. THE CEREMONY

Long Lenses and Quiet Shoes

"I love this time of day; it's when I can create something new, something different … when people's emotions are always right there at the surface, waiting to be captured. I also find it to be the most challenging part of the day. You never know what's going to happen: a groomsmen goes down, someone starts crying, you're banished to the back of the church, who knows? I love to go in and find memorable, unique moments and create beautiful images out of them."

—PARKER J. PFISTER

(opposite) This photo was shot immediately after the first kiss during an outdoor ceremony at the Ritz, in Sarasota, Florida: "This image has a very warm, emotional color," says Pfister. "It's not the bride's exact skin tone, but that's okay; it's more about how the image makes you feel, I think, and as soon as you look at it, that color—it's not the super-saturated color that everyone seems to be into these days and which I don't like—it's warm, real color. I'll do a lot of color toning; I have no problem with that."
CAMERA: Canon EOS-1D Mark II N; **EXPOSURE PROGRAM:** Aperture Priority; **ISO:** 100; **SHUTTER SPEED** 1/125 sec.; **F-STOP:** *f*/3.5; **LENS:** EF 70-200mm *f*/2.8L IS USM; **FOCAL LENGTH:** 195mm

The wedding ceremony is the real deal: the emotions, the nerves, the religious aspects. And no matter the location—in a church, a synagogue, in front of a justice of the peace at city hall, or even on a tropical island surrounded by sand, rose petals, and loved ones—it's an affair of the heart. Which means anything can happen along the way.

When my older sister, Donna, got married twenty years ago, I was the maid of honor, and my two younger sisters, Pamela and Deirdre, were bridesmaids. On the big day, the three of us dutifully accepted our roles and eagerly took our places under the hupa as the rabbi addressed the bride and groom. Seconds into what began as a lovely event, the ceremony nosedived into a panic-filled situation as bridesmaid Deirdre began to lose her balance, weaving back and forth and then squatting down on the stage and placing her head in her hands (turns out she hadn't eaten all day). Ten minutes later—with the help of two little old ladies armed with hard candy and tissues—Deirdre was back on her feet and ready to continue her bridal duties.

Wedding ceremonies, though typically very scripted, can have their unscripted moments, too, as happened at my sister's wedding. According to the five photographers highlighted here—Parker J. Pfister, Jose Villa, Kathi Littwin, Meg Smith, and Shannon Ho—despite the shooting restrictions, the time constraints, and the raw emotions on display, the ceremony can be one of the most creative and visually stunning parts of the day.

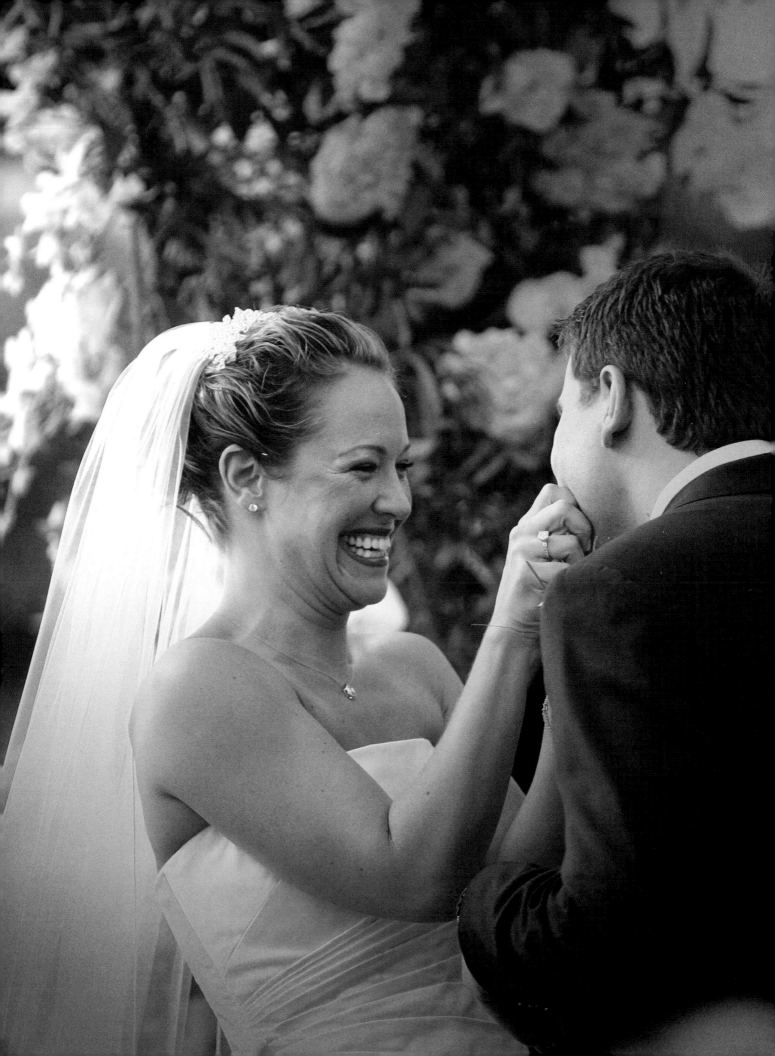

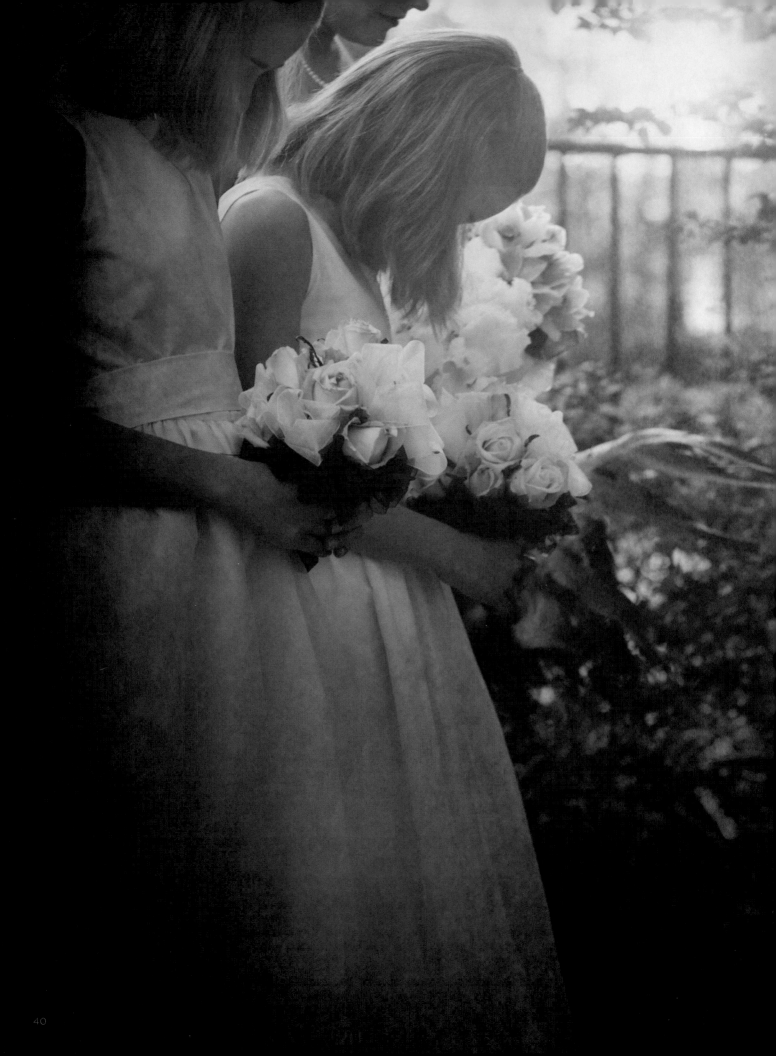

PARKER J. PFISTER

PARKER J. PFISTER says he is always looking for the real moments, especially during the ceremony and the situations that occur right before and right after it. Based in Asheville, North Carolina, Pfister shoots 99 percent destination weddings and says he photographs "for his soul." Known for images that are photojournalistic and fine-art in nature—moody, vintage black and whites; muted colors; textures and layers done later on in Photoshop; a Polaroid overlay on occasion—Pfister acknowledges that photographing the actual wedding ceremony can be tricky. Many churches and synagogues have shooting restrictions, no-flash policies, or no up-front or aisle access. And some ceremonies, he says, are literally under a minute long, while others can go for two hours or longer. "There's so much happening, so much to catch, and you've got to be there, and aware, to catch it," he says.

Pfister emphasizes that one of the most important things a photographer can do during the ceremony is to see it from all sides, especially at outdoor weddings when you can move around wherever you want and get different vantage points and unique angles. "It's not always just about the bride and groom," he says. "There's so much going on in the audience as well. For instance, the mother and father are there, seeing their daughter get married, and they are just beyond happiness. That's quite an emotion to try and capture—to pull off that one fleeting moment in a story with one image. But that's our job as photographers, and it's what I love about wedding photography. It's spectacular."

The good thing about covering the ceremony portion of the day, Pfister continues, is that you can find shots that are related to, but not necessarily taking place during, the actual vow exchange. At a wedding in Mexico (on page 43, #2), Pfister stumbled onto a poignant moment as the bride passed through the hallway of the home she was getting ready in on her way to the ceremony. "I absolutely love this one," Pfister exclaims, "and so did the bride. Some photographers might think, 'Oh, I should toss this one because the bride is soft and out of focus,' but she's really not out of focus; she's blurry because everything else is sharp except her and that gives motion to the image." According to Pfister, everything doesn't always have to be tack sharp in an image, and you don't always have to see the bride or groom's face. "They just want moments from the day," he states.

For ceremony images and beyond, Pfister works more or less with natural lighting and, later on, will often enhance the images in Photoshop, including doing black-and-white and color toning and vignetting and texturing, among other things. It adds, he says, a vintage feel to his work. He's also been known to print out an image and do some "funky stuff to it with coffees and teas and such," and then re-photograph it. "We're known to be mad scientists around here, for sure," he laughs. "To say you're a photojournalist, you're not supposed to use color tones or do anything to the image, really, other than take it. But that's not me, and that's not how it is in wedding photography anymore. People do stuff to their images nowadays, and it's okay."

The bridal party bowed their heads in prayer. "I saw this shot from the altar and thought, *That's it, that's the one!* with the warm, beautiful light coming in from the back." Pfister did some vignetting and added texture and color toning later on in Photoshop. **CAMERA:** Canon EOS-1D Mark II N: **EXPOSURE PROGRAM:** Aperture Priority: **ISO:** 400: **SHUTTER SPEED:** 1/320 sec.: **F-STOP:** f/4: **LENS:** EF 70-200mm f/2.8L IS USM: **FOCAL LENGTH:** 70mm

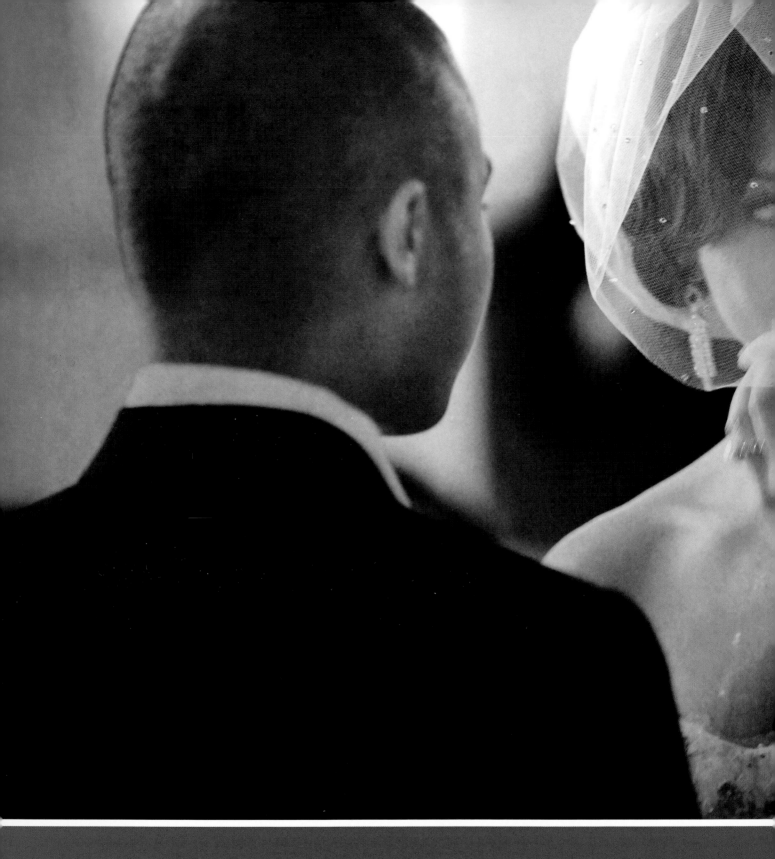

1. Parker Pfister captured the raw emotions of this bride as her husband-to-be was reciting his vows during their ceremony in Cabo San Lucas, Mexico. "He was just killing her," Pfister said, describing the scene. "He had her laughing, crying, happy, nervous . . . it was awesome." Pfister says he shot several other frames of the same scene as he stood in the corner of the tiny church they were in. "There was no room for movement; I had to stay in my one little spot, behind the altar, shooting through the floral arrangements." Pfister loves this image, he adds, because the "light was perfect and the tears on her cheek just glistened. It was a gift!" This image is toned, as are most of his black-and-whites, to give it a bit of softness: "It's my signature."
CAMERA: Canon EOS-1D Mark II N; **EXPOSURE PROGRAM:** Aperture Priority; **ISO:** 1000; **SHUTTER SPEED:** 1/25 sec.; **F-STOP:** *f*/2.8; **LENS:** EF 70–200mm *f*/2.8L IS USM; **FOCAL LENGTH:** 153mm

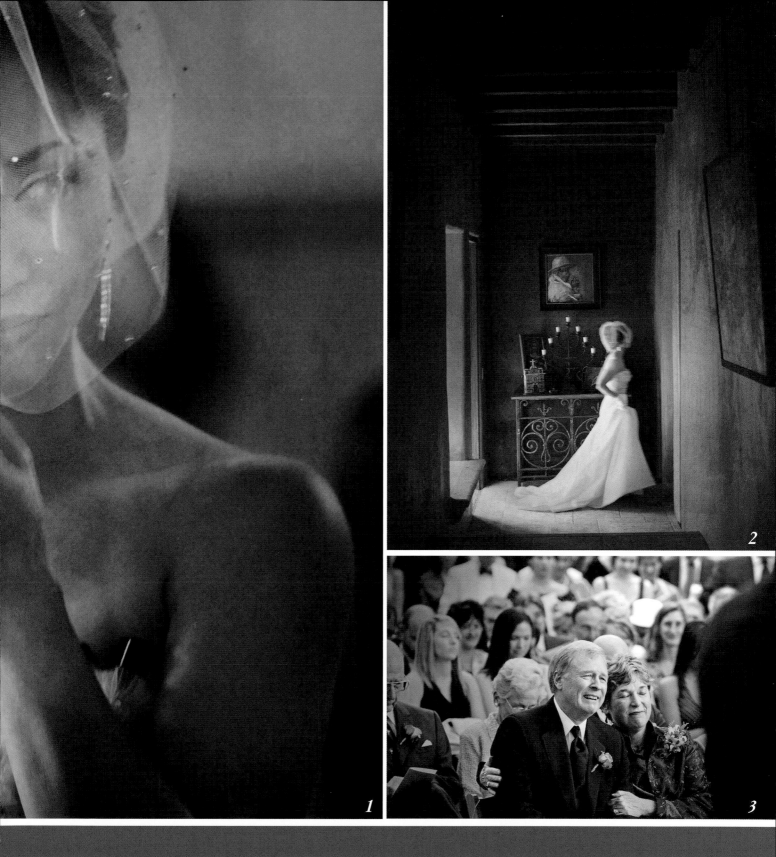

2. With this image, taken on the way to the ceremony, Pfister did some color toning and added a vignette in Photoshop. The dark candle lighting added to the warmth and softness of the scene. "Before hiring me, the couple saw my fine-art work," he explains, "and that's what they fell in love with. There were no rules that day—actually there were three days of wedding on this job—they just turned me loose and let me do my thing. That's how 95 percent of my weddings are. They hire me for a unique look." **CAMERA:** Canon EOS-1D Mark II N; **EXPOSURE PROGRAM:** Aperture Priority; **ISO:** 100; **SHUTTER SPEED:** 1/10 sec.; **F-STOP:** f/4; **LENS:** EF 50mm f/1.4 USM; **FOCAL LENGTH:** 50mm

3. At this outdoor wedding in Columbia, South Carolina, Pfister zeroed in on the parents of the bride and the emotions they were experiencing at the moment. "I was in the back, behind the altar—I always get permission first to go back there—and the bride and groom wanted a pure photo feel, just straight black-and-white shots for some scenes—rare for me, but that's what they wanted." **CAMERA:** Canon EOS-1D Mark II N; **EXPOSURE PROGRAM:** Aperture Priority; **ISO:** 400; **SHUTTER SPEED:** 1/160 sec.; **F-STOP:** f/4.5; **LENS:** EF 70–200mm f/2.8L IS USM; **FOCAL LENGTH:** 200mm

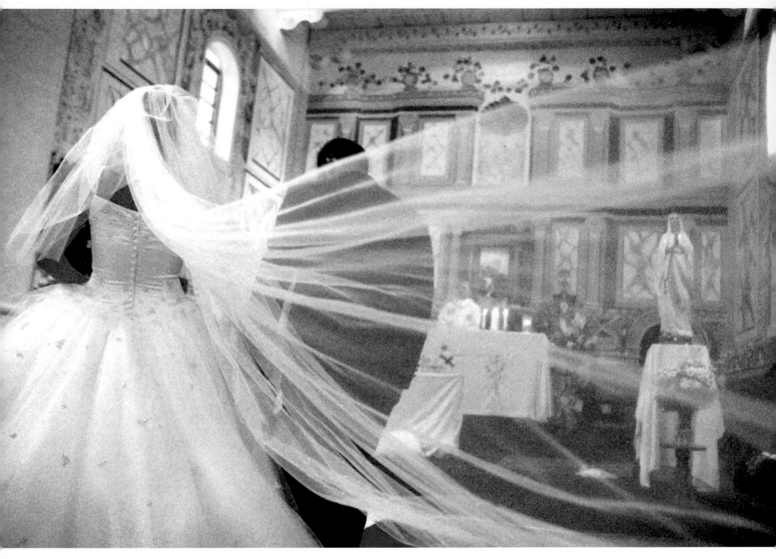

FILM-SHOOTER JOSE VILLA, from Solvang, California, says he was in exactly the right place at the right time during a Catholic Church ceremony where bride and groom were about to deliver a bouquet to the Virgin Mary. He says he was squatting down in the first pew—which led to where the couple was going to place the flowers—when midway through it became the perfect spot to be in because they ended up walking right past him, delivering the bouquet, and then walking back again. "They were walking around the pew when I ended up almost touching the bride's veil," describes Villa. "It was really close to my lens—it was wide angle so it was *really* close— and the veil got caught on the fibers of the carpet. It didn't pull her hair or anything, it just slowly draped out." Villa saw the picture unfolding in front of him and took three shots. Only one frame was in focus because, as he puts it, "I was fumbling around and thinking 'I can't believe this is happening.'"

And although digital is getting more and more popular among wedding photographers, Villa continues to stick with film and has no regrets doing so. "Film is unique these days," he explains, "which sets me apart right away. Film has a different look; it feels real, especially the skin tones. I overexpose color film by a stop or stop and a half, which results in a beautiful, glowing pastel lighting effect. The lab processes it normally, which really brings out the saturated colors, giving it more of a fine-art feel. I'm no stranger to digital, but film's workflow better suits my business."

During the ceremony, Villa shoots about four rolls of film during the vow50
s and then another two rolls on details, like a shot of candles placed up by the altar or the exterior of the church if it is visually interesting. At a night ceremony

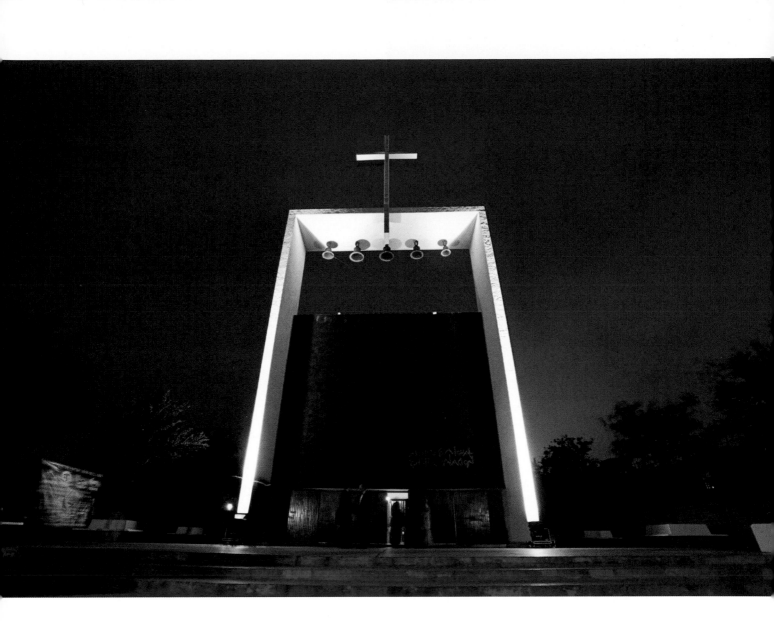

in a church in Monterey, Mexico, Villa was struck by the building's interesting shape, rectangular and boxlike, with a tremendous arch and cross attached.

In the image above, the bride and groom are visible right outside the church doors—the groom is greeting guests and the bride is in the background. "This is probably a half-second exposure, so there is a little bit of blur," Villa explains. "And this was taken right before they were walking down the aisle, so I actually stepped out, took the picture, ran back into church, and got them going inside right before the ceremony began." In this case, Villa says the

couple was not concerned about not seeing each other beforehand—the way some couples are—so he was able to capture another aspect of the moment. "They were out there trying to figure out where people were going to line up and that sort of thing; the wedding party is right inside that door, to the left and to the right, waiting for the ceremony to begin."

After getting the shot, Villa ran back into the church to switch cameras. "I always have a 35mm camera strapped on me, and then I'll have my medium-format [Contax 645] in my hand, usually at all times—and then if I need the other 35mm

© *Jose Villa*

(opposite) Talk about being in the right place at the right time! The veil fanned out perfectly right in front of Villa, naturally, as the bride passed him while he squatted in the pew. And because of the film he was using—1600 speed—he was even happier with the soft, grainy quality and warm tones. **CAMERA:** Canon EOS 1V 35mm; **SHUTTER SPEED:** 1/30 sec.; **F-STOP:** *f*/2.8; **LENS:** 24–70mm; **FOCAL LENGTH:** 24mm; **FILM:** Fuji Press 1600

(above) Villa was fascinated by the shape of this church in Monterey. "If you look toward the bottom where the arches start to the right and to the left of the building, you can see there are huge lights illuminating the church's exterior," says Villa, "because the couple brought in a lot of extra lighting." **CAMERA:** Canon EOS 1V 35mm; **SHUTTER SPEED:** 1/2 sec.; **F-STOP:** *f*/2.8; **LENS:** 16–35mm; **FOCAL LENGTH:** 16mm; **FILM:** Fuji Press1600

© *Jose Villa*

1. Villa put to good use the plentiful and colorful light inside this church in Monterey. "There's a bluish tone to the image because there was a blue filter on the lights behind the couple. There was also one above the groom's head and one to the left of them, and then there were five more lights placed at the front of the church, lighting the couple with orange and yellow filters. **CAMERA:** Contax 645; **SHUTTER SPEED:** 1/5 sec.; **F-STOP:** *f*/2; **LENS:** 80mm *f*/2; **FOCAL LENGTH:** 80mm; **FILM:** Fuji NPZ 800

2. Photographing at city hall in San Francisco right before the ceremony began, Villa says there was a lot going on: The bride was coming down the steps with her father, the groom was looking up at them, the flower girl was fidgeting. "I kept thinking, *How am I going to get this shot and include everybody in it?*" At first, Villa was concerned that he would be unable to capture the groom's reaction—"It would be too intrusive for me to go over to the steps where they all were standing"—but since the bride hadn't requested that shot in advance, he let it go. Ultimately, he got shots of the bride and groom with both his Contax and his 35mm camera, as well as this scene shot from a side angle at his widest setting, 16mm. There was a lot of available light, thanks to lights the bride had brought in and the extra lighting provided by the videographer. **CAMERA:** Canon EOS 1V 35mm; **SHUTTER SPEED:** 1/60 sec.; **F-STOP:** *f*/2.8; **LENS:** 16–24mm; **FOCAL LENGTH:** 16mm; **FILM:** Fuji Press 1600

3. Villa turned his camera on the guests at the Four Seasons Biltmore in Santa Barbara to get a sense of who was present at the ceremony. In this image, it was the bride's mom, brother, and aunt. **CAMERA:** Contax 645; **SHUTTER SPEED:** 125/sec.; **F-STOP:** *f*/2; **LENS:** 80mm *f*/2; **FOCAL LENGTH:** 80mm; **FILM:** Fuji Pro 400 H

camera, I'll run and go get it. I don't like to have too many cameras on me. I try to be as unobtrusive as possible."

Once inside the church in Monterey, Villa took this image (left) of the bride and groom kneeling by the altar. "This priest was very cool, he told me I could be wherever I wanted to be as long as I wasn't too intrusive." Here, he says he was "hiding" behind a very large structure, close to where the priest was standing as he officiated, so he was only about twenty feet from the bride and groom. Luckily for Villa, the church's interior was just as beautifully lit as the exterior. "It was great. I was able to shoot with available light in there," he exclaims. "There's a bluish tone to the image because there was a blue filter on the lights behind the couple. There was also one above the groom's head and one to the left of them, and then there were five more lights placed at the front of the church, lighting the couple with orange and yellow filters. "It added a warm, soft light on the couple, versus the cooler blue light in the back of the church."

For Villa, shooting with film and infusing a fine-art style into his wedding images have resulted in an infinite array of very creative, striking scenes, as illustrated with the wedding in Monterey. But what if you are based in a place to which everyone flocks to get married? Villas says that being located in a top wedding destination like Santa Barbara and near a super-popular wedding spot like the Firestone Vineyard means you really have to go the extra mile to make the images for each wedding look different. "When you're shooting in a place where everybody has their wedding, and where everyone gets married under the same tree and everyone has their reception in the same barn, you need to think outside the box. Use different techniques, maybe different cameras"—Villa will often bring his Rollei and Holga to mix things up—"so you can incorporate something a little different from what you shot two weeks ago at the same location."

KATHI LITTWIN

"THERE ARE CERTAIN things that allow me to be a low-key shooter during the ceremony," says Kathi Littwin of New York. "First, I always check in advance what I can and cannot do. Second, fast films and the greater sensitivity of digital mean I probably won't need flash. Third, I can always use a tripod if necessary—a tripod with a long lens from the balcony can keep the shots intimate. Mostly, I want to keep things quiet and stay as invisible as I can."

This is the ceremony after all, the time when you need to be the most discreet and try to avoid noisy equipment and blinding flashes going off. Littwin says she is usually able to use flash during the procession and recession parts of the ceremony, but if the spot she's in has enough natural light, then she'll pass on the flash. It's been her experience during some Jewish ceremonies, for example, to see the hupa lit from above, in which case she says there is plenty of light bouncing around to work off of the natural light during the ceremony. "I want to shoot the essential moments, and I want to make sure I'm not blasting the shutter all over the place." During certain ceremonies, she'll shoot with high-speed black-and-white film instead of turning to flash: "It just reads the low light situations in a really nice way. It has a little grain to it as well, and there are just some things that, in my head, I see specifically with that type of film."

And whether she's shooting film or digital,

Littwin says her favorite lenses are the all-purpose 28–105mm f/2.8 or 24–85mm f/2.8 macro—"the 28–105 lens offers a bit more range, and the 24–85 has the macro feature"—and the 85mm f/1.4. Next, she likes the 70–200 f/2.8 and the 17–35 f/2.8. "I only buy fast lenses. I never want to be in a spot where I wish I had more range and can't get it." Lastly, she likes to have a 16mm fisheye and a 50mm f/1.2, which is "my fastest, but small and lightweight lens. It's easy to have on hand."

Of course, there are times, Littwin explains, when she's not allowed to photograph the ceremony at all, and it doesn't matter what lens she has. "But that shouldn't be something that just pops up on the wedding day. You need to find out ahead of time and then decide how to proceed. I try to get enough information in advance from the couple or the wedding planner as to what I can or can't do and where I can or can't be." Like the time she photographed a wedding in Venice, Italy, and the priest told her she could do whatever she wanted to do. "I asked him, 'Can I shoot from over here?' He said yes. I asked him 'Can I shoot from over there?' He said yes. He said, 'You can go here and there, but just don't go on that little red spot.' Everything else was fine," she laughs. "Funny, I'm shooting in one of the most religious places in Italy, and I was allowed to practically stand on top of the priest during the ring ceremony!"

Unfortunately, not everyone is as accommodating. "Remember," Littwin points out, "to respect the regulations that are in place for the ceremony and that while a couple may see a shot in your book ahead of time that they want you to recreate for them at their wedding, you may be unable to if their priest or pastor or rabbi or whoever is presiding over the service does not allow it. Know what to expect in advance. Prepare, prepare, prepare, and you'll be able to avoid any surprises on the day of the ceremony."

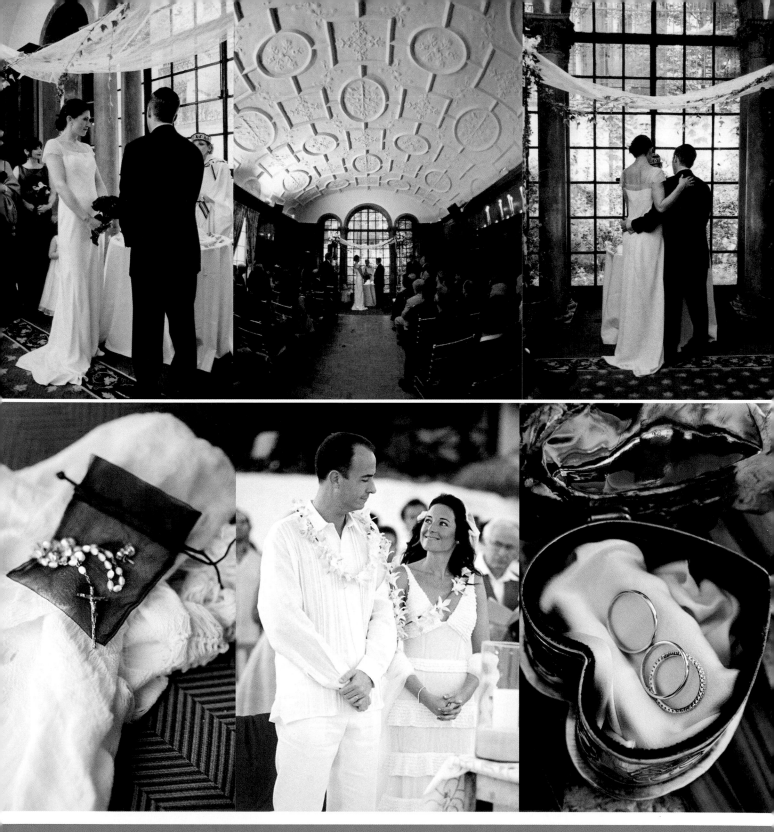

© *Kathi Littwin*

(top row) Image elements like composition and layout are as important to Littwin as the shot itself. Here, she features her favorite grouping to give clients—a set of three images—which convey different vantage points of a Jewish wedding ceremony she photographed at the New York Academy of Science. The black-and-white shots have an Old World charm to them, while the color image in the center gives a sense of the warmth and design of the ceremony space.**CAMERA:** Nikon F100; **SHUTTER SPEED:** 1/30 sec.; **F-STOP:** *f*/2.8; **LENS:** 50mm *f*/1.2 (for black-and-white image); 24–105mm (for color image); **FOCAL LENGTH:** 50mm (black and white); 24mm (color); **FILM:** Kodak TMZ3200 (for black-and-white image); Fuji 1600 (for color image)

(bottom row) Littwin likes outdoor ceremonies, like this one in Tulum, Mexico, because there is more space to move around in and fewer rules about where you can be. Here again is her favorite grouping of three images, which together tell a mini-story of a particular moment from the ceremony. **CAMERA:** Nikon F100; **SHUTTER SPEED:** 1/60 sec. (left and right images), 1/125 sec. (center); **F-STOP:** 2.8 (left and right), 5.6 (center); **LENS:** 24–85mm Macro set at 85mm (left and right images); 24–85mm set at 35mm (center image); **FOCAL LENGTH:** 85mm (left and right), 35mm (center); **FILM:** Kodak VPS 400

Note: Llittwin's settings are usually based on natural light. If she's not using flash, then she has to use films (or digital settings when that's the case) that have high ISO ratings. She prefers Kodak TMZ 3200 and Fuji 1600 for indoor shots—unless she has huge windows with loads of light. She can change to VPS 400 and Tri-X 400 when she is outside, or when she has to add flash (when the natural light is too low to work). Indoors she's working at the wide-open end of her lenses and not shooting hand-held slower than 1/30th of a second. "I have been adding more digital coverage recently," she says, "but these rules are the same."

COUPLES LOOKING FOR gimmicks and photo tricks—things like soft-focus filters, infrared, hand-coloring, etc.—might opt out of hiring Meg Smith to photograph their wedding, and that's perfectly fine with her. "I'm the anti-technology photographer," Smith, of Napa, California, jokes, describing her wedding photography as all about composition, lighting, and contrast. "The image needs to be strong and solid," she states matter-of-factly. Smith, a film shooter, draws her inspiration from the masters, photographers like Henri Cartier-Bresson, Marc Riboud, Sebastião Salgado, and others. "These are the ones to study and emulate," she says. And while she admits that covering the ceremony is not her favorite part of the day—"I kind of hold back and don't get in as close as I am used to"—she'll rely on a long lens and her love of the simplicity of pure moments to get her most successful ceremony shots.

"I don't do anything specific," Smith continues. "I just stay in the moment." She also likes to use fast lenses. For this image (#1), photographed at St. John the Divine Church on the Upper West Side in New York City, Smith used her favorite lens, her Nikon 85mm f/1.4. "This was a wonderful church to photograph in because it's just so massive. I walked around the back of the altar, and no one ever knew I was back there," she laughs. "Normally photographers

might feel intimidated during the ceremony because they don't want to be intrusive or disruptive. I'm tall, so it's hard for me to crouch down. Plus, every time I click the shutter it feels like it echoes throughout the entire church, especially the big cavernous ones." Smith says she just tries to stay as invisible as possible, which includes wearing "quiet shoes" and dark clothing. She also makes a mental checklist of images she wants to make sure she gets, as well as ones she knows the bride and groom will want: the interior and exterior of the location, the groom coming down the aisle, the bride walking with her father, the exchange of rings, the moments immediately preceding and succeeding ceremony, etc.

Smith also looks for the images that aren't on any bride's checklist, ones that add charm and personality to a couple's wedding album. For one such special one (opposite, top right), taken at St. John the Divine, Smith was outside after the ceremony as the newlyweds' car was about to pull away from the curb. If you look closely, you can see that the groom is holding up a beer can in a toast to the groomsmen who are all watching from the sidewalk. "I just love those kinds of shots," Smith exclaims. "It's what makes the day special later on when you see the images all together to tell the story of that particular couple and their wedding."

She continues: "I seek out the excitement and elegance of the wedding as well as the connections between the people in it. I'm able to shoot the whole wedding as it is happening, and that's what's fun." In the image of a mom kissing her daughter on the cheek right after the ceremony at Union Station in Los Angeles (#2), Smith captured a moment that isn't staged but rather a genuine moment between mother and daughter, complete with the daughter's squished-up face in a sort of "ew!" expression. These are the kinds of priceless moments Smith thrives on capturing throughout the wedding day.

Smith adds that while it's true that you know what's going to happen for the most part—you know the couple will kiss at the end of ceremony,

you know they will walk toward you, etc.—it's like "being present at the same play over and over again, but each time it's on a different stage or with different characters." She says it's nice because you can plan how to get a certain shot; you can also anticipate what's coming, be one step ahead of it, and get the spontaneous moments as well. Just keep it real, no matter what.

"When I'm photographing the ceremony—or any other part of the wedding day—part of what is strong about my work is that it is very classic and timeless, and because I don't do wacky angles or cross-processing or whatever the latest fad is, it could be a newer or an older shot—it doesn't matter. If it's a good photo, you don't need anything else."

© *Meg Smith*

1. Low lighting and a list of restrictions from church officials can often hinder a photographer's ability to get creative. Here, at St. John the Divine Church in New York City, Smith moves beyond those limitations to get an interesting back view of the groomsmen as the groom makes his way toward his bride. **CAMERA:** Nikon F100 or N-90; **SHUTTER SPEED:** 1/30 sec.; **F-STOP:** *f*/2 or *f*/1.4; **LENS:** 85mm; **FOCAL LENGTH:** 85mm; **FILM:** Kodak Tri-X

2. An exuberant mom kisses her caught-off-guard newlywed daughter after the wedding ceremony, held at Union Station in Los Angeles. Capturing unexpected displays of emotion is what Smith thrives on. **CAMERA:** Mamiya 645; **F-STOP:** *f*/4; **FOCAL LENGTH:** 80mm; **LENS:** 80mm; **FILM:** Fuji NPH 400

3. At Grace Cathedral in San Francisco, Smith fulfills a key image on the bride's shot list: an aisle view of the couple leaving the church as husband and wife. **CAMERA:** Nikon F100; **SHUTTER SPEED:** 1/30 sec.; **F-STOP:** *f*/2; **LENS:** 85mm; **FOCAL LENGTH:** 85mm; **FILM:** Fuji 1600

4. Smith is on the scene as bride and groom run through a shower of rose petals and rice in Rome, right after the couple's civil ceremony. **CAMERA:** Mamiya 645; **F-STOP:** *f*/4; **LENS:** 80mm; **FILM:** Fuji NPH 400

5. As the newlyweds were about to drive off after their ceremony at St. John the Divine Church, Smith noticed the beer can in the groom's hand and felt it would make for an interesting real moment. **CAMERA:** Nikon F100; **FILM:** Kodak Tri-X

6. Smith says photographing the ceremony is not her favorite part of the wedding day, as it has the most limitations. Nevertheless, she manages to get creative images, like this ring exchange, by staying close—but not too close—and anticipating reactions before they happen.

SHANNON HO

WHEN SHANNON HO, of Norman, Oklahoma, attended Baylor University in Texas in the late nineties, she knew she wanted to major in photography—an art form she pursued all through high school—even though the school didn't have a photography program back then. "It was introduced in my sophomore year," Ho says, "and I became the first person to graduate from Baylor with a degree in photography in 2000."

Fast-forward to today, and Ho has her own thriving wedding and portrait studio in Norman, where she gets hired by mostly high-end brides from Oklahoma City and surrounding areas such as Dallas and Tulsa. Her studio is 100 percent digital—she converted in 2002—because, she says, it gives her control over the final look of the image instead of having to depend on a lab to interpret her vision. "It's a far more efficient and organized way of running my business," she insists.

During the wedding ceremony and beyond, Ho likes to photograph in a documentary style, through which she strives to capture the emotions of the day: the true smiles and the true reactions instead of posed, static images. She especially enjoys it when the bride and groom decide to see each other before the ceremony and always tries to spend at least fifteen minutes with them for candid, unposed images. "It allows for a more relaxed time for photos," she explains. "I usually prompt them with questions like, 'Tell me about your first kiss,'" to get them to show their true emotions." She also likes to be there right after the ceremony, when the couple is exiting the church, because that too is the perfect time for catching unguarded moments and images that follow the flow of the day.

During the ceremony itself, most of which Ho says take place indoors in Oklahoma because it's just too hot to be outside, she likes to stay at the back of the church to capture the bride and her father right before they walk down the aisle. She also will sometimes go up in the balcony and capture the scene as it unfolds below. If she's able to stand at the side of an aisle, she'll photograph the bride and her dad coming down the aisle and then move to the front of the church to capture the groom's expression as he anticipates the arrival of his bride. Next, she'll turn back and get images of the bride and her father again.

"I try to make sure there are spots where I know I'm going to be able to walk. If there's just a center aisle and no side ones, then I will probably operate a little differently. I just don't like people to see me; I don't like the spotlight to be on me, especially during the ceremony." For the rest of the time, Ho will stay at the front of the church where the "action" is taking place, and, if she has to, she'll get down low and try to be discreet, especially during prayers. She says she doesn't take any shots of the bridesmaids walking down the aisle or the grandparents being seated: "I don't shoot any of that. I've already made sure I've captured amazing images of the bridesmaids prior to the ceremony when we are shooting outdoor portraits."

Ho maintains that one of the most important things you can do during this time is to draw on your expertise of searching out beautiful light to capture beautiful images. "That way, it doesn't matter if the location is completely unattractive or the most stunning of venues; either way you will still always be able to capture amazing moments."

1. Shannon Ho took this overview of the ceremony at McFarlin Memorial United Methodist Church in Norman, Oklahoma, from the balcony of the church. The ceremony took place at 6:00 P.M. and the windows were facing west, so all the light was coming in from that direction. **CAMERA:** Canon EOS-1D Mark II; **EXPOSURE PROGRAM:** Aperture Priority; **ISO:** 1000; **SHUTTER SPEED:** 1/30 sec.; **F-STOP:** f/2.8; **LENS:** 24–70mm f/2.8; **FOCAL LENGTH:** 32mm

2. Ho likes to photograph as many personal, touching moments as she can, such as this scene of an Episcopal priest saying a prayer over the bride before she walks down the aisle. "This took place in the room where the bride was getting ready—it was actually a really beautiful space and had gorgeous, arched windows," Ho describes. "The bride had grown up attending this church, and the priest had known her since she was a little girl." **CAMERA:** Nikon D100; **EXPOSURE PROGRAM:** Aperture Priority; **ISO:** 400; **SHUTTER SPEED:** 1/45 sec.; **F-STOP:** f/2.8; **LENS:** 24–70mm f/2.8; **FOCAL LENGTH:** 48mm

3. Ho captured a moment during a ritual common in wedding ceremonies in Oklahoma: The parents of both the bride and the groom will take a candle as they are being seated, light it, and then place it in a stand where a middle candle remains unlit. When the bride and groom walk up, the bride takes the candle her mom put up there and the groom takes the candle his mom put up there, and they both light the Unity Candle. "It marks the occasion of two families coming together." Ho says the bride told her in advance that the most important shots would be those taken during the ceremony. "I'm a girl who loves to stay in the shadows, but the bride was fine with me being up in her face!" This ceremony took place in a big tent and was lit with several chandeliers. Ho was able to be right up front and was shooting wide open. **CAMERA:** Canon EOS-1D Mark II; **EXPOSURE PROGRAM:** Aperture Priority; **ISO:** 400; **SHUTTER SPEED:** 1/100 sec.; **F-STOP:** f/1.6; **LENS:** 85mm f/1.2; **FOCAL LENGTH:** 85mm

4. A bride and her bridesmaids peer out into the sanctuary of McFarlin Memorial United Methodist Church in Norman, Oklahoma, after they finish getting ready. Ho says that because it is so hot in this part of the country, most of the weddings take place indoors, in massive churches that have several rooms and areas for the bride to get dressed in and then wait until it's time to walk down the aisle. Ho spens a lot of time in those areas as well to get unscripted moments that document the day at certain key parts. **CAMERA:** Canon EOS-1D Mark II; **EXPOSURE PROGRAM:** Aperture Priority; **ISO:** 1250; **SHUTTER SPEED:** 1/40 sec.; **F-STOP:** f/2.8; **LENS:** 24–70mm; **FOCAL LENGTH:** 24mm

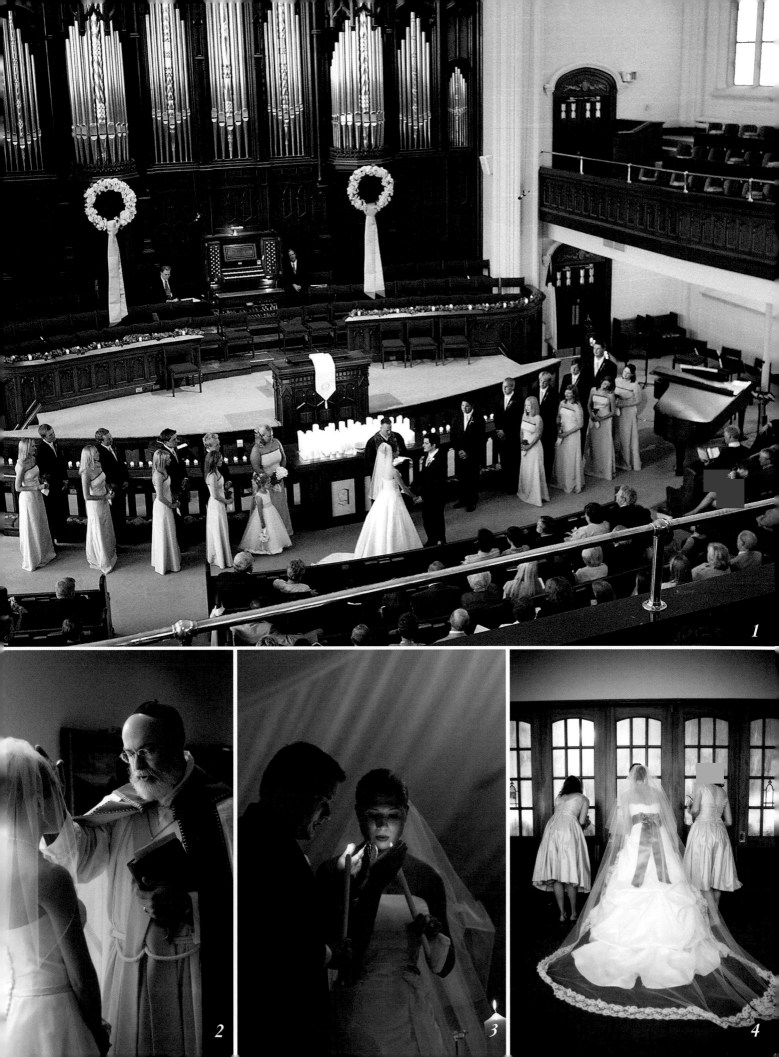

V. PORTRAITS AND "FORMALS"

Posed, Unposed, and in Nature

Vibrant pops of color mixed with texture, clean lines set against unusual backdrops, movement and energy bursting through the stillness of the frame as husband and wife connect with their environment to create a distinct sense of place. This is definitely not your grandparents' wedding portrait. Couples and their wedding parties are increasingly being photographed in unique situations and interesting locales for a modern take on a decades-old tradition.

Basically, there are three different kinds of portrait opportunities that present themselves during the wedding day:

THE BRIDE AND GROOM: This category also includes portraits of the bride without the groom. Says Christian Oth: "If I have five minutes, I can come back with three or four different great shots; if I have a half hour, I can go around the city and find interesting locations; if I have two hours, I get bored!" Some photographers try to do these portraits before the ceremony, while others will take them right afterward or even pull the couple away from the reception later on for a few minutes. Whatever the technique, Oth and the other photographers highlighted here—Chenin Boutwell, Ben Quillinan, Melanie Nashan, Suzy Clement, and Philippe Cheng—say they get inspired by whatever else is happening around them, so they might place the couple among a crowd of people, use a famous bridge or building as a backdrop, have the couple walk toward them or away from them or place them against a visually interesting wall. There's great stuff that can be done. And most couples are happy to give the time for it because it is so important for them to get great portraits.

THE BRIDAL PARTY/THE GROOMSMEN: Oth likes to make these photos as much fun as possible. A lot of photographers opt for having the group walk toward the camera. Oth says he tries to keep everybody energized and not too stiff or posed. "I'll start off with maybe one posed shot just to align everyone, but that shot probably never makes the album. Instead, I like to keep these shots light and somewhat spontaneous."

FAMILY PORTRAITS: These are the pictures most photographers want to be done with as quickly as possible. "They usually happen right after the ceremony, and you're practically checking people off a list so they can move on to cocktail hour," says Oth. "They are also my most formal photos of the day. I try to make them as nice and beautiful as I can, but it all depends on the family dynamics unfolding. It's better, and sometimes safer, to work through these pictures quickly!"

© Christian Oth
(opposite) Christian Oth let out all the stops (no pun intended) when he photographed this bride at the garden site of her wedding ceremony on a massive estate. On wedding day, Oth says, he strives to incorporate environment, strong composition, and a genuine reaction.
CAMERA: Canon 1D Mark II; EXPOSURE PROGRAM: Normal; ISO: 100; SHUTTER SPEED: 1/250 sec.; F-STOP: f/8; LENS: 24–70mm f/2.8; FOCAL LENGTH: 24mm

CHENIN BOUTWELL

DIGITAL PHOTOGRAPHER Chenin Boutwell, based in Southern California, likes to push the boundaries of tradition with her images. "I got into the business after my own wedding after seeing a real need for wedding photographers who were willing to take risks with their work," she explains. "My husband, Doug, and I started shooting weddings more or less to prove that wedding photos could be cool."

They definitely succeeded. And although Doug has transitioned out of the business in the past few years to build up his commercial portfolio, Chenin is still going strong and has become the sole photographer of the business, one based on wedding images that are funky and full of life. Chenin says she likes to "plant the seed" during her engagement sessions with couples so they know exactly what to expect from her come wedding day. It's why they hire her in the first place.

"I tell people it's more about the journey than the destination, and what I really want to do on wedding day is just walk around with them and look for things—light and color, interesting architecture—things in the environment that will stand out or make the couple stand out." One thing she never does is scout a location ahead of time. "I find that the light is going to look different at different times of day. When I first started out I would get nervous before a wedding and try to plan out exactly where I was going to shoot everything, but then I'd get there and the light wouldn't look the same, and I found that I was just using up time doing that as opposed to just walking around and opening my eyes to find something that looked good at that moment."

Take, for example, this portrait taken against the side of a "dive bar" (#4) Boutwell says she discovered the unique location a few blocks from the wedding reception after slipping out of the cocktail hour with the bride and groom in tow. In another image (#2), a couple is leaning against what appears to be a bathroom wall but is really the exterior of someone's house she stumbled upon in a back alley. She advised the groom to lean up against the wall and his bride to get in "nice and close." Then she let things happen naturally. "First, I find the spots that interest me, and next I tell the couple where to stand or encourage them to chat with each other and enjoy each other's company. Whatever happens after that just happens, naturally."

Boutwell generally likes to put more time and thought into the bridal/groom party images than the family group shots. "I'll do a lot of staggered photos and use a lot of furniture, place people in spots— some sitting, some standing. It's more interesting visually, and those are the photos that make it into an album. I don't really put family photos in my albums. The most important thing, of course, is to put people at ease. I chat with them, laugh with them, even ask them about pets or family or jobs—anything to get them to forget that the camera is there. A lot of people comment that my work is very natural and that my subjects seem at ease. I think that is just a result of treating each client like a friend and creating a playful, easygoing atmosphere at every shoot."

© *Chenin Boutwell*

1. Boutwell shot this image in Hawaii. "They were a very soft-spoken couple—in fact, the groom spoke very little English—and was not super-comfy being affectionate. Instead of forcing some sexy or steamy 'pose' on them, I really focused on their body language and how they interacted with each other. I guess I like it because it has this real sense of fantasy, and I think they look really natural and content. It was, by far, one of their favorite images from the day. For me, this image is what it's all about: giving the couple photos that really get deep down as to how they interact with one another." **CAMERA**: Canon EOS 5D; **EXPOSURE PROGRAM**: Aperture Priority; **ISO**: 800; **SHUTTER SPEED**: 1/250 sec.; **F-STOP**: *f*/5.6; **LENS**: EF 24–70mm *f*/2.8L USM; **FOCAL LENGTH**: 46mm

2. Vibrant color mixed with unusual settings—this façade resembles a bathroom wall—is pure Boutwell. She caters to a youthful, hip clientele and her images, like this different kind of portrait of bride and groom, reflect that.

3. This image, taken at Greystone Park & Mansion in Beverly Hills, is one of Boutwell's favorite engagement photos. **CAMERA**: Canon EOS 5D; **EXPOSURE PROGRAM**: Manual; **ISO**: 400; **SHUTTER SPEED**: 1/320 sec.; **F-STOP**: *f*/5; **LENS**: EF 17–40mm *f*/4L USM; **FOCAL LENGTH**: 17mm

4. Here, Boutwell spirited the bride and groom away from their cocktail hour and took to the streets. She found this dive bar to serve as a bright, unique backdrop for a fun portrait. **CAMERA**: Canon EOS 5D; **EXPOSURE PROGRAM**: Aperture Priority; **ISO**: 250; **SHUTTER SPEED**: 1/160 sec.; **F-STOP**: *f*/5.6; **LENS**: EF 24–70mm *f*/2.8L USM; **FOCAL LENGTH**: 70mm

5. "The moment I saw them walk out I knew exactly the shot I wanted. I knew exactly what it was going to look like. It's kind of quirky, and I just love that about it. I take that as a compliment—to call my shots quirky—that's exactly what I'm going for, something really classic but also slightly off in some way." **CAMERA**: Canon EOS 5D; **EXPOSURE PROGRAM**: Aperture Priority; **ISO**: 500; **SHUTTER SPEED**: 1/500 sec.; **F-STOP**: *f*/4.5; **LENS**: 24–70mm *f*/2.8; **FOCAL LENGTH**: 30mm

BEN QUILLINAN

AFTER GRADUATING COLLEGE in 2000 Ben Quillinan moved to New York City to shoot lifestyle and documentary photography and to assist for a couple of editorial photographers. Currently based in Phoenix, Arizona, he sees each wedding he photographs as "a unique tale that I artistically narrate with an interpretive style reflecting a couple's needs and desires." Nowhere is this more evident than in photographs of the couples themselves alone or with their wedding parties.

Quillinan says this portrait (page 63) reflects the unique personality of this bride and groom. She's an interior designer, and they both love New York City, especially the theater. Their reception was at a warehouse in downtown Tucson. "I wanted a shot of just the bouquet here. The bride and groom themselves were just a great backdrop for the flowers, she with her hand on his chest and he wearing that bright jacket."

"I like sometimes," Quillinan explains, "to take an image that leaves a little bit of intrigue and has some imagination rather than just being an obvious, straightforward shot." Even the one (page 62, #2), of a bride sitting on a couch, might appear pretty straightforward at first glance, but the composition, proportion, and balance of the scene all work together to make a portrait that has Quillinan written all over it.

In this next shot (page 62, #1), which Quillinan uses as the lead image on his self-promotion mailers, he was struck by what a happy couple they were and was intent on capturing that. "I wanted to convey

every joy and emotion that came out of them," he remarks, "because they were just so much fun and emotional and so in love." Quillinan explains that he was sitting in the front of the car, using a long shutter that dragged everything surrounding the couple to show movement. He also used an on-camera flash to freeze them as the car was moving and to create a nice light drag-off on the right side of the image as cars moved past them in the opposite direction.

As far as family shots go—parents, grandparents, and extended family—Quillinan says he still does them fairly traditionally because of the time factor. "I could get really creative, but it might take all day," he sighs. "Instead, I'll pick a spot and take these images more classically, and more quickly, sometimes before the ceremony, sometimes after. My assistant and I try to find somewhere nice with a good backdrop that's going to look nice and mom's going to want to buy a print of it." After that, he photographs the bridal couple and their respective parties more creatively, using editorial and photojournalistic skills he learned while assisting in New York. In terms of lighting, he says that with the family portraits he might put one light off to the side so it's "not harsh lighting but instead just directional lighting: It pops the subjects out of the background. I'll usually have the background a stop or so under what the people are so that they really come out. Occasionally, I don't have a chance to set up a light, so we find a place that has good natural light."

© *Ben Quillinan*

1. Quillinan sat in the front seat of this moving car while he photographed the newlyweds as they kissed in the backseat. The couple was on their way to their reception in Oaxaca, Mexico. **CAMERA**: Canon EOS 20D; **ISO**: 800; **SHUTTER SPEED**: .3 sec.; **F-STOP**: *f*/2.8; **LENS**: 16–35mm *f*/2.8L USM; **FOCAL LENGTH**: 16mm

2. Sometimes the simplest portraits are the most interesting. This one was taken in the lobby of the hotel where the wedding was held. **CAMERA**: Canon EOS-1D Mark II; **ISO**: 800; **SHUTTER SPEED**: 1/85; **F-STOP**: *f*/2.8; **LENS**: 24–70mm *f*/2.8L USM; **FOCAL LENGTH**: 27mm

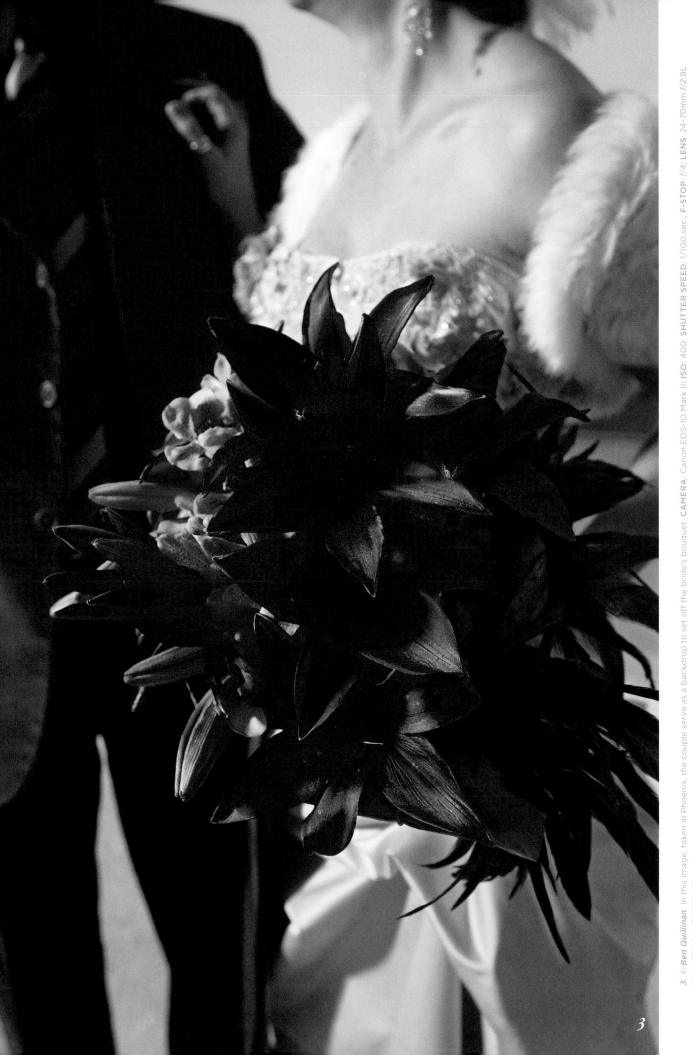

3. © *Ben Quillinan.* In this image, taken in Phoenix, the couple serve as a backdrop to set off the bride's bouquet. CAMERA: Canon EOS-1D Mark II; ISO: 400; SHUTTER SPEED: 1/100 sec.; F-STOP: f/4; LENS: 24-70mm f/2.8L USM; FOCAL LENGTH: 28mm

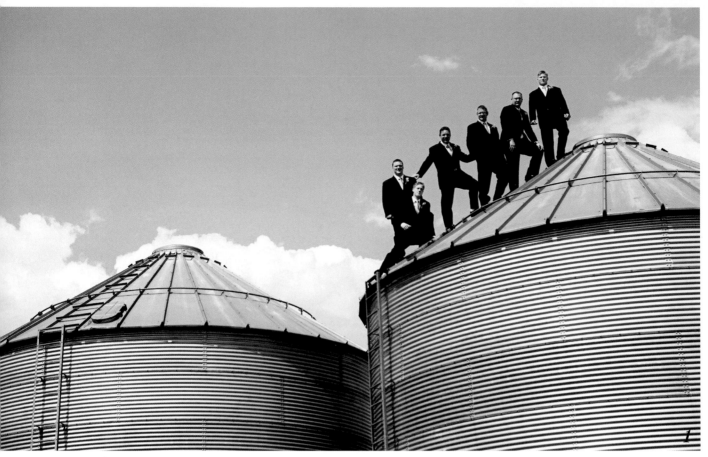

"I FIND GREAT satisfaction in helping to create family histories by photographing weddings or family portraits. It brings me back to the moments I have shared with the people I love, and is one of the things I do that really matters in life," says Melanie Nashan of Livingston, Montana.

Nashan, a digital photographer who uses mainly the Canon 5D and the 20D as backup, says her philosophy is to keep things as simple as possible so that when she is at a wedding she's not encumbered by technical information. "I keep the meter the same way each time and then use different lenses. In my mind, it's the lens choice and *f*-stop that makes something so visually appealing once you have the composition down."

In terms of lenses, she likes the 20–35mm, as well as the 24–70mm. She says she'll use her 70–200mm lens when she wants to isolate elements in the frame. For instance, if she wants to photograph a couple with a mountain range in the background, she'll shoot with a long lens to bring the mountains in closer. "It all depends on what the environment dictates," she explains. Sometimes she'll use her 50mm lens and use a real shallow depth of field, but for the most part she admits to being "just not that technical; I'm shooting more from an emotional viewpoint."

It was an extremely windy day when she photographed this groom and his groomsmen perched on top of a grain silo (above). She tried to shoot quickly, since the men were perched up there forty feet above the ground. "I love this photograph," Nashan declares. "Visually, it is simple and strong; it gives a sense of place without a landscape; it is relevant to their family life; and finally, it is relevant to the couple because the last photo of the groom's brother, who was murdered a few weeks prior to the wedding, was taken on top of this

© *Melanie Nashan*

1. Melanie Nashan says grain silos have always fascinated her. "These structures are scattered across my landscape and represent a lifestyle that many people are not familiar with: a slow-paced life that relies on a connection to the land and weather." In this instance, it is a connection with the groom's brother, whom I can visualize standing beside the groom at the very top of the silo, and the bride's history of visiting this ranch—Gunsmoke Ranch located in the Shields Valley in Livingston, Montana—during her childhood.
CAMERA: Canon EOS 5D; **EXPOSURE PROGRAM:** Aperture Priority; **ISO:** 200; **SHUTTER SPEED:** 1/2000 sec.; **F-STOP:** *f*/5; **LENS:** 24–70mm *f*/2.8L; **FOCAL LENGTH:** 66mm

very silo." As she was shooting, she kept refining her angle, she says, to make the silo look even taller. "It is amazing what a slight tilt and steeper angle can do to an image." Nashan was safely based on solid ground below, shooting with a 24–70mm lens. She later used Photoshop to make the clouds stand out a bit more.

Nashan warns that taking an image like this is not for the faint of heart—be it the photographer or the subject. The men were adamant about being up there to honor the dead brother, but the wind made it all feel a little bit dicey. "I think the most important thing about photographing subjects who might be scared or nervous is to be as calm as possible. I was being very calm and encouraging to the young man who was squatting in the photo to stand straight up, but he felt vulnerable because he was closest to the edge." (Fortunately, there were foot grips up there, making the situation a little safer than it might seem.)

Most of the weddings Nashan covers are outdoors. "I have a real passion for these place shots," she sums up. "I studied architecture and the environment, and so these images really mean a lot to me. It becomes personal for the couple as well as for me. And it's not static; it's not the same thing all the time. Every time I go to a location, I try to find something new, something that inspires me. Posing a couple stiffly in front of a building—that just won't do for me or for my clients."

2. For this image, Nashan started taking photos when the light hit her lens, put on her wide lens to capture that light ray coming in from the left, and framed the couple in the doorway of this twig sculpture. **CAMERA:** Canon EOS 5D; **EXPOSURE PROGRAM:** Aperture Priority; **ISO:** 320; **SHUTTER SPEED:** 1/160 sec.; **F-STOP:** f/2.8; **LENS:** 24-70mm; **FOCAL LENGTH:** 24mm

3. "Ninety-five percent of my clients are okay with doing things I suggest," says Nashan, "like lying down in the grass in a bridal gown or a suit. Most of the time they are totally up for it." **CAMERA:** Canon EOS 20D; **EXPOSURE PROGRAM:** Aperture Priority; **ISO:** 400; **SHUTTER SPEED:** 1/1000 sec.; **F-STOP:** f/3.5; **LENS:** 20-35mm; **FOCAL LENGTH:** 20mm

4. Nashan is a big fan of environmental portraiture, as are her clients. "I got here ten minutes early and just walked around, looking for something to make the portrait of the groom and his groomsmen more unique," she explains. "I saw the trees, told them to go stand in between them, and they did, and it worked out well." **CAMERA:** Canon EOS D60; **ISO:** 1000; **SHUTTER SPEED:** 1/45 sec.; **F-STOP:** f/4.5; **LENS:** 20-35mm; **FOCAL LENGTH:** 20mm

5. This image was taken at a church camp in the Beartooth Mountains, just above Paradise Valley in Livingston, Montana. (The ceremony was held in a field surrounded by cabins and woodsheds.) Nashan chose this particular setting in front of a woodshed because she wanted a place in open shade that was also a beautiful setting and offered a variety of compositions. Nashan also photographed shots of the bride alone in the doorway of the shed as everything behind her faded to black, and later did some bride and groom shots as well as larger family portraits here. **CAMERA:** Canon EOS 5D; **EXPOSURE PROGRAM:** Aperture Priority; **ISO:** 400; **SHUTTER SPEED:** 1/400 sec.; **F-STOP:** f/3.5; **LENS:** 20-35mm; **FOCAL LENGTH:** 28mm

SUZY CLEMENT

SUZY CLEMENT OF San Francisco, whose work is often seen in *Martha Stewart Weddings* and *Elegant Bride*, among many other publications, knows how to bring out the best in her subjects. "I want to capture the real emotion that grabs the viewer, including those unexpected moments."

Generally, Clement likes to do the portrait session with the bride and groom during cocktail hour, so while her assistant is shooting candids of the guests during that time, Clement takes the couple and two cameras—one with color film one with black and white—and tries to take portraits that capture a couple's essence. "I do have a method I follow, a very liberating one, in fact, because it allows me to know that I'm going to get what I want to get and then beyond—that I have room to play." For instance, with the black-and-whites, she tends to use a longer lens and goes in for a tight, more close-up shot of a couple kissing, whereas with the color she goes wider and likes to get more of the environment in the frame. "It's not a hard-and-fast rule, by any means, but it just allows me to move quickly. After all, you only have about two minutes to regroup after the ceremony or after the family shots to go head off with the couple and take interesting portraits, so I like to have a loose plan of what I'm going to do. If it ends up that I get them in a setting that's a really beautiful garden in late afternoon with golden light filtering in or something like that, then I might switch the lenses around and shoot more color and use a telephoto lens." And although she might dabble a little bit with digital later in the day, Clement really likes using film for the portraits, especially because she's mostly working outdoors, shooting with natural light and playing around with backlighting. "It's my shooting style; I just really prefer the way the portraits look on film."

Other than having her "little strategy of black and white versus color" usage, Clement says that for the most part her next approach to portraits consist of checking out locations and trying to find really beautiful settings in which to place the couple. If she hasn't photographed at a site before, then she will go ahead of time and check it out—she'll even try to go at the same time of day that she is going to photograph the ceremony, couple portraits, and family shots. That way, she explains, by the time everyone has gathered, she will have visited the site already and gotten an idea of some of the things she wants to do with the couple or places she wants to situate them. Of course, she adds, it can all change later on, or you might be struck with a new idea while everything is unfolding—the light might be a little different, you find a better spot, and so on.

"The thing to keep in mind with wedding photography is that everything is always changing; it's good to have some spontaneity, but it's also nice for me to have a few ideas in the can of where I want to put people," she states. "Beyond that, the direction that I give is very loose. I might say, 'Stroll up and down' or 'Hold hands and put your arms around each other' or 'Just walk up and down this path a couple of times.' Then, when they hit the spot of really beautiful light, I might say, 'Okay, stop, turn and face each other, have a little chat, have a little kiss. . . .' It's actually a really nice time for the couples because it's a moment away from the crowd to absorb everything and be just with each other. I hear from a lot of my clients afterward that they really enjoyed the time we spent on the portrait session. Even though I'm there with them, it's still a very intimate and sweet moment that they get to share. If we take the portraits right after the ceremony, they are now husband and wife, which is the perfect time to get all the emotions they are feeling come out. Those are the really great shots."

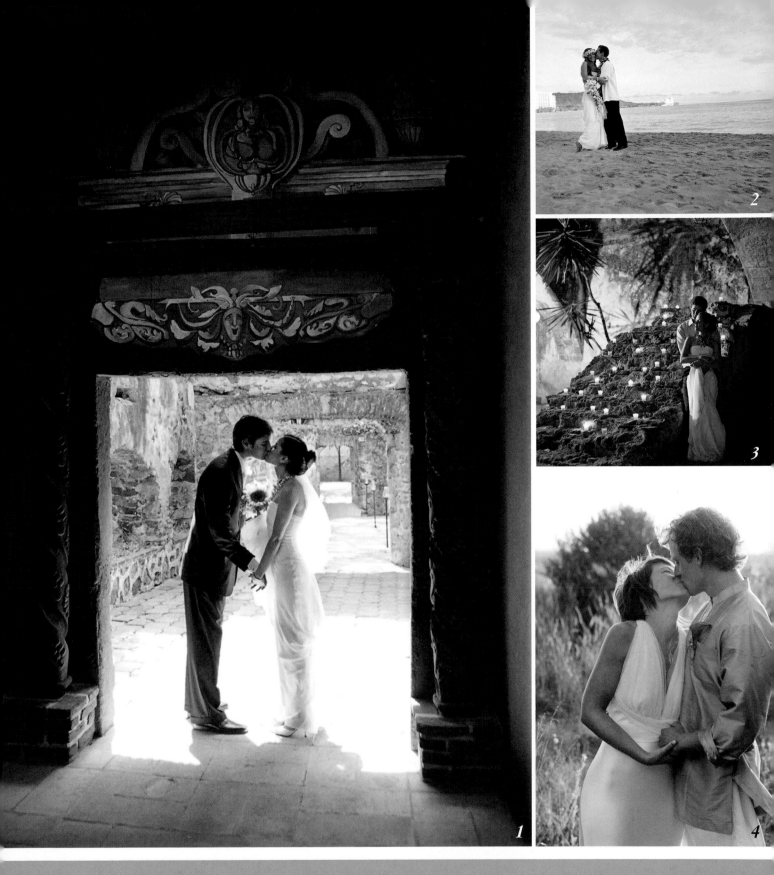

3. As someone who can appreciate an interesting location, Clement was thrilled to have the chance to photograph the bride and groom on a Mexican hacienda near their wedding venue. Great locales for photo ops abounded here. Photographing inside a cave was made easier with soft candlelight positioned on the rocks and natural light coming into the cave.
CAMERA: Rollei 6006 md2 (medium format); **SHUTTER SPEED:** 4 sec.; **F-STOP:** f/2.8; **LENS:** 80mm f/2.8; **FOCAL LENGTH:** 80mm; **FILM:** Fuji NPH

4. Yes, the groom really wore that! This shot of a more artsy bride and groom was taken at a resort south of San Francisco. In this case, the clothing wins out over the environment, leading the viewer's eye more toward the groom's jacket than to the not-so-visually-appealing field, which served more as a neutral backdrop for the couple to pop against.
CAMERA: Nikon F100; **SHUTTER SPEED:** 1/60 sec.; **F-STOP:** f/4; **LENS:** Nikkor 28–70mm F2.8; **FOCAL LENGTH:** 70mm; **FILM:** Fuji NPH

PHILIPPE CHENG

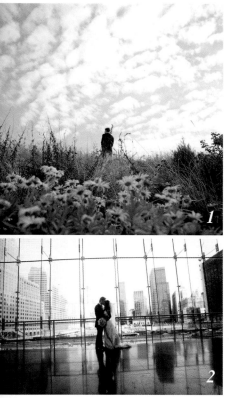

TAKE A CLOSE look at a wedding portrait by Philippe Cheng (#2) and you'll see not just a thoughtful still image but also one filled with the energy and emotions of the day as well. Just how does he achieve this? It's important, he explains, to keep two things in mind when taking portraits during the wedding day: One is to find that iconic moment that is going to combine both the place and the person, and make those two things meet and work together; and the other is to place the couple in an environment that means something to them.

Cheng strives to emphasize the presence of the environment as well as the couple, as in this portrait of a couple standing out in the cold with the Brooklyn Bridge serving as a ghostly backdrop (opposite, #5). The groom's mother, who had recently passed away, loved the snow, so Cheng took the couple's portrait in the snow; he says the groom felt his mother's presence all around him. He was happy to embrace his wife-to-be and happy to be close to his mom, and Cheng was able to capture this joy on film. "This is why it's important for me to chat with a couple beforehand and find these things out," he explains, "to discover what— as well as where—is important to a couple." For example, Chen took a photo of a couple standing in front of the Plaza Hotel in Manhattan (#3); the couple didn't get married there, but this particular spot in the middle of Manhattan was important to them.

Cheng, who shoots both film and digital, says that when he shoots outdoors like this and is using film, he prefers Kodak VC 160—the VC stands for Vivid Color—because it has slightly more contrast and pop to it. "When I'm outdoors and I have enough light, I can use a slower speed film because it gives a slightly better quality of grain." Indoors, he'll use a faster film.

Chen has plenty of his own good memories, as well as souvenirs, from each wedding. "One day I will do an installation piece on all the yarmulkes I've acquired during all the Jewish weddings I've photographed over the years," he laughs. "It's a ritual for me, as part of my experience, to have a yarmulke as an artifact from each wedding I've covered. I have a beautiful collection so far of about fifty different ones, and the next wedding book I do will have a photo of all of them!"

© *Philippe Cheng*

1. "Sometimes," says Cheng, "a wedding portrait does not have to feature the subject's face." Here, a contemplative groom is shown in the middle of a field of wildflowers in Southampton, New York. Most of Cheng's weddings take place either in the Hamptons on Long Island or in Manhattan, both of which have an infinite number of backdrop possibilities, Cheng says. **CAMERA:** Hasselblad; **SHUTTER SPEED:** 125/sec.; **F-STOP:** *f*/11; **LENS:** 60mm; **FOCAL LENGTH:** 60mm; **FILM:** Kodak VC 160

2. Cheng photographed this couple digitally right before their ceremony. Most of Cheng's portraits combine a joyful, loving couple with a stunning backdrop; here, it is the World Financial Center in Lower Manhattan. **CAMERA:** Canon EOS-1Ds Mark II; **EXPOSURE PROGRAM:** Normal; **ISO:** 800; **SHUTTER SPEED:** 1/320 sec.; **F-STOP:** *f*/9; **LENS:** 20-35mm

3. Here, Cheng utilizes the strong, iconic facade of the Plaza Hotel in New York City to create a powerful portrait of these newlyweds. **CAMERA:** Leica; **SHUTTER SPEED:** 1/60 sec.; **F-STOP:** *f*/5.6; **LENS:** 35mm; **FOCAL LENGTH:** 35mm; **FILM:** Kodak VC 160

4. Cheng strives for images that convey a subject who is connected to his or her environment. This bride had a summer wedding in the Hamptons, surrounded by sun and surf. **CAMERA:** Hasselblad; **SHUTTER SPEED:** 1/60 sec.; **F-STOP:** *f*/8; **LENS:** 60mm; **FOCAL LENGTH:** 60mm; **FILM:** Kodak VC 160

5. Here, Cheng used his "lens of choice," the 60mm, photographing the couple in the late afternoon before the ceremony, with his medium-format camera and film. **CAMERA:** Hasselblad; **SHUTTER SPEED:** 1/30 sec.; **F-STOP:** *f*/4; **LENS:** 60mm; **FOCAL LENGTH:** 60mm; **FILM:** Kodak VC 160

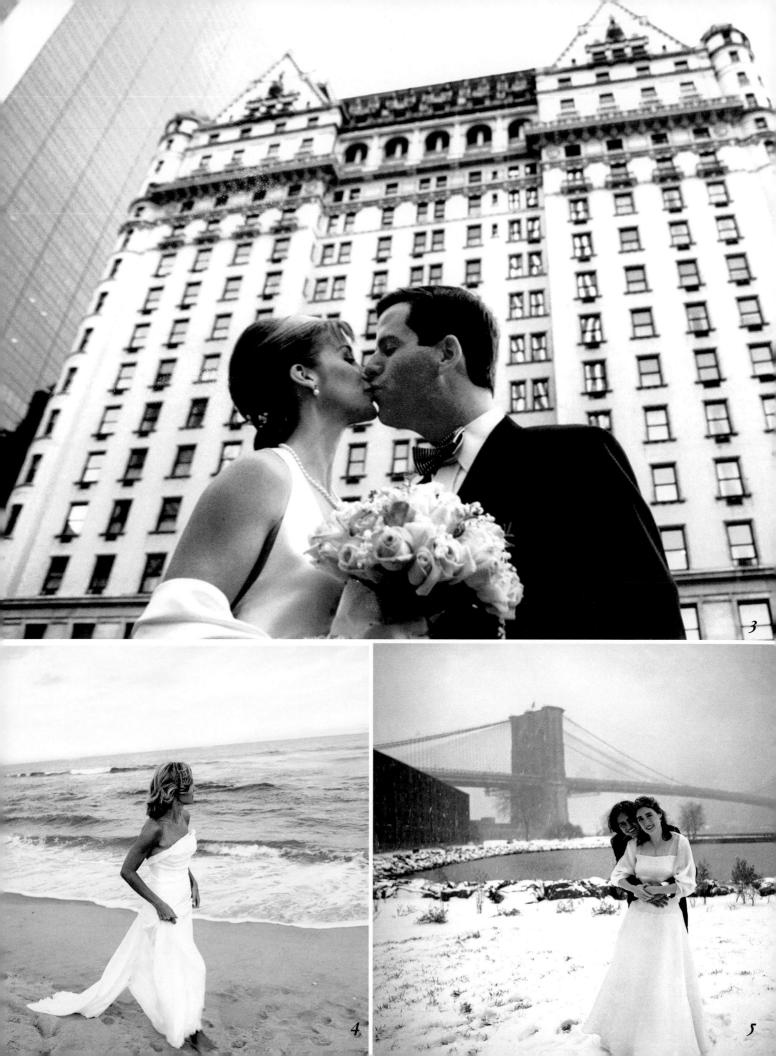

3

4

5

VI. THE RECEPTION

Fast Lenses, High ISOs, and Candid Moments Galore

"I'm already in 'full-tilt-go' mode, working a hundred miles an hour as I've seamlessly covered the ceremony, quickly captured the formal portraits, and am about to head off to the reception site to photograph various details and table settings before the guests arrive. Next, I might set up external strobes around the room before I cover the introductions, first dance, and speeches. Finally, I get to use the bathroom, have some water, nibble on a Balance bar, sigh and DECOMPRESS. This is when I can breathe, stretch, do a little yoga on my dinner break, think about the massage I'm getting tomorrow. From this point on, I can shoot at a much more leisurely pace and not have to worry about the time."

—MELISSA MERMIN

© Melissa Mermin
(opposite, top and bottom) To photograph this night reception, Melissa Mermin, who has been 100 percent digital since 2003, used a Canon 5D. She started using the Canon 5D because of "its full-frame effect, something that digital had always lacked before." For tent receptions, she says she also likes to set up a remote flash at a 45-degree angle up high on a stand to add interesting light and dimension, especially on the dance floor (top image). She also tries to work off the videographer's light whenever possible.
(top) CAMERA: Canon EOS 5D; EXPOSURE PROGRAM: Manual; ISO: 1000; SHUTTER SPEED: 1/25 sec.; F-STOP: f/2.8; LENS: 16–35mm f/2.8L USM; FOCAL LENGTH: 16mm

(bottom) CAMERA: Canon EOS 5D; EXPOSURE PROGRAM: Aperture Priority; ISO: 1000; SHUTTER SPEED: 1/15 sec.; F-STOP: f/2; LENS: EF 85mm f/1.8 USM; FOCAL LENGTH: 85mm

The "I dos" have been exchanged, tears of joy shed, and congratulatory best wishes doled out. Now it's time to photograph the happy couple as they host their first major event as husband and wife in the ultimate setting displaying their lifestyle and personality center stage. It's also the part of the wedding in which the photographer can thrive and have his or her signature style really shine through, shooting less formal images and creating more candid shots. Here, it's not as much about who and what is photographed as much as it's about conveying a mood and documenting the day's story as it continues to unfold.

From the photographer's standpoint, receptions come in all shapes, sizes, and lighting situations: brightly lit rooms with colorful decorations, loud music, and group dances; romantic outdoor settings adorned with tents, string lights, and paper lanterns; a clambake on the beach at dusk; an elegant gathering at the local art gallery, museum, or cultural center where the couple first met (you may need a permit to shoot there); even a floating fantasy aboard a yacht. Whatever the setting, at its core the reception is a party, and where there's a party there's usually fun, sometimes wild behavior unfolding in various parts of the room fueled by lots of—in this case free—alcohol. Look, there in the corner, it's crazy Uncle Herbie taking off his jacket and tie as he struts his stuff on the dance floor and . . . oh, wait . . . is that cousin Kimmie fighting tooth and nail to catch the coveted bridal bouquet? Did she just trip the maid of honor?

Of course, it's the wedding photographer's job to observe and document the good, the bad, and the ugly, with calm and grace, committed to getting the best pictures he or she can that will serve as a cherished keepsake of the day—and night. Although, as one photographer (who shall remain nameless) confessed, "The drunk guests are actually the easiest to deal with because they always do something funny that you can capture."

Melissa Mermin, Mike Colón, the Marings (Charles and Jennifer), Amanda Sudimack, and Jesse Leake avoid formulas at all costs, especially during the wedding reception. Here, they each break down some of their favorite and most successful images—at both indoor and outdoor events—and talk strategy in general for covering the wedding reception as unobtrusively as possible.

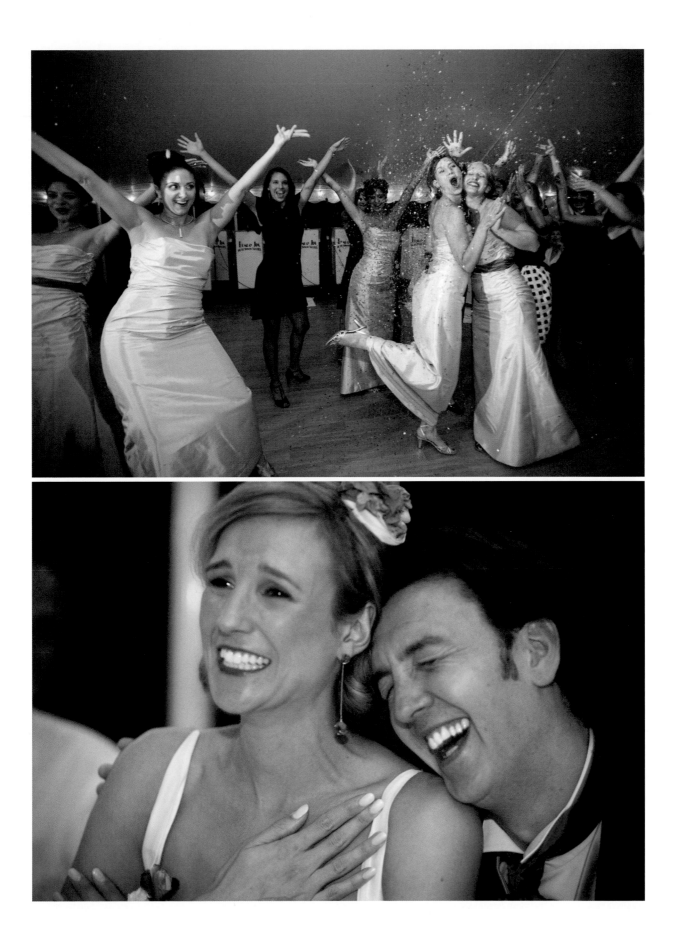

MELISSA MERMIN

"AT WEDDINGS, I always walk a fine line between making pretty images for the client and making images that are personal to me," states Melissa Mermin who has studios in both San Francisco and Boston. So, for instance, instead of getting basic pictures of the bride and groom cutting the cake, she will think about different angles and lighting to create an interesting photo that has great compositional elements, or, she says, "one that just makes you feel as if you were there and gets you caught up in the moment."

For instance, when Mermin photographed a couple during the typical "wedding cake moment" at their reception (#3), she sought out a more interesting angle. "Lucky for me, the bride and groom chose to cut the cake next to the stairs leading directly overhead to a second floor, so I was able to look straight down on them and get a great composition," she explains. "I had my partner shoot the cake-cutting from the first floor—the 'safety' shot in case my experiment of shooting from above didn't work out or the client hated the shots and wanted their faces to be shown in the images."

She continues: "Like my personality, my images always seem to have something odd or funny about them." And while she has tackled plenty of both indoor and outdoor receptions over the years, she admits that each comes with challenges. Outside, she explains, you may have to deal with harsh or uneven sunlight, the lack of light at night, or even a range of annoying weather conditions—wind, rain, severe heat. "Though, I don't mind when it's windy," she concedes. "I love a bride's veil to fly around; it adds interest and can create a striking image, even though everyone else might complain about their

hair looking silly and flying around all over the place." Sometimes, she says, when the sun is directly overhead, she will seek out shade or a place where the sun is bouncing off the couple from another direction. "Despite the challenges, I much prefer shooting in the great outdoors."

Shooting receptions indoors, she explains, will often come down to having to fake a lot of the lighting through strobes, which means more setup time and fewer choices on where you can shoot. Mermin finds her way around this issue by varying the types of lenses she uses, instead of going for the artificial light. She particularly likes her 85mm $f/1.4$ in light-lacking situations: "I really like using available light, and it's amazing to be able to shoot in these dark, cavelike receptions with no flash. I also love super-shallow depth-of-field and will sometimes shoot wide open outside on a sunny day to get the effect."

Mermin also likes shooting night receptions in tents. "Tents are great—perfect for bouncing flash directly. The tent is usually white and angles the light nicely, especially the closer you get to the sides (which are lower and more angled and make for better bouncing). For clear-top tents at night (or just nothing, which is a big thing in California, where they don't have to worry about rain, bugs, or heat), I set up a remote flash at a 45-degree angle up high on a stand to add interesting light and dimension, especially on the dance floor."

For the most part, Mermin confesses to being "anti-tripod," although she has used tripods on occasion. "I heard that Joe Buissink never uses a tripod and instead learned to steady himself with a few tricks, like shooting a few images in a burst. I

© *Melissa Mermin*

1. "I loved how the lanterns were blowing in the wind, and the blue sky behind them made them really pop," says Mermin of this shot. **CAMERA:** Nikon D2X; **EXPOSURE PROGRAM:** Aperture Priority; **ISO:** 125; **SHUTTER SPEED:** 1/250 sec.; **F-STOP:** *f*/4; **LENS:** 12–17mm; **FOCAL LENGTH:** 12mm

2. Mermin captured this shot of the bride and groom's first dance by getting down low with a wide-angle lens to show the ornate ceilings and details. She also lit the dark ballroom with three remote-controlled strobes to show the details of the room and to freeze the action. **CAMERA:** Nikon D1X; **EXPOSURE PROGRAM:** Manual; **ISO:** 400; **SHUTTER SPEED:** 1/60; **F-STOP** *f*/3.5; **LENS:** 17–35mm; **FOCAL LENGTH:** 17mm; **FLASH:** three 1200 w/s powerpacks, two on second level behind couple, one on first level, all aimed at the ceiling.

3. Mermin was lucky that the location of the cake-cutting at this wedding allowed her to get this very interesting angle from almost directly above. **CAMERA:** Nikon D70; **EXPOSURE PROGRAM:** Manual; **ISO:** 400; **SHUTTER SPEED:** 1/50 sec.; **F-STOP:** *f*/5; **LENS:** 50mm *f*/1.4; **FOCAL LENGTH:** 50mm. (Remote-controlled strobes were bounced off the ceiling.)

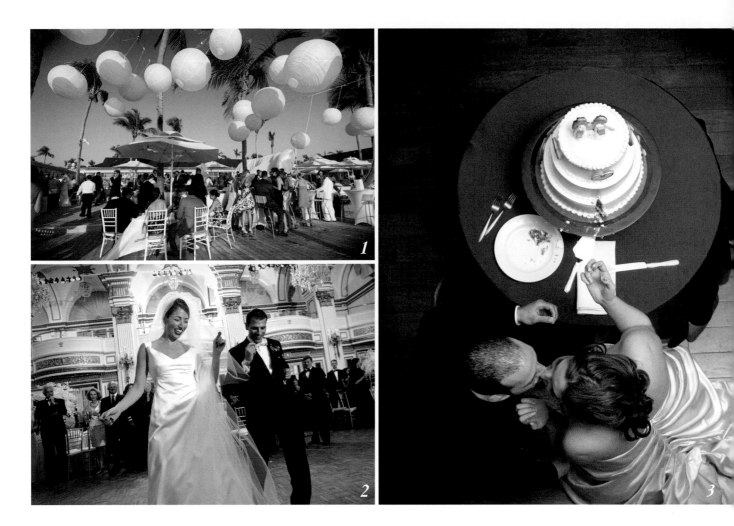

was also tired of lugging the extra weight and feeling very slowed down and encumbered when seeing a lot of shots I wanted quickly." With the Canon 5D, she adds, she can shoot with higher ISOs without too much noise, and she can steady herself to half-second handheld for dusk images.

Mermin offers the following advice to photographers seeking the best reception coverage possible:

- **CARRY SEVERAL FAST LENSES (*f*/1.2–*f*/2.8) FOR DARK, INDOOR RECEPTIONS.** Wedding photographers especially like the 85mm lens, combined with fast film or high ISO settings. This telephoto is exceptionally fast and sharp and is often used for throwing backgrounds out of focus.

- **BEFRIEND THE VIDEOGRAPHER.** "I used to curse them, but now their annoying video light is a godsend when my camera can barely focus

because it's too dark inside," Mermin says. "The video light really helps, and it can also create gorgeous light if you stay at a 45-degree angle from the videographer's direct light, or try to keep him or her directly behind the couple to use as a backlight during their first dance.

- **BRING A SELECTION OF LENSES.** The more the guests notice you and pose if they catch your eye, the longer your lenses should get and the farther away you need to be.

- **NEVER USE DIRECT FLASH.** Bounce off the ceiling or tent, or slave a second strobe remotely for depth.

- **KEEP IN TOUCH WITH THE CATERING COORDINATOR.** He or she will want to see great pictures that illustrate images they can use to showcase their venue, and now you've created a relationship and a referral.

MIKE COLÓN

BASED IN NEWPORT Beach, California, photographer Mike Colón was named a "Legend Behind the Lens" by Nikon in 2006 and photographed pop star Usher's wedding for *People* magazine's September 2007 issue. He specializes in digital wedding and lifestyle photography, and his view on receptions—and weddings in general—is as follows: "I follow my heart and go after candid moments that appeal to me and make me feel good inside."

Colón says that if the bride wants something specific photographed during the reception, or at any point in the day, he will get it for her. "She just needs to tell me," he explains. "I tell brides, 'If there are certain shots you want that you haven't seen in my books, or something you want to be sure I don't miss, give me a list.'" At the wedding he always makes sure to have an assistant with him who can shoot the traditional images that the client expects. "That way it frees me to think outside the box."

Such an approach includes constantly looking for angles that include capturing the reactions of people in the background who are watching the bride and groom. "While shooting the wedding couple's first dance, I'll try to include the parents or close friends of the couple in the background, looking on with excitement and emotion; the right backgrounds can dramatically increase the power of an image."

Colón primarily uses available light during his wedding shoots, but in extremely low-light situations, he'll carry a few Nikon SB 800 AF Speed-lights with him that he sets up strategically around the dance floor for a dramatic background light or for table shots to get a natural look. "I'll throw some light on the table from behind with one of the SB-800s and have an SB-800 on the camera, but powered down to minus two or three stops so it looks almost like the ambient light in the room is hitting the table from the front. If you took out the backlight and shot by available light only, the lighting would look very flat. The backlighting from the Speedlights makes the image really stand out. We're capturing a lot of available light in the room anyway; the flash is being used more to create a rim lighting around the scene or to add a little bit of contrast to the image."

Colón shoots in both color and black and white. He used to shoot all color and then would later convert some images to black and white, but now he usually decides on the spot if he wants the image black and white and makes the change in camera. "You lose the option of color when you do that, obviously, but I'm more inspired when I'm shooting." Colón says he'll usually want an image in black and white when either the color in the room is not flattering or it's distracting or there is just too much going on with the color and he can't get his white balance right or the skin tones don't look right. "With black and white, it looks more artsy, you can shoot more with available light, and the color isn't killing the image. I shoot at least 25 percent in black-and-white mode."

Occasionally, Colón will have his assistant wirelessly download images from his camera that he shot at the ceremony to his laptop and prepare a slideshow to project onto a wall during the reception—all done using high-speed Wi-Fi wireless transmitters—while he is still shooting. "When I first started doing it, in 2005, it added a real 'Wow' factor to the reception," Colón explains, "and people were blown away by seeing the images appear as they were enjoying the party." And, while he admits that not every client wants it, "the ones who do really get a kick out of it. It definitely adds to the party atmosphere."

Most important, Colón wants to present a totally unique perspective on the couple's big day. "My ultimate goal overall is to create images that not only tell a story of the entire day but that become a tangible reminder of the feelings and chemistry shared between a bride and groom."

1

2

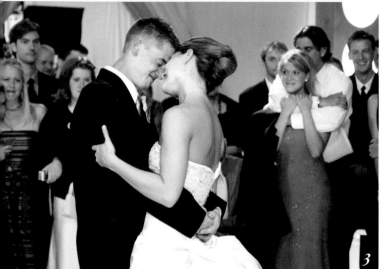

3

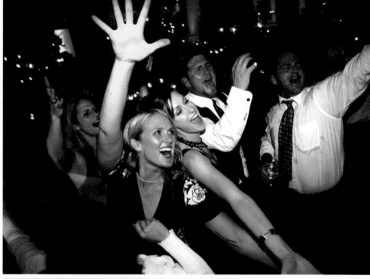

4

5

6

using an on-camera flash. The reception took place inside a tent and was being televised, although even with a lot of cameras and lights around, it was still too dark to shoot without a flash. "I was bouncing flash off the ceiling of the tent for this one."

CAMERA: Nikon D1X; **EXPOSURE PROGRAM:** Manual; **ISO:** 800; **SHUTTER SPEED:** 1/60; **F-STOP:** f/2.8; **LENS:** 28–70mm; **FOCAL LENGTH:** 60mm

4. CAMERA: Nikon D2Xs; **EXPOSURE PROGRAM:** Manual; **ISO:** 800; **SHUTTER SPEED:** 1/50 sec.; **F-STOP:** f/2.8; **LENS:** 17–55mm f/2.8; **FOCAL LENGTH:** 17mm

5. Colón used off-camera strobes for this shot that added rim lighting around a few of the guests and some brightness in certain areas.

CAMERA: Nikon D2Xs; **EXPOSURE PROGRAM:** Manual; **ISO:** 800; **SHUTTER SPEED:** 1/100 sec.; **F-STOP:** f/2.8; **LENS:** 17–55mm f/2.8; **FOCAL LENGTH:** 17mm

6. CAMERA: Nikon D2X; **EXPOSURE PROGRAM:** Manual; **ISO:** 400; **SHUTTER SPEED:** 1/20; **F-STOP:** f/2.8; **LENS:** 17–55mm; **FOCAL LENGTH:** 17mm

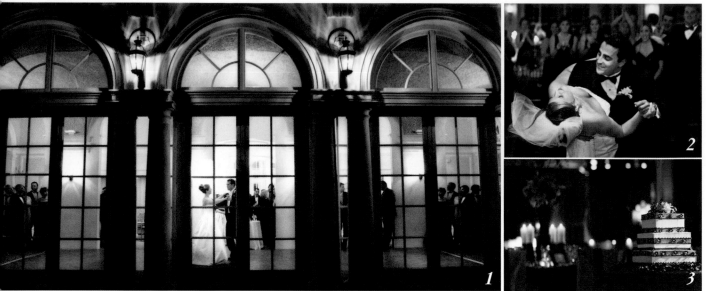

FOR CHARLES AND Jennifer Maring of Wallingford, Connecticut—who both enjoy following a storytelling and journalistic path in which they are not controlling every moment—the reception is the time when the magic comes to life. "I love that thirty-minute gap just after the first course of the meal and that first glass of wine or two," Charles acknowledges. "People relax and conversations get interesting. Couples lean into one another to hear over the band, and it offers endless opportunities to capture relationships without people even knowing. At that point, it's so much fun for me to shoot wide open with my 85mm *f*/1.2 lens, which is my favorite piece of glass. I could photograph an entire wedding with it due to its low-light capabilities."

Part of the allure of the Marings—a dynamic duo who in November 2004 photographed former *View* co-host Star Jones's wedding to Al Reynolds and then Donald Trump's wedding to Melania Knauss in January 2005—is their unobtrusive approach and that they consider themselves life and style photographers offering a little bit of everything rolled into one package: fashion, interior design, photojournalism, and portrait photography. During the reception, they prefer to work without flash whenever possible. "Basically, the challenge during the reception is that we're sort of living on the edge of what the camera is capable of, being held in your

hand," says Charles, who usually has two cameras on him at all times during the reception: one with a wide-angle lens on it—typically a 24–70mm *f*/2.8, with a flash on it "just in case a moment starts to happen and I need something where I absolutely need flash"—and a Canon EOS 30D and 85mm *f*/1.2 lens, which he uses most of the night without a flash. He says there are very few lighting situations where he can't work with that at ISO 800 or 1600 and get the result he wants.

The Marings will typically have a pre-wedding consultation with their couples to obtain a rundown of the staged events that are going to happen and approximately when, and "from that point on, we just sort of follow our hearts and remain in the moment and watch what happens and capture what happens."

For instance, there was the time Charles captured an image of the bride and groom dancing as he watched them through French doors at the reception (#1). The image is one of his all-time favorites. "The story behind it—and this is why I love digital so much—is that during the couple's first dance, I had already seen on the back of my camera that I had great close-ups and I had great full lengths. Once I know that, it then gives me the opportunity to say, 'Hey, I've got what they expect to see, now let me step outside of that and try to find something more

magical.'" In this situation, he went and stood outside in the rain and waited. "The funny thing was the couple danced to the right and to the left so many times, but between the windows they were always blocked by a pane. Finally, they took that one step, and I got one or two shots off, and it was just a magical shot. The couple loved it."

Charles says that capturing the file, though, is just one aspect of the creative process. The majority of our images have layers of techniques that add to the overall feeling of the photograph." He says he and his wife work in RAW format because there is more information in the file to work with. "A lot of the times," he explains, "I'll process the file three different ways and then combine the three images together: First I'll process it normal, which is run-of-the-mill down the middle; then I will process the image maybe a stop over; and then sometimes I'll process the image a stop or two under because when I'm taking pictures of a couple, for instance, and they are in a room, the sconce lighting on the walls of the chandeliers may be blown out with a standard exposure, but the information is still there in the RAW file, and by processing it under I can make sure that the chandeliers have as much detail as the subject."

Basically, Charles sums up, the talent and skill he and his wife bring to the wedding day and beyond extends far past the basic label of photographer. And, he says, "having a complete understanding of our capabilities has raised the value of our work." As for advice to other photographers out there, he says, "Just follow your heart. There are just so many moments that are going to unfold beyond what you think to see. The opportunities are endless if you kind of just walk the room and pay attention during those moments where it's not a staged event, necessarily. We're there to see what unfold and to capture history."

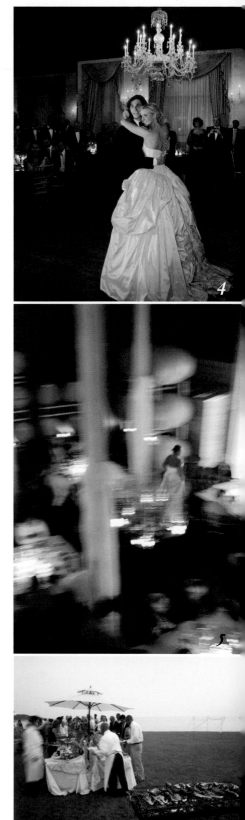

© *Maring Photography*

1. Charles Maring captured this magical shot by waiting outside in the rain until the couple danced into just the right position in relation to the panes on the French doors. **CAMERA:** Nikon D1X; **SHUTTER SPEED:** 1/8 sec.; **F-STOP:** *f*/2.8; **LENS:** 17–35mm *f*/2.8

2. The Marings capture everything in color and then convert some images to black and white using Apple Aperture software. "Black and white," says Charles Maring, "tends to make you focus more on the expressiveness of the photograph. This shot was great in color because of the composition and grace of the subjects in motion, but the image in black and white looks absolutely classic." **CAMERA:** Canon EOS-1Ds Mark II; **EXPOSURE PROGRAM:** Manual; **ISO:** 640; **SHUTTER SPEED:** 1/30 sec.; **F-STOP:** *f*/3.2; **LENS:** 85mm *f*/1.2; **FOCAL LENGTH:** 85mm

3. Color, as opposed to black and white, is best for capturing overall views of the reception space as well as close-ups of the details, such as the table settings, wedding cake, and the flowers, according to the Marings. **CAMERA:** Nikon D1X; **EXPOSURE PROGRAM:** Aperture Priority; **SHUTTER SPEED:** 1/40 sec.; **F-STOP:** *f*/1.4; **LENS:** 85mm *f*/1.2; **FOCAL LENGTH:** 85mm

4. The amber glow in this shot is part of what makes it so beautiful. Maring says he gets that effect by dragging the shutter so that the ambiance coming from the room light blends in with the flash. That way the image doesn't look stark and cold and flash lit. **CAMERA:** Canon EOS-1Ds Mark II; **EXPOSURE PROGRAM:** Manual; **ISO:** 400; **SHUTTER SPEED:** 1/20 sec.; **F-STOP:** *f*/2.8; **LENS:** 24–70mm *f*/2.8; **FOCAL LENGTH:** 24mm

5. Charles Maring followed the bride and panned the room while dragging the shutter to create this intentionally blurred image in which the bride is a little sharper than everything around her. The viewer can make out just enough details—such as tables and a few guests—to realize this is the reception and to get a sense of the whirlwind of activity the bride was enjoying in those moments. **CAMERA:** Canon EOS-1Ds Mark II; **EXPOSURE PROGRAM:** Aperture Priority; **ISO:** 800; **SHUTTER SPEED:** 0.4 sec.; **F-STOP:** *f*/2.8; **LENS:** 85mm *f*/1.2; **FOCAL LENGTH:** 40mm

6. Shooting right at dusk, the challenge for Charles Maring in this shot was to keep the table details sharp. **CAMERA:** Nikon D1X; **EXPOSURE PROGRAM:** Aperture Priority; **SHUTTER SPEED:** 0.3 sec.; **F-STOP:** *f*/2.8; **LENS:** 28–70mm; **FOCAL LENGTH:** 14mm

AMANDA SUDIMACK

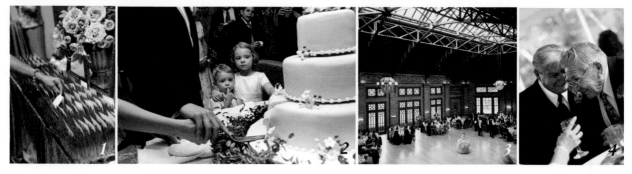

"MY WEDDING WORK is about the beauty of the day and the people," states Amanda Sudimack, president, photography team principal, and founder of Artisan Events in Chicago. "I always try to capture that in an honest and real way that isn't forced. I'm all about subtle objects, moments, and gestures."

The majority of Sudimack's reception shots, she says, are created with medium to high ISO ratings and available light. "Most of the time my receptions take place at night or indoors, so over the years I've gotten very accustomed to working well in low light; it's something that really comes with experience and time. I'm very comfortable doing it at this point and people come to expect it from me." And since the majority of her weddings take place in Chicago, she says it's a rare thing that she shoots somewhere that she hasn't shot before. "With the national and international weddings there is an element of surprise, but in those situations I almost always have time the day before to check things out. That is key."

Sudimack knows from experience that there is usually a lull at some point in the reception—usually when everyone is eating—which is when she says she is able to just go around and be creative, looking for different vantage points, taking overall shots, and spending a little more time on details than she is able to during other times of the day.

"For me, it's the attention to moments and details that describe the essence of a moment that I'm always looking for," she continues. "And I don't believe in over-producing things. It's a trend today that I strive to stay away from. So I don't use Photoshop Actions for anything; we rarely alter things, whether it be the day of the event or in the actual production process.

What Sudimack does rely on is her eye and her equipment. Of her 16–35mm $f/2.8$ lens she says: "I couldn't shoot a wedding without it; it's my gold standard." And like Melissa Mermin, Sudimack started using Canon 5Ds after using Nikons for years and years. She says she shoots both film and digital and loves both for very different reasons. "Digital appeals to my obsessive side, knowing on the spot if an image works, working on the job with an image until I nail it—I love that. On the other hand, I sometimes think you can miss things when you get too caught up in the technical. And I still don't think you can replace film—the nostalgic feel, the grittiness of 3200. You just can't replicate that without making it feel forced or over-produced. And honestly, I get bored with digital. I keep shooting film to keep me on my toes, to continue practicing the craft I love, and because it forces me to think outside a formula when I'm shooting."

© Amanda Sudimack/Artisan Events

1. Sudimack loves shooting details. "With most detail images, you just see the objects. I love that here you see a guest interacting with something that's part of the overall theme of the wedding. It puts the objects in a place and gives the image a more documentary feel." **CAMERA:** FinePixS2Pro; **EXPOSURE PROGRAM:** Manual; **ISO:** 800; **SHUTTER SPEED:** 1/30 sec.; **F-STOP:** $f/2.8$; **LENS:** 16–35 $f/2.8$; **FOCAL LENGTH:** 40mm (the camera had a 1.5 factor on it)

2. "This was just one of those OMG! moments," Sudimack recalls. "I had already gotten the image of the bride and groom, but those kids were just too cute to not be focused on. They made the image so much more, I think. It makes me think about weddings I went to as a child and that wonder and impatience you have when you're a little kid. Fortunately, most of my brides prefer me to capture moments like this, even if it's not a traditional composition of their faces during the cutting of the cake." **CAMERA:** Nikon N90s; **LENS:** 16–35mm $f/2.8$; **FILM:** Tri-x 400 black and white

3. Sudimack says she always does overall images of the "space" because the clients obviously chose a venue they love or are connected to in some way. "I'm not a huge 'room shot' fan, which, of course, all planners and editors typically request. I prefer instead to have a view of how the space is being used. I'm also always thinking about the architecture and giving the imagery a sense of place—how I can use it to frame the image and use it in the composition." She used a tripod and a slower shutter speed for this shot. **CAMERA:** Hasselblad 503cw; **SHUTTER SPEED:** 1/30 or 1/15; **F-STOP:** $f/8$; **LENS:** 50mm; **FOCAL LENGTH:** 50mm; **FILM:** 400 speed Fuji (Neg)

4. Cocktail hour is one of Sudimack's favorite parts of the wedding day. She likes to find the funny moments and captures as many people at the event as she can—not just the bride and groom. "I have no idea what they were talking about here, but I'll always wonder! I always imagine it's a really good, tasteless joke." **CAMERA:** FinePix S2 Pro; **EXPOSURE PROGRAM:** Normal; **ISO:** 800; **SHUTTER SPEED:** 1/180 sec.; **F-STOP:** $f/1.7$; **LENS:** 50mm; **FOCAL LENGTH:** 50mm

5. Sudimack took this image at a low shutter to capture the drag, light, and motion of this couple's first dance. "I love images that are borderline abstract, when you start to lose details and simply let the light show the motion. My goal is to capture what people don't see, and hopefully do it in a way that is artful and subtle." **CAMERA:** Canon EOS 5D; **EXPOSURE PROGRAM:** Manual; **ISO:** 800; **SHUTTER SPEED:** 1/15 sec.; **F-STOP:** f/2.8; **LENS:** 17–35mm f/2.8; **FOCAL LENGTH:** 20mm

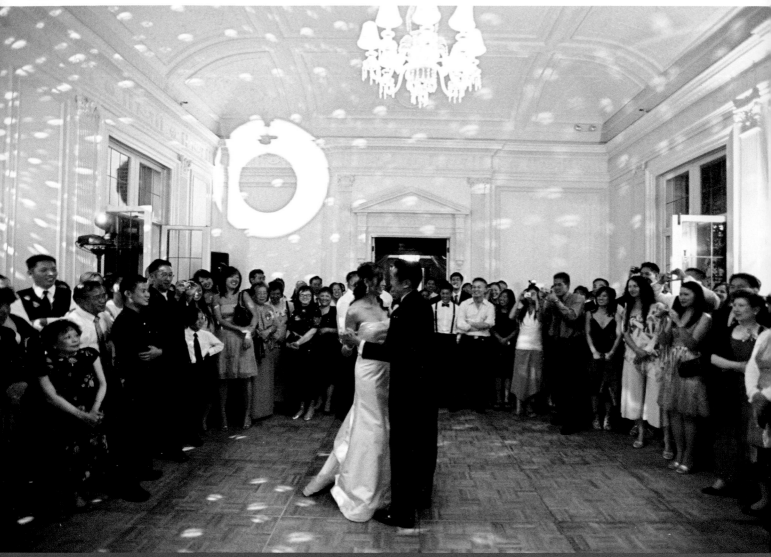

© *Jesse Leake*

1. This image has a dual vibe of a seventies/*Saturday Night Fever* dance party mixed with chic ballroom elegance. The strobes bouncing off the wall add a surreal charm as well as some movement (despite the semicircle of bystanders). **CAMERA:** Nikon F100; **SHUTTER SPEED:** 1/20 sec.; **F-STOP:** *f*/2.8; **LENS:** 17-35mm; **FILM:** Fuji NPZ 800

2. Even though Leake's images are photojournalistic in nature, he knows that certain couples still come with shot lists, especially for the reception. Getting an image of the cake-cutting is key; the challenge for Leake is to make it more interesting and unusual. Here, he captures the couple's personality while managing to still focus on the ornateness of the cake. He also knows when an image works better in black and white; here, it adds a documentary feel to the image. **CAMERA:** Nikon F100; **SHUTTER SPEED:** 1/30 sec.; **F-STOP:** *f*/5.6; **LENS:** 28-70mm; **FILM:** Kodak Tri-X 400

WHEN IT COMES to describing the style of San Francisco–based photographer Jesse Leake on wedding day, most clients say the same thing: He's fun, he's easygoing, and he's always nearby—although you never really notice him. And he shoots very fast. Once the "formal" portraits are completed, says Leake, who has been shooting weddings since 2001 and only recently delved into digital, "It's like, 'Whew, okay now we're on cruise control,' and from that point on I'm creating purely candid photographs. I have zero interaction. I might say hello, but I'm really hands off at that point and just capturing what is unfolding before me."

Leake's approach to photographing the reception includes shooting the actual setup—the tables, the menu, the tablecloths, the flowers—every detail that is important to the couple, he says, because, that's where they put so much effort. Next, he says, there's a meal, so the couple and their guests will be eating for a couple of hours, and then there's a toast—"either they can have the whole meal straightforward or have the meal interrupted by toasts and the first dance,

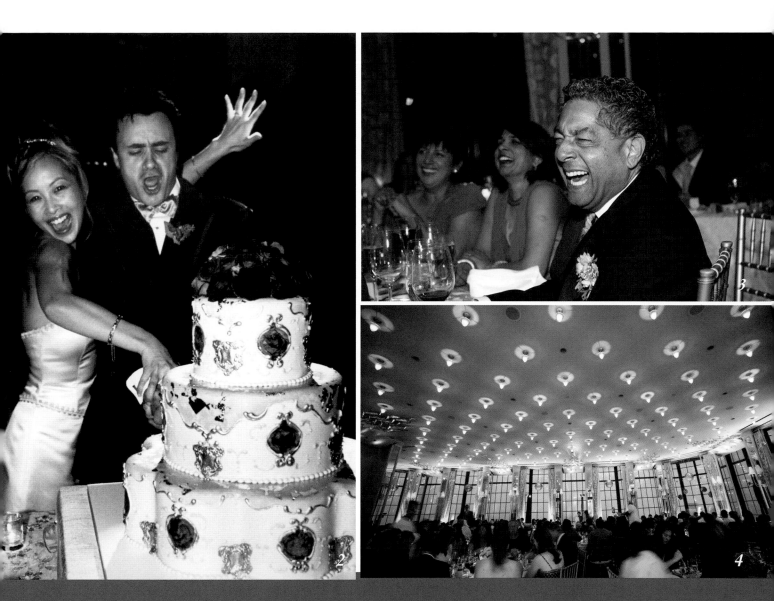

so I have to be on hand to get the toast and then fire off a couple of shots of the person giving the toast." At that point, Leake likes to turn around and focus on the guests and look for reactions. "I want to be listening to what they are saying and be able to predict a laugh coming or some kind of emotion. That's the fun part of the reception, I think, shooting toasts—especially if they are good ones."

It's a big responsibility, documenting a couple's wedding, but one he cherishes. "The couple is entrusting us to do this, to capture their day—and it is a huge day, a beautiful event—and there are great moments and details to find everywhere you look." Leake also revels in the fact that covering a wedding includes so many aspects and genres of photography: photojournalism, still life, portraiture. "It's about capturing moments, it's about timing, it's about being in a place where you can just be in the zone and flow with it all. Watch and observe and you'll get it. And the best part is, each wedding is different. I like that about weddings—different locations, different people."

3. Leake makes a point to stay out of the way during the reception but still be ready to photograph candid, genuine moments like this one during a toast. This is when Leake is most aware of his surroundings and is on the lookout for an emotional response coming from the seated guests or the bride and groom's table. For Leake, that's the fun part of covering the reception.
CAMERA: Canon EOS-5D; **EXPOSURE PROGRAM:** Manual; **ISO:** 500; **SHUTTER SPEED:** 1/15 sec.; **F-STOP:** f/5.6; **LENS:** EF 24-70mm f/2.8L USM; **FOCAL LENGTH:** 57mm

4. Capturing a sense of place—in this case, the reception venue—is just as important to Leake as capturing the people. Here, he manages both, a just a hint of blur in the foreground helps add some movement to the frame.
CAMERA: Canon EOS-5D; **EXPOSURE PROGRAM:** Aperture Priority; **ISO:** 500; **SHUTTER SPEED:** 1/2 sec.; **F-STOP:** f/5.6; **LENS:** 16-35mm f/2.8L USM; **FOCAL LENGTH:** 16mm

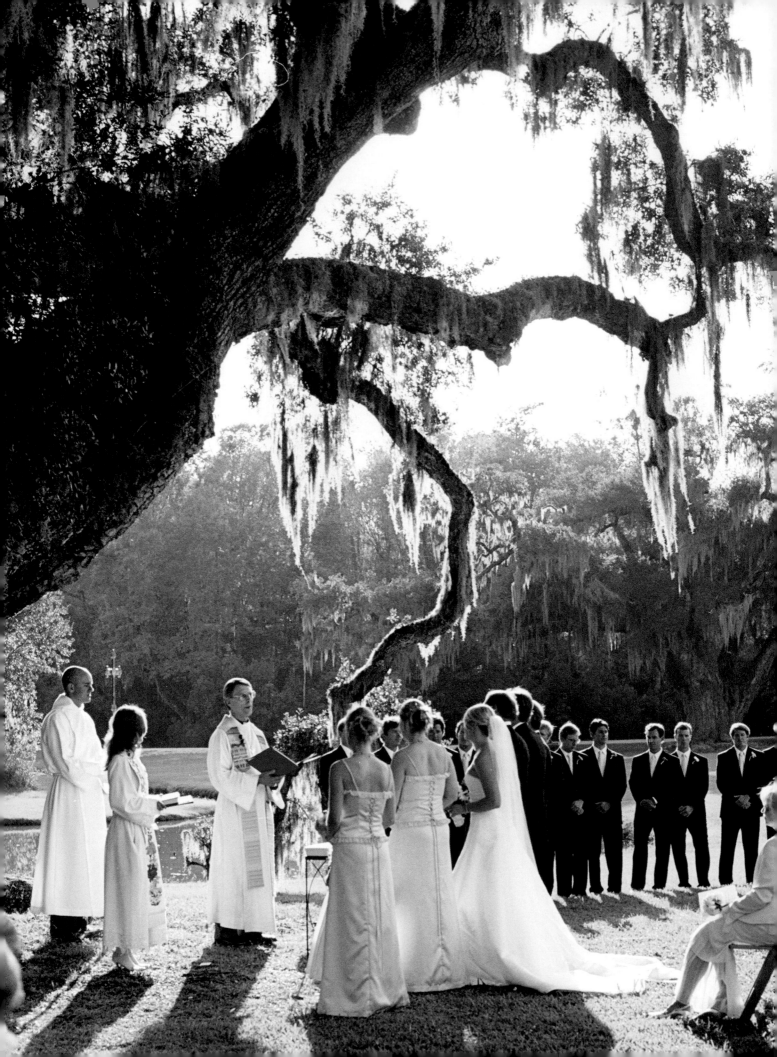

VII. AFTER WEDDING DAY

Getting Published

"There are marketing reasons for wanting to be featured in bridal magazines. You're getting a third-party endorsement that people think you're good enough to be in their magazine. It helps with your image with brides and with wedding planners."

—LIZ BANFIELD

(page 84) Liz Banfield says the magazines want images that suggest a "sense of place." This image of a ceremony in Charleston, South Carolina, published in *Elegant Bride*, shows vows being exchanged under an ancient moss-draped oak on the grounds of Drayton Hall Plantation House.

(above) Floral bouquets and invitations make for interesting elements from the day and add to the feel of a particular wedding for a magazine layout.

(opposite) Details, such as an elegant take on a slice of wedding cake, are important. This image by Banfield has a real editorial feel to it.

As brides become more discerning and lavish more money on their dream weddings, photo coverage of such events—once thought of as stilted and formulaic—has vastly improved as well, as shown throughout this book. Weddings have become a showcase for a couple's good taste, style, and social status: They've got it, and they want to flaunt it. Nowadays, most brides get their inspiration from the bridal magazines—*Elegant Bride*, *grace ormonde Wedding Style*, *Modern Bride*, *Brides*, *Martha Stewart Weddings*, etc.—specifically, what's known as the "real weddings" section. It varies from magazine to magazine, but the term "real weddings" typically means images of actual young brides and grooms (as opposed to models), preferably extremely good-looking ones, exuding style and taste. Most established wedding photographers will tell you that getting published in these types of magazines is the ultimate accolade—it's the best advertisement for their work and a good way to brand their name.

Of course, in this digital age, it's becoming easier to shoot a wedding than ever before, and as a result, there are thousands of photographers entering the profession each year. Getting published targets your key client—the bride—and also catches the attention of wedding planners. In other words, it can boost your business and your rates. As someone who gets inundated with e-mails and print campaigns on a regular basis, I can't stress enough the importance of standing out from the pack to get your work noticed. Liz Banfield and Elizabeth Messina discuss what works for them, and a few other photographers share their advice on the topic as well.

LIZ BANFIELD

"WHEN I FIRST got into covering weddings, I was nuts about magazines," says Liz Banfield, "and I had at least twenty-five subscriptions." She defines her photographic approach as being in the context of an editorial style. "I was always inspired by what I was seeing, and when I started out, *Martha Stewart Weddings* was the first magazine I found that took wedding photos to the next level and treated them as an art form." She was first published in *Martha Stewart Weddings* in 2001 and is also regularly featured in *Martha Stewart Living*, *InStyle*, *Elegant Bride*, *Town & Country*, and *People*, among others.

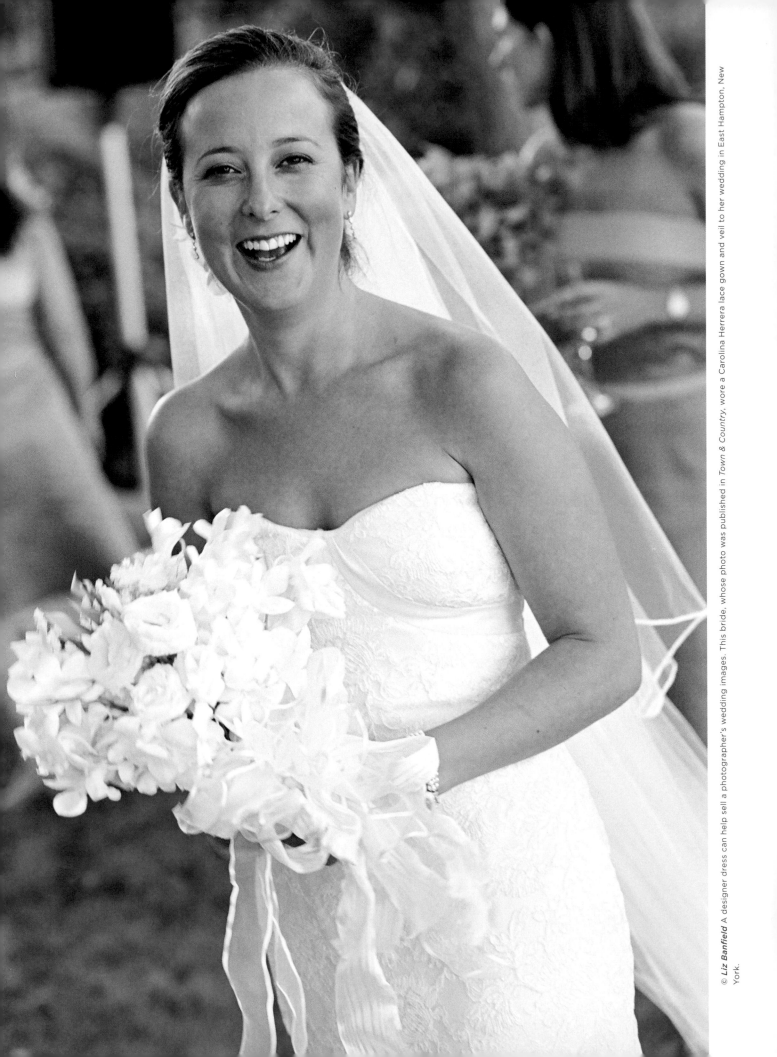

Known for her "fresh, uncluttered style," Banfield often gives presentations to other photographers on how to get published. She says there are three important building blocks to keep in mind when submitting work: "One, you always have to have a beautiful couple (especially a beautiful bride); two, you have to have two or three images that really encompass the uniqueness of a location and give you a sense of place—the 'establishing shots' that really make your wedding stand out and help create an editorial moment; and three, you have to have great details."

Keep in mind, Banfield adds, that establishing shots don't necessarily need to be of the bride and groom, or their location. "They can also be great detail shots, and you want things that say 'editorial moment' and make your weddings more saleable and different." The bottom line: Magazines always want an angle to the wedding, whether through diversity—say, a Scottish wedding with men in kilts or an Indian wedding highlighting the bride's hennaed hands—or affluence, such as a couple's high-society nuptials in the Hamptons. Banfield stresses, though, that you shouldn't take it personally when a magazine doesn't choose your great images: It might just be because the pictures don't fit its particular angle or theme that month.

BANFIELD'S TIPS FOR SUBMITTING WORK:

- **MAKE SURE THAT THE INFORMATION ON THE COUPLE (OR ANYONE ELSE IN THE PHOTO) IS INCLUDED:** who the bride and groom are, where they came from, what they do for a living, the names of their important vendors, the wedding venue, and, if applicable, the name of the bride's gown designer and shoe designer.

- **MAGAZINE EDITORS ALWAYS NEED SOMETHING THEY CAN PASS ALONG TO ANOTHER EDITOR.** Always finds the three elements—people, place, things—that make the wedding special and publishable, and print them out.

- **IF YOU DON'T HAVE THE THREE ELEMENTS, LOOK AT YOUR WEDDINGS AND SEE IF THERE IS** at least one thing that is really great—like a wedding with a fantastically beautiful bride or a stunning detail that suggests a sense of place. Sometimes you can sell a wedding just on a special detail.

- **BUILD RELATIONSHIPS.** The more you work with one particular photo editor, the better it is for you.

It also helps to know the target audience of the magazine you are sending work to. *Elegant Bride* photo editor Claudia Grimaldi told photographers at a *PDN* seminar that the goal of her magazine is to speak to the sophisticated bride who wants to translate her lifestyle into her wedding day. "We're looking for photo-driven weddings that tell a story in a way that gives a bride ideas for her own wedding," she said. She also noted that for her magazine, the bride's dress has to be from a designer. "It's not always a deal breaker if it is an amazing wedding and the bride picked up the dress in, say, some vintage store, but I'm more likely to look at the wedding if she spent a certain amount of money on the dress." Again, every magazine has a different need and a different target audience.

For instance, Grimaldi is always on the lookout for events connected to the wedding that don't actually occur on the wedding day, anything from a bridesmaids' spa day to a day-after brunch. The bottom line: Do your homework. Certain magazines want high-budget, destination weddings with brides wearing designer everything, whereas other publications might prefer exotic, ethnic weddings with unusual table settings, interesting food still lifes, and so on. It's the original details and personalized features of a wedding that catch editors' eyes. Weddings are no longer cookie-cutter and neither is the photo coverage, thank goodness.

ELIZABETH MESSINA

ELIZABETH MESSINA SAYS one of the most important things you can do is to know your style and then become familiar with all the wedding magazines you might want to see your work published in and determine which ones you connect with the most. "Don't just send your images to dozens of magazines hoping that someone will respond," she advises, "but instead pick five or even ten of your favorites that you think best represent your overall style."

For example, when she first realized how important it would be for her to get published (about eight years ago), Messina started out by targeting magazines like *The Knot, Martha Stewart Weddings,* and *grace ormonde Wedding Style* because she felt that her style was most in sync with the look and tone of these publications. And apparently the photo editors at these magazines agreed. But she didn't stop there. "I also felt that it was important for me to target local titles from my area as well." That led to her getting the exclusive to shoot the covers for *Your Wedding Day* in Southern California, as well as being published on a regular basis in *Los Angeles Weddings* magazine. And now, with both the local and national exposure,

Messina finds that magazine editors are contacting her and asking for specific wedding images.

Messina recommends sending a personal card or note along with examples of your best work to your favorite magazines. Messina likes to send twenty prints (only send a disk if you include prints along with it) and a handwritten card that says, "Call me if you want to see more." The first time she did this with five photo editors, four called her back. In choosing what to send, keep in mind that what a bride wants image-wise from you is much different than what a magazine wants. Photo editors want to see what the wedding looks like; they want to see the details.

Messina says most cities publish local wedding guides, and these are a good first step to getting your work, and your name, out there. Keep in mind that even if a magazine doesn't want a whole wedding of yours, oftentimes an editor will use one or two images to illustrate a supporting story. She recommends that you "be yourself." If you have great work, people will respond.

OTHER VOICES WEIGH IN ON HOW TO GET PUBLISHED

BEN QUILLINAN SAYS he submits a lot of wedding images to local publications, such as *Arizona Weddings, Phoenix Bride and Groom,* and the *Wedding Chronicle* (Phoenix). Occasionally, he'll send work to the national magazines, and some images will run as featured weddings and some will get separated out to illustrate a specific article. It makes a huge difference in the business to get published because newly engaged brides will look through the magazines from front to back and might see a featured wedding with his name on it, then a few photos in different articles, and then his ad. "The more my name is seen, the more interest it builds. It has taken some time to get in with the editors who run my images, but any photographer can—and should—submit."

Suzy Clement has been published in many magazines, including *Martha Stewart, Brides, Elegant Bride, InStyle, People, Wedding Bells, The Knot, Sunset,* and *San Francisco.* She feels that having work published gives her credibility with potential clients: "It shows

them I'm the real deal." She notes that the editors of these magazines generally want to show beautiful and original events that provide inspiration to brides. They also like to see lots of details and lots of color. "My main tip: Submit often and work on building relationships always."

Jose Villa says that when he decided he wanted to get published, he bought all the magazines he thought were really beautiful and wanted to be featured in—about ten or twelve—and looked up every single photo editor on every masthead and called them all. He introduced himself, apologized for bothering them, and then told them to look up his website. Then he sent a link to some of his wedding slide shows. Eventually, the requests started coming in for submissions of his work. "The most important things I learned while doing all this?" he says. "A lot of editors don't stay at one magazine very long, so keep building relationships. And they all love details!"

© *Elizabeth Messina* Elizabeth Messina will often send a piece like this one, with details of one wedding, along with a disk and a handwritten note, to the magazines she's interested in.

VIII. THE BUSINESS BASICS

Websites, Albums, and Equipment

> "I use my tools but do not get distracted by having too many toys." —MELANIE NASHAN

To be a successful wedding photographer, you need to do more than just capture various parts of the day with creative, fresh approaches. You need to keep your name out there, market yourself appropriately, and stay current with industry trends and technology. The question is "How?" Of course, everyone is different and has different goals, so it's important to find what works best for you and take it from there. Here is a brief rundown on websites, albums, and equipment.

THE WEBSITE

Websites are a major marketing tool for wedding photographers: You can showcase your images from previous weddings to potential clients; introduce yourself through videos and blogs to brides, wedding planners, and photo editors; and even have clients book your services online (something Mike Colón started doing in 2008). As Kathi Littwin sees it, "You can't be in this field without one. My website is one important piece of how people find me and recognize my style—it's a very important calling card." And for wedding photographers in particular, it isn't enough to just have your images on a site; you need to have your personality and style reflected in every detail on it: the colors and fonts you select, the news and information you share in your blog, and the music you choose to complement your photo galleries.

"Your website *is* your business," Melissa Mermin emphasizes. "A florist or a band can almost get away with a bad-looking website, but we are visual artists, so your site is a reflection of who you are. Brides are always telling me that they go through tons of sites they find online and if the homepage doesn't grab them instantly, they move on." It makes sense, then, that when Melissa Mermin and former partner Earl Christie amicably dissolved their partnership in late 2007, she faced a major dilemma: how to extricate herself not only from that business and their highly identifiable name, Mermin + Christie, but from their website as well. "I needed to re-brand myself, and fast," she exclaims.

Hence the birth of her new site in 2008, www.melissamermin.com, and her wedding photography company, Melissa Mermin Love Stories—("Creative Documentary Wedding Photography from Newport to Napa"). "I liked the name because it really is what I create, and it gets people asking at parties, 'What's a love story?' rather than just reading 'photography' next to the name," she says. And, she adds, it took only weeks to get the new site up and running.

Mermin says she went to BluDomain (www.bludomain.com), a site that sells Flash and HTML website templates for photographers and creative professionals ranging from $100 to $800 (in 2008) and purchased the template George (the templates are given names that people would have). Mermin liked George

© *Amanda Sudimack/Artisan Events* (page 92) Here is a sample coffee-table book from Amanda Sudimack's company, Artisan Events in Chicago. Artisan Events produces a high-end line of couture albums and custom-designed wedding albums in-house for weddings and other events (baby books, memory books, graduations, etc.).

because it was an "edgy, in-your-face site versus the female-named offerings that were prettier and had colors that changed."

As described on the BluDomain site, George is a template "loaded with attitude and good-for-your-business things to deliver instant attention." When Mermin purchased it in 2008, it came with unlimited galleries, four text sections, a calendar, a shopping cart, client proofing, music added to each gallery individually, image watermarks, and a four-link splash page. (For an extra $100 a year you can host with the company.)

The next step for Mermin is to add video to her site (an extra $150 in 2008) of her in action at a wedding, as well as going to the couple's home months later and showing them proofs in their living room. "You get to know who I am, how I work, and what my shooting style and client relationships are like. What can be better than that?"

© *Melanie Nashan* Melanie Nashan uses this simple black-and-white photo as the opening image on her website, www.nashan.com. Nashan says the most important part of her site is the Photographs section, which features several galleries of weddings that appeared in magazines. Next is her blog, used to show clients images from their weddings before the event gets hosted on her website. **CAMERA:** Canon D60; **EXPOSURE PROGRAM:** Manual; **ISO:** 400; **SHUTTER SPEED:** 1/60 sec.; **F-STOP:** *f*/1.8; **LENS:** 85mm; **FOCAL LENGTH:** 85mm

TO BLOG OR NOT TO BLOG

Everyone's doing it—blogging, that is. Which is exactly why Jose Villa was so opposed to it . . . initially. "The blogs I came across seemed to be all 'me, me, me, me' oriented," Villa explains, "instead of targeting potential clients, specifically brides and grooms." He wondered why people were spending so much time on their blogs and sharing so much personal information, but after speaking with a good friend, he determined that he needed to start his own. "I found that clients expected me to have one because so many other wedding photographers did. Nowadays, if you don't have one, then you're out of the loop, and prospective clients think the images up on your site are not current. He looked into sites like Blogspot.com, WordPress.com, and Typepad.com before settling on Big Folio's Blog Solution (he doesn't have a site with them, just a blog). "I thought Big Folio's blog options were really beautiful . . . very simple and clean and very much my style," Villa says.

The best part, he continues, is that Big Folio customized his blog to look like his website (http://josevilla.bigfolioblog.com/). "They made it consistent with the design of my existing site, so that when you click on my website first and then go to my blog, it doesn't look like a dramatic change or an off-site change." Instead, he says, it's an easy, flowing change and it becomes a continuous journal of Villa's new images and updates. "It's a simple yet effective way to continually add a collection of brand new, fresh images I can share with existing clients, future clients, photo editors, other photographers, and so on."

Mike Colón is a master marketer who was already making $10,000 a wedding when he managed to raise his fee to $20,000 virtually overnight because he knew there was a market consisting of high-end brides wanting the best and willing to pay for it. In turn, his website reflects his savvy business sense: he's got video, online booking, EXIF data included for every image posted in his gallery section, a product page and shopping cart where one can buy instructional DVDs and such, workshop listings, a resource page for professionals, a virtual tour of his Newport Beach studio, and so on. And Colón has a blog—www.mikecolon.net/blog/—and he agrees with Villa about the importance of having one. "Blogging is vital for me; it's the way I can communicate with a lot of people all at one time. I can't take every phone call, I can't answer everyone's e-mail, but I can post something on my blog and make a personal connection with a lot of people at one time. It's also a good way for me to promote my educational products and seminars."

In sum, there are a lot of options these days for photographers wanting to build a website that reflects who they are and what their work is about. A lot of wedding photographers prefer using sites like Big Folio (www.bigfolio.com), Livebooks (www.livebooks.com), and Photo Identities (wwwphotoidentities.com) for site hosting and

custom-designed templates. On the other hand, Charles Maring says that with the advent of Flash 4, he was able to design his own site and now uses Adobe Flash CS3 for posting updates. Melanie Nashan hired a Web designer to work with her to create a site that is unique and personalized. And Ben Quillinan, who likes having a clean, simple site where couples won't get caught up in flashy stuff and miss the images, uses SiteWelder (www.sitewelder.com). "An artist's work is not as noticeable without a good gallery to hang it in," he says. "Elaborate websites that are tough to maneuver through with too much stuff going on can be frustrating and distract the viewer from what's important. Ultimately, the images are the most important part. Prospective clients need to see beautiful, fun, and emotional images they can put themselves in."

One last note: Music plays a big role in personalizing a photographer's site and accompanying photo galleries. Some photographers secure written permission from the musical artist before using his or her music online; others link to a musician's site directly or make sure to credit him or her properly; a few probably even use the music without getting permission (not recommended!) but do name the artist. It gets a little sketchy, and for photographers who realize the value of a copyright, the last thing you want to do is post someone's music up on your site without getting permission or paying for it. Fortunately, there is the royalty-free music collection of Triple Scoop (www.triplescoopmusic .com), which bills itself as "the first and only music licensing service built specifically for professional photographers and videographers," used by Mike Colón, as well as industry legends Joe Buissink and Bambi Cantrell (both of whom handpicked song collections other photographers can choose from for their sites) and many others.

"We spent the last two years working directly with record labels, artists, publishers, and managers with the specific goal of bringing world-class music to professional photographers and videographers," describes Triple Scoop cofounder Roy Ashen on his site, "and we've created the first royalty-free licensing service specifically built for their music and marketing needs." This is one resource definitely worth checking out.

ALBUMS

Breathtaking images deserve an equally stunning showcase. And these days, even as online multimedia slide show and DVD packages gain in popularity, there's still nothing that can equal the beauty and elegance of a tactile, custom-designed album. Liz Banfield offers coffee-table-style books that are printed and bound in Italy; the Marings design and print all their albums in-house and then get them bound by John Garner of Bookcrafts in Australia; and Virginie Blachère, who often goes with Italian leathers for her albums, also works with a bookbinder who produces beautiful handmade books with rice paper, Japanese cloth, and archival ivory pages. The options are endless and usually depend on your photographic style as well as the type of clientele you cater to. For example, Chenin Boutwell's clientele consists of young, hip couples, and her images are very vibrant and joyful, even offbeat and quirky at times—which is why she likes to keep the albums she offers more simple and timeless. "I don't like to do borders or crazy collages or bright colors or anything like that. I lay my albums out in a way that's very similar to a magazine fashion spread. I really feel that if the photos are strong enough, you don't need to dress them up; it's enough to just put a gorgeous photo on a page."

Boutwell says she designs her albums freehand in Photoshop and likes to have only one to three images per page. After that, she posts the designed pages on her site, where they can be password accessed, viewed, and approved by the client. She uses album company Finao (www.finaoonline.com), based

inside front cover (blank)

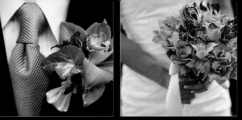

krysti + dave.
rancho del sol pacifico.
august 25, 2007.

in Saline, Michigan, to bind the finalized books. "I'm really happy with Finao. They do a fabulous high-end, flush-mount album, which works well with my simplified layouts." Apparently, flush-mount albums are all the rage among wedding photographers and their clients these days; the process entails photographic prints being hot-pressed onto a stiff page, which is then trimmed until the photo appears flush to the edge of the page.

Elizabeth Messina gets her flush-mount albums from Cypress Fine Handmade Albums and Boxes in Glendale, California (www.cypressalbums. com). "It looks and feels like a real book; the pages are thicker and the photo page is the book page." Dena Robertson, founder and president of Cypress Albums, further explains it: "The page has a weight thickness—it's mounted to board, so it's a heavyweight page . . . a two-ply board or sometimes even a four-ply board. It's a very popular style, now that more and more people are designing their own books."

Robertson says Cypress Albums customer Jose Villa likes to sometimes add a minor element of design onto his album pages, like a thin, pale gray vine—which is actually the same identifying element he uses on his website and blog. He also likes a lot of white space around his images, so the album page may be 12 x 12, or even a spread, but the images are smaller and there might be only two or three on a page. Customer Elizabeth Messina, on the other hand, prefers full-bleed images and might take the entire 12 x 12 page with just one image full-bleed to the edges, or she might take four images, all full-bleed and touching each other. And though Messina and Villa shoot film, Cypress Albums has a partnership with the well-known Richard Photo Lab (RPL, www .richardphotolab.com) in Los Angeles, meaning you can send your negatives to RPL directly and they'll send prints to Cypress, or Cypress will forward the negatives to RPL. Cypress can even set up an FTP site for photographers to upload their images and have Cypress send them to the lab to be printed and sent back again to use in an album. Says Robertson, "We both share the same business philosophy and care deeply about our clients as well as the quality of the final product."

© *Chenin Boutwell* (above and page 98) Chenin Boutwell designs her albums simply and elegantly and doesn't like to use more than one to three images per page. Here is a sample inside-cover design (above) and page layout (page 98).

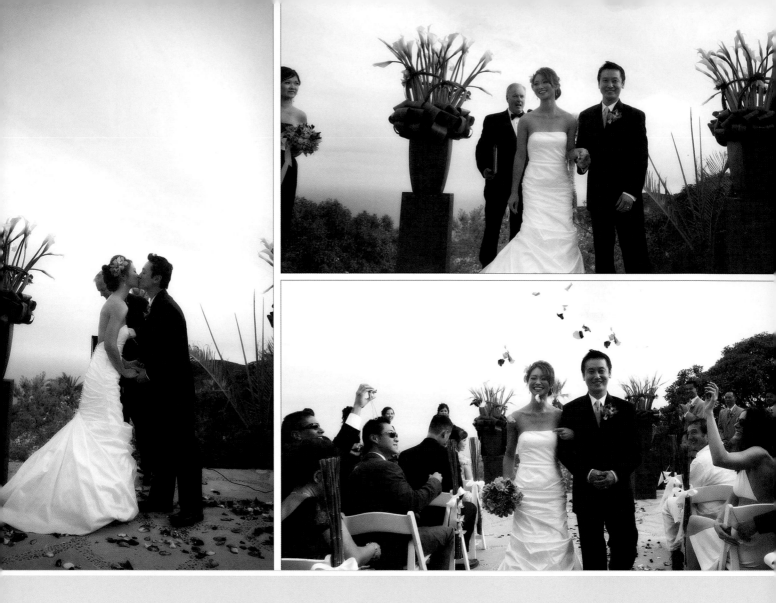

The following are album companies popular with many wedding photographers:

- Albums Inc., Cleveland and Atlanta
 www.albumsinc.com
- AsukaBook USA, Bend, OR
 www.asukabook.com
- Cypress Albums, Glendale, CA
 www.*cypressalbums*.com
- Finao, Saline, MI: *www.finaoonline.com*
- GP Albums, Chicago:
 www.gpalbums.com
- John Garner Bookcrafts (based in Australia):
 www.bookcrafts.net
- La-Vie Album, Santa Monica, CA:
 www.la-viealbum.com

- Leathercraftsmen, Farmingdale, NY, and Santa Ana, CA:
 www.leathercraftsmen.com
- Lush Album Couture, Bellingham, WA:
 www.lushalbums.com
- Memory Link, Port Washington, NY:
 www.albumml.com
- Photo Book Press, Minneapolis:
 www.photobookpress.com
- Queensberry (based in New Zealand and Australia): www.*queensberry*.com
- ZoomAlbum, Kirkland, WA:
 www.zoomalbum.com

NOTE: For online proofing and viewing solutions, many wedding photographers use either Collages. net (www.collages.net) or Pictage (www.pictage.com), both of which also offer album options.

AMANDA SUDIMACK'S EQUIPMENT CHECKLIST

CANON–DIG|35 SYSTEM:

- [] 16-35 lens 2.8
- [] 70-200 lens 2.8
- [] 50mm Lens 1.4
- [] ___Digital Bodies/5D
- [] ___Digital Bodies/5D
- [] ___CF Cards
- [] ___Battery Packs (3)

- [] Manuals to Bodies, lens
- [] ___Lens Caps/Front & rear total
- [] ___Camera Straps
- [] ___Extra Battery Clips (2)
- [] Cords to Battery Pack (2)
- [] Extra Canon Batteries (2)

- [] Card Reader & cord
- [] Hard drive for cards/cord (2)
- [] ___Tripod (2)
- [] ___Tripod Plates (6)
- [] ___Monopod (1)
- [] ___Pocket Wizards & Cords
- [] Laptop (1)

NIKON–DIG|35 SYSTEM:

- [] 17-55 lens 2.8 DX
- [] 17-35 lens 2.8
- [] 70-200 lens 2.8
- [] Lensbaby
- [] 10.5 Fisheye lens DX
- [] 50mm Lens 1.4
- [] ___Cords to Battery Pack (3)
- [] ___Battery Packs (4)

- [] ___Digital Bodies/D200 (2)
- [] ___Digital Bodies Backup/D70
- [] ___Digital Cards
- [] ___Extra Battery Clips (1)
- [] Manuals to Bodies, lens
- [] ___Lens Caps/Front & rear total
- [] ___Film Bodies/N90s (3)

- [] ___Camera Straps
- [] Hard drive for cards/cord (2)
- [] ___Tripod (2)
- [] ___Tripod Plates (6)
- [] ___Monopod (1)
- [] ___Off Camera Cords (3)
- [] Laptop (1)
- [] Card Reader & cord

LIGHTING:

- [] ___Fong Dongs (3)
- [] Studio Lighting Kit (1)

- [] ___Umbrellas (3 sets)
- [] ___Umbrellas Clips (2 sets)
- [] ___Large Fill/Shade Kit (1)

- [] ___Light Reflector (1)
- [] ___Light Stands (3 sets)
- [] Digital Color Target (1)

MEDIUM FORMAT:

- [] ___Body (1)
- [] ___Prism (1)
- [] ___A12 backs (2)

- [] 50mm
- [] 80 mm
- [] 120 mm

- [] Strap
- [] Holga Body
- [] 120 Film

OTHER:

- [] Contact Juice & Extra Pair
- [] Extra Batteries
- [] ___Battery Charger (AA,Nikon)
- [] Business |Web Cards
- [] Purse for film
- [] Pens/Marker
- [] Film:

- [] Leatherman Tool
- [] Tape
- [] Lens Cloth & Cleaner
- [] Flash Light
- [] Kleenex
- [] Directions & Phone to all
- [] Rental Gear:

- [] Cell Phone
- [] Glasses
- [] Water Bottles
- [] Extra Car Keys
- [] Make-up/Deo
- [] Cash-Visa & License
- [] Assistant(s) Phone

CARDS TOTAL: QTY: NO'S:

Amanda Sudimack and her team of associate photographers run through this equipment checklist before every wedding they cover.

EQUIPMENT

As this book is being read, there are no doubt new lines and next-generation models of equipment flooding the marketplace. Whatever equipment wedding photographers fell in love with yesterday has already been revamped and remodeled for tomorrow.

CAMERAS/LENSES

The one consistent piece of news is that as far as cameras go, the 35mm DSLR (digital single-lens reflex) is still the digital wedding photographer's camera of choice; what varies is the make and model. Most of the photographers featured in this book use either Canon or Nikon models and most were big fans of the Canon EOS 5D for its full frame capability, something Melissa Mermin says digital always lacked in the past. As this book went to press, most of the photographers I spoke with were just waiting for the next generation of that camera to be unveiled. If you're a Nikon shooter, the Nikon D3 (which is what Mike Colón was using at press time) is another full-frame digital body option. Photographers say these bodies offer the best wide-angle capabilities and the best image quality in low light. (Other manufacturers offering DSLR systems include Olympus, Fuji, Pentax, Sony, Minolta/Konica, and Sigma.) Whatever you use, most of the photographers here say you should always have a backup or two when you're photographing a wedding.

In terms of lenses, fast ones— $f/2.8$, $f/2$, $f/1.8$, $f/1.4$, $f/1.2$, etc.—are the weapons of choice for the wedding photographer, especially the ones in this book, who all use available light and avoid flash as much as possible. Also favored are zoom lenses—wide-angle, wide-to-tele zoom, and image-stabilized telephoto zoom. Other popular lenses for full-frame camera bodies include the 28mm (good for overview coverage and crowded spaces), 50mm (for small groups and dances), and 85mm (a long lens good for capturing intimate gestures during the ceremony).

Of course, in a perfect world you could just show up at a wedding with a camera and a few lenses and that would be that. In the real world, there's a broad range of equipment wedding photographers rely on, including everything from batteries, memory cards, handheld flash meters, and remote triggering devices to reflectors, light stands, and tripods. The list can be endless. Check out the Up Close and Personal section at the back of this book for a complete rundown on what each of the twenty photographers likes to bring along when covering a wedding.

WORKFLOW PROGRAMS

Melissa Mermin says that the one drawback to shooting digital is the workflow: "You've taken thousands of images, and now you have endless hours of editing and image management ahead of you—it's not creative, and it's not fun." But it is necessary. Digital wedding photographers come back from big events with thousands of images and gigabytes of data. Before delivering a great product to a client, you need to work your way through endless hours of reviewing, cataloging, and organizing your files. The good news is that there is a broad range of pretty decent digital asset-management programs on the market that can help streamline the process and provide applications for managing, adjusting, and presenting large volumes of digital photographs. Popular choices among the wedding photographers in this book include Apple Aperture, Adobe Photoshop Lightroom (Melissa Mermin uses this one), Adobe Bridge, Camera Bits' Photo Mechanic (Amy Deputy's choice), iView-Media Pro (Melanie Nashan's preference), and Microsoft Expression Media.

© *Chenin Boutwell* Boutwell ran her original image (opposite, left) through some of her "Totally Rad Action" sets. First she used an action called Yin/Yang, which dodges and burns an image, followed by Technicolor Dream World, in order to, she says, "give it that kind of punchy glow." She finished by using Big Blue to saturate the blues in the image (opposite, right). "I really like that it still looks very natural," she declares.

IMAGE ENHANCEMENT

A wedding is one of the most important events in a couple's life, and the wedding photographer is there to capture the memories that will continue to be viewed generation after generation. Some images might need a little image enhancement, a little tweaking here and there before they make their way into the happy couple's album; nothing wrong with that.

According to the Webopedia Computer Dictionary, image enhancement is:

the process of improving the quality of a digitally stored image by manipulating the image with software. It is quite easy, for example, to make an image lighter or darker, or to increase or decrease contrast. Advanced image enhancement software also supports many filters for altering images in various ways.

Many of the photographers featured here do some degree of image enhancement in postproduction using various software programs, the most popular one being Adobe Photoshop and its series of predefined "actions."

The Web resource Visual-Blast Media (www.visual-blast.com) says an action is:

a series of tasks that you play back on a single file or a batch of files—menu commands, palette options, tool actions, and so on. You can create an action that changes the size of an image, applies a filter to the image for a particular effect, and then saves the file in the desired format.

You can also customize these actions to meet your needs or create new ones.

Chenin Boutwell and her husband, Doug, sell a complete workflow set of forty-six Photoshop actions under the name Totally Rad Actions (http://totallyradactions.com) designed to, they say, "make images come alive, and to streamline the process of working on photos" using Adobe Photoshop version CS2 or later. The Boutwells' actions are basically mini programs that work within Photoshop (the larger program) and are ways to quickly and simply manipulate images. A lot of them will run a series of steps to come to a finished effect on the photo. They all work within layers, and they all maintain the layers. They're also designed to run several actions on one photo. For example, Chenin might have an image on which she ran a dodging and burning action followed by a warming action followed by an effect and then added some grain. "A lot of times we're running four, five, or even six different actions," she says. "It's never really just one—which is what's really cool about it, because I never feel like other photographers' work looks like mine. What we're really doing is encouraging people to combine these actions in their own unique ways and create recipes, so to speak. They can make more combinations on their own from our basic ones." Parker Pfister also sells actions for use in PhotoShop 7, CS, CS2, and CS3, on his site, www.parkerjphoto.com.

Both the Boutwells and Pfister's action sets, as well as others that are out there on the market, are really there to provide photographers with everything from the basics, like lightening and darkening and dealing with white balance, to much more specialized needs, like adding grain and vignetting and selectively blurring. The best part, says Chenin, is that the images still look natural and not like they've been Photoshopped to death." And that is what most brides want captured on their wedding day, after all—real-life moments, only better-looking.

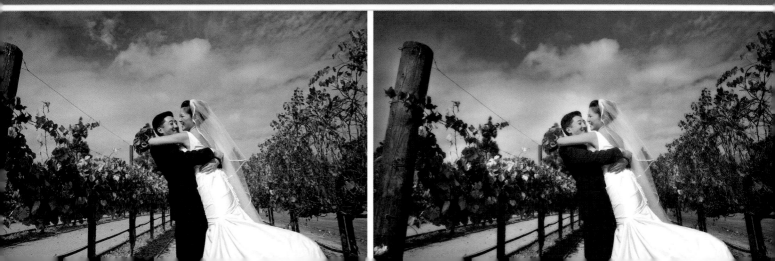

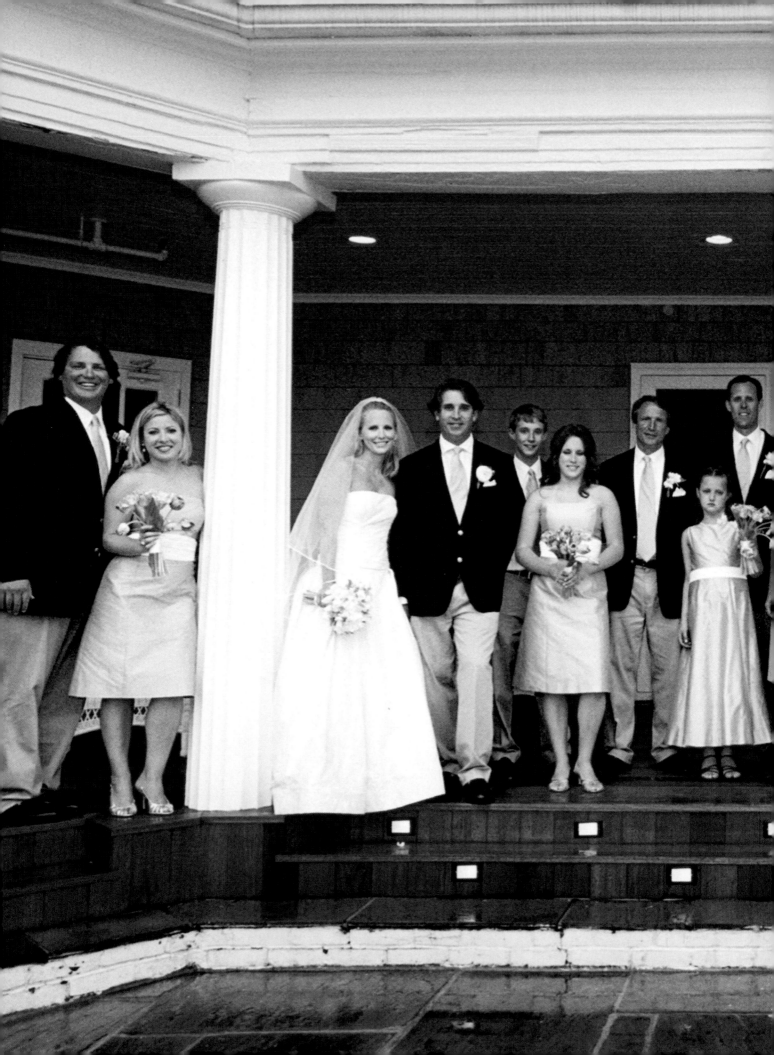

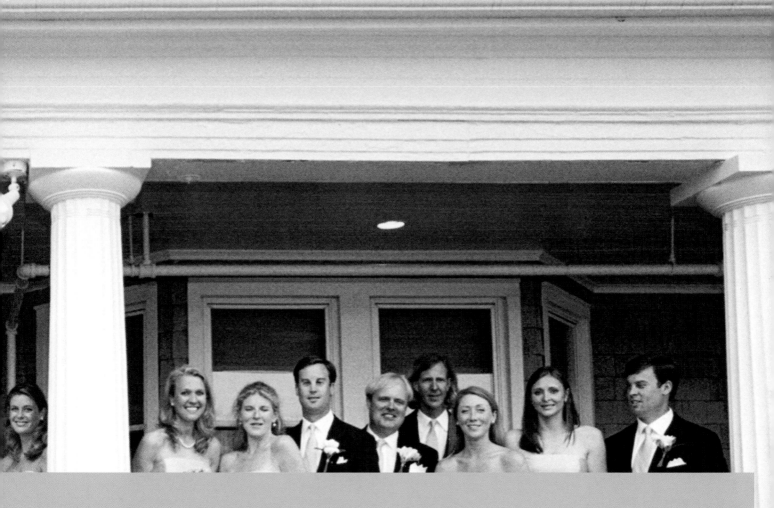

IX. UP CLOSE AND PERSONAL

Who's Who

Here is a closer look at the twenty photographers who generously shared their expertise, insight, and wedding-day images. Following are summaries of their backgrounds, philosophies, more photo picks from weddings they've covered, and, most important, the contents of their gear bags!

Liz Banfield

© Michelle Dupuis

LOCATION: Minneapolis
IN BUSINESS: Weddings since 1998
FILM OR DIGITAL: Film
COVERAGE: Fifteen weddings a year
WEBSITE: www.lizbanfield.com
KNOWN FOR: Shooting weddings with the same meticulous style and attention she gives to her editorial assignments, without looking staged.

IN HER OWN WORDS: "I think clients are attracted to the beautiful, effortlessly candid look of my images. Also, I'm a really tight designer of the image in the sense that I compose for the full frame as if nothing will be cropped."

BACKGROUND: Liz Banfield is a former advertising executive without formal training in photography. A hobby photographer since age eleven, she has a liberal arts degree from Grinnell College in Grinnell, Iowa. After a few years at top advertising agency Fallon McElligott, she was assigned to the Nikon account, where she learned more about the technical side of photography and was exposed to some of the world's best photographers, including fashion photographer Matthew Rolston. Banfield's first wedding clients were colleagues who liked the photographs of her friends and family that she kept tacked up in her office. Soon she was so busy shooting assignments and weddings that she quit her ad job and has been a full-time photographer ever since. Getting published is a high priority for Banfield, and her wedding images regularly appear in *Martha Stewart Weddings, Town & Country Weddings, Brides,* and *Elegant Bride.* She juggles wedding assignments with advertising shoots for clients such as Target and her editorial clients *People, Parenting, Better Homes & Gardens, Blueprint,* and *Southern Accents,* among others.

IN LIZ'S BAG: Three 35mm film camera bodies; 28–70mm *f*/2.8, two 50mm *f*/1.4, 85mm *f*/1.4, 80–200mm *f*/2.8 lenses; one medium-format camera with 80mm *f*/2.0 lens; two Speedlights. Everything fits into one roller bag that she takes onboard with her when she flies. Tripods, stands, and miscellaneous items (they vary from wedding to wedding) get checked into a long Lightware bag.

CAN'T LEAVE HOME WITHOUT: "My tripod. That wasn't always the case, but now I consider it essential."

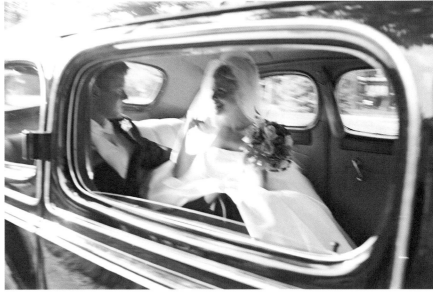

Virginie Blachère

LOCATION: New York City
IN BUSINESS: Weddings since 1998
FILM OR DIGITAL: Mostly film; digital for the reception
COVERAGE: Ten weddings a year; rest of time works on travel, editorial and commercial shoots

WEBSITE: www.imagesinguliere .com, www.virginieblachere.com
KNOWN FOR: Striking cinematic/ romantic documentary-style images that are timeless.

IN HER OWN WORDS: "I photograph what I feel, who I am, and what I love. My goal each time is to emotionally bond to the time and place and find a way to visually capture the essence of the moment in a wedding."

BACKGROUND: Photography has been a passion for the French-born Virginie Blachère since the age of twelve. She graduated from the University of California at Berkeley with a degree in art history and studied documentary photography at the Academy of Art in San Francisco. Later, she attended the International Center of Photography in New York and assisted a variety of fashion, still-life, and editorial photographers, including well-known *Town & Country* photographer Julie Skarratt. Blachère's photographs have been published in *grace ormonde Wedding Style*, *Elegant Bride*, *Manhattan Bride*, *Marriage*, *Modern Bride*, *New York* magazine, and *The Knot*, among others.

IN VIRGINIE'S BAG: Two 35mm Canon EOS cameras with (40D and 6D) L-series lenses (L16–35mm II, two 24–70mm L, 85mm L, 70–200mm L), one Canon digital camera, one Leica M6 with 35mm lens, two Hasselblad bodies with a 50mm, 80mm, and 120mm lens, two Holga cameras, one Diana camera, one Widelux panoramic camera; one tripod; one Quantum Turbo battery; three Canon Speedlight flashes (which include the 580 II); two Minolta light meters; one SpeedGraflex 4 x 5 camera (occasionally).

CAN'T LEAVE HOME WITHOUT: "My Leica M6 with a 35mm $f/1.4$ lens. I love the way it feels and fits in your hands, its quietness, the mechanics of it, and the luminosity of the lenses."

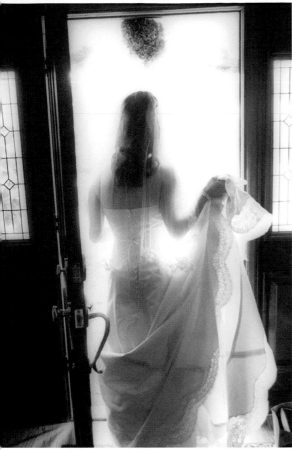
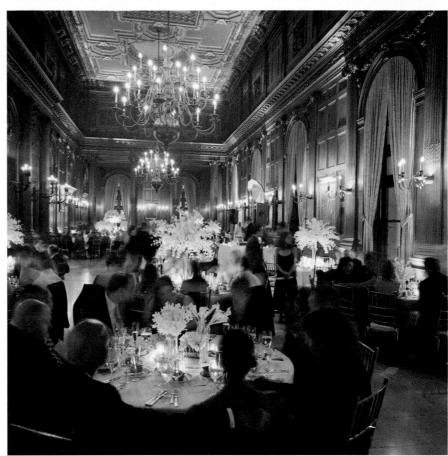

Chenin Boutwell

LOCATION: Ladera Ranch, California

IN BUSINESS: Weddings since 2002

FILM OR DIGITAL: Digital

COVERAGE: Thirty-five to forty weddings a year, plus about twenty-five portrait sessions

WEBSITE: www.boutwellstudio.com

KNOWN FOR: Fun, youthful, energetic imagery with an editorial feel.

IN HER OWN WORDS: "I work hard to make my photos about the couple, not about the trappings of a wedding. Maybe it's my personality, maybe it's something about the clients that I book, but there is definitely always a bit of unexpected quirkiness and a sense of whimsy in my images."

BACKGROUND: Chenin Boutwell and her husband, Doug, started their photography business in 2002 to "prove that wedding photos could be cool" and subsequently watched their bookings double every year as they worked to combine both documentary and fashion styles in their images. Over the years, Doug transitioned out of the business, and Chenin is now the sole photographer. She has no formal training in photography. In 2005, she received her law degree from Chapman University School of Law in Anaheim, California.

IN CHENIN'S BAG: A Canon 5D (main body) and a 20D (backup); mainly fast lenses—24mm, 50mm, and 85mm, as well as a 17–40mm *f*/4 and a 70–200mm, for ceremonies; two Speedlights, two portable video lights, and occasionally a deer light.

CAN'T LEAVE HOME WITHOUT: "There isn't anything. The images are about the people, not the equipment."

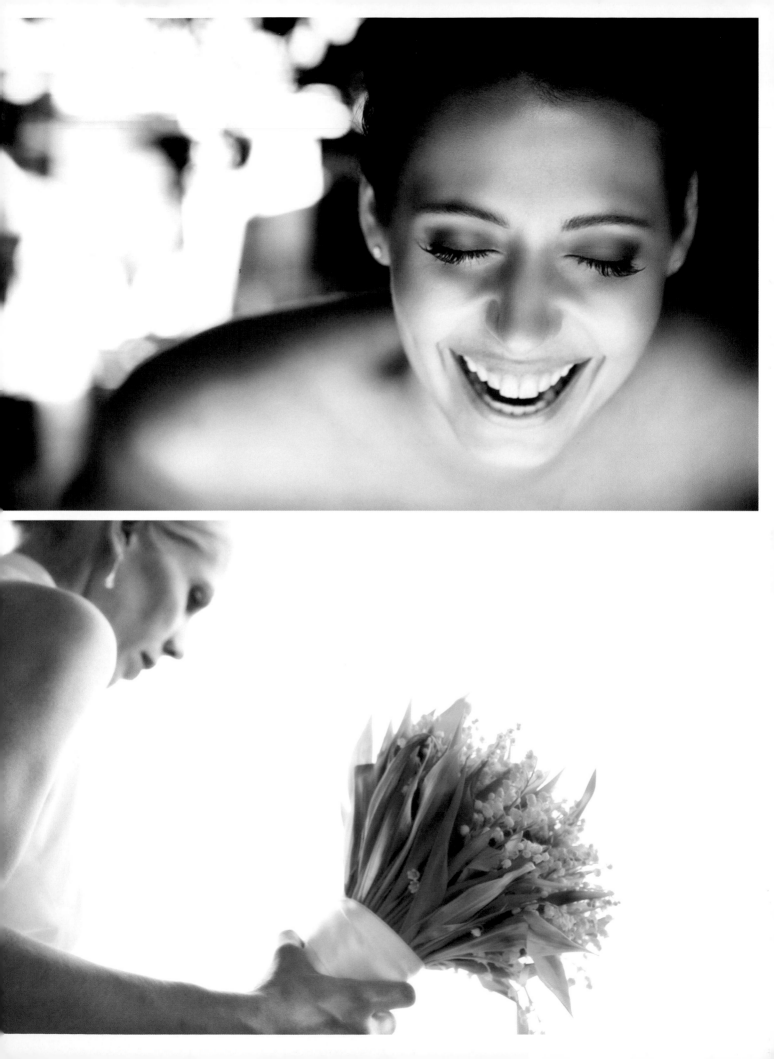

Philippe Cheng

LOCATION: New York City and Bridgehampton, New York

IN BUSINESS: Weddings since 1993

FILM OR DIGITAL: Both

COVERAGE: Twenty weddings a year

WEBSITE: www.philippechengweddings.com, www.philippecheng.com

KNOWN FOR: Dramatic and emotional photographs while capturing and documenting the small and large moments that define a wedding day.

IN HIS OWN WORDS: "Photographing a wedding is a challenge because you are creating images that are at once both extraordinarily personal and hopefully universal in spirit. I love this challenge because if you are successful, you can create remarkable images."

BACKGROUND: Philippe Cheng was born and raised in Manhattan, where he studied his craft at the School of Visual Arts and New York University. He later worked at Magnum Photo Agency in Manhattan before embarking on a career as a freelance photographer in the early nineties. His wedding photography career developed out of a photo-book project on Manhattan, which included images he took of street weddings. From those early images he was able to put together a portfolio and get hired to shoot weddings on a regular basis. His images have been published in *Elegant Bride, InStyle, The Knot, Martha Stewart Weddings, PDN,* as well as in the books *Forever and a Day: Wedding Moments* (Edition Stemmle), *Radiance* (Chronicle Books), *Town & Country: Elegant Weddings,* and *Vera Wang on Weddings* (HarperCollins).

IN PHILIPPE'S BAG: A Hasselblad, a Rolleiflex, a Canon Mark III, Canon G9; lots of black-and-white film, meter, reflector, flashes, memory cards.

CAN'T LEAVE HOME WITHOUT: "My Canon Mark III. If I went to a wedding with just that one camera, I'd still be able to do a great job because of the creative and technical range of the camera."

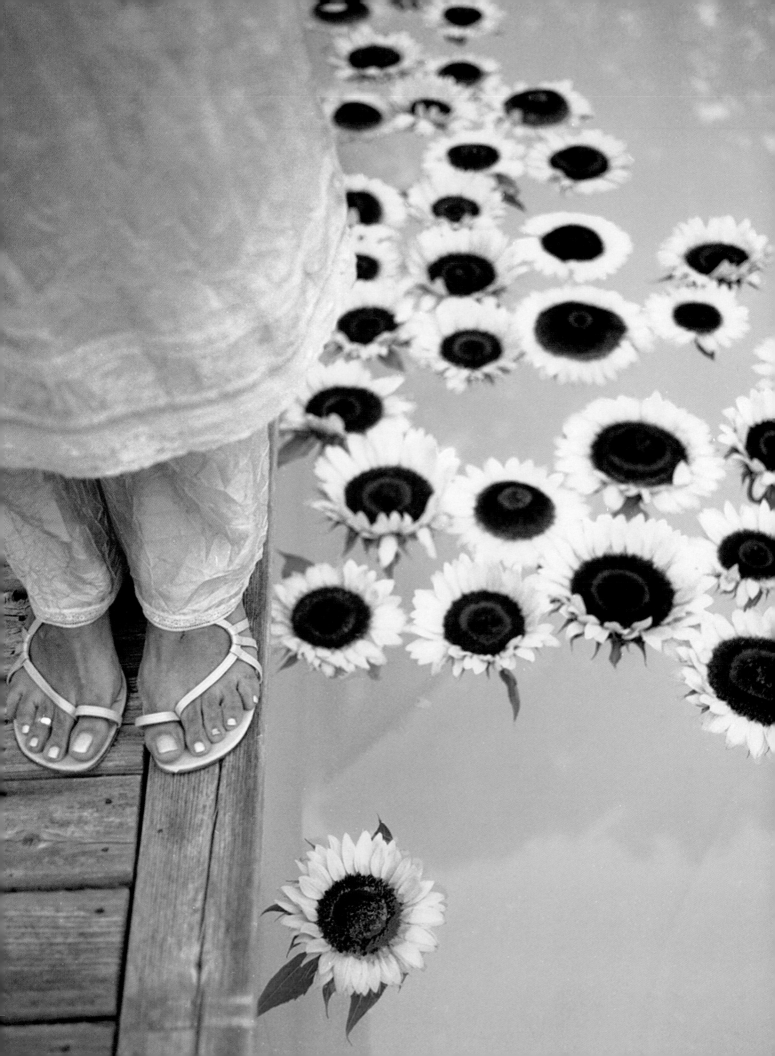

Suzy Clement

LOCATION: San Francisco
IN BUSINESS: Weddings since 1996
FILM OR DIGITAL: Both (25 percent digital and the rest film)
COVERAGE: Fifteen to twenty weddings a year
WEBSITE: www.suzyclement.com

KNOWN FOR: Finding beautiful environments in which to photograph a couple right after the wedding ceremony, and making it a really special time for them to absorb the gravity and wonder of what has just taken place between them.

IN HER OWN WORDS: "I have a passion for capturing the authenticity and genuine nature of a wedding, and I strive to create images that are beautiful and that emphasize the emotional substance of the moment—from the broad overview to the minute details—every time."

BACKGROUND: Suzy Clement studied photography at Wesleyan University in Connecticut, the Corcoran School of Art, Smithsonian Institute, and UC Berkeley. Her photography work has taken her across the country and around the world, and her images have been featured extensively in *Elegant Bride, Martha Stewart Weddings, InStyle, Brides, People, Wedding Bells, San Francisco* magazine, *Sunset* magazine, and in the books *InStyle Weddings* and *I Do! The Great Celebrity Weddings*. Clement was the only photographer selected for *Brides* magazine's "Best of 2006" list, and *San Francisco* magazine named her one of the "Bay Area's Best" wedding photographers.

IN SUZY'S BAG: Nikon 35mm and digital bodies and lenses; Mamiya 645 bodies and lenses; a couple of flashes; a handheld light meter; backup gear and lots of batteries, Clif bars, ibuprofen, Band-Aids, and a second pair of shoes.

CAN'T LEAVE HOME WITHOUT: "My handheld light meter."

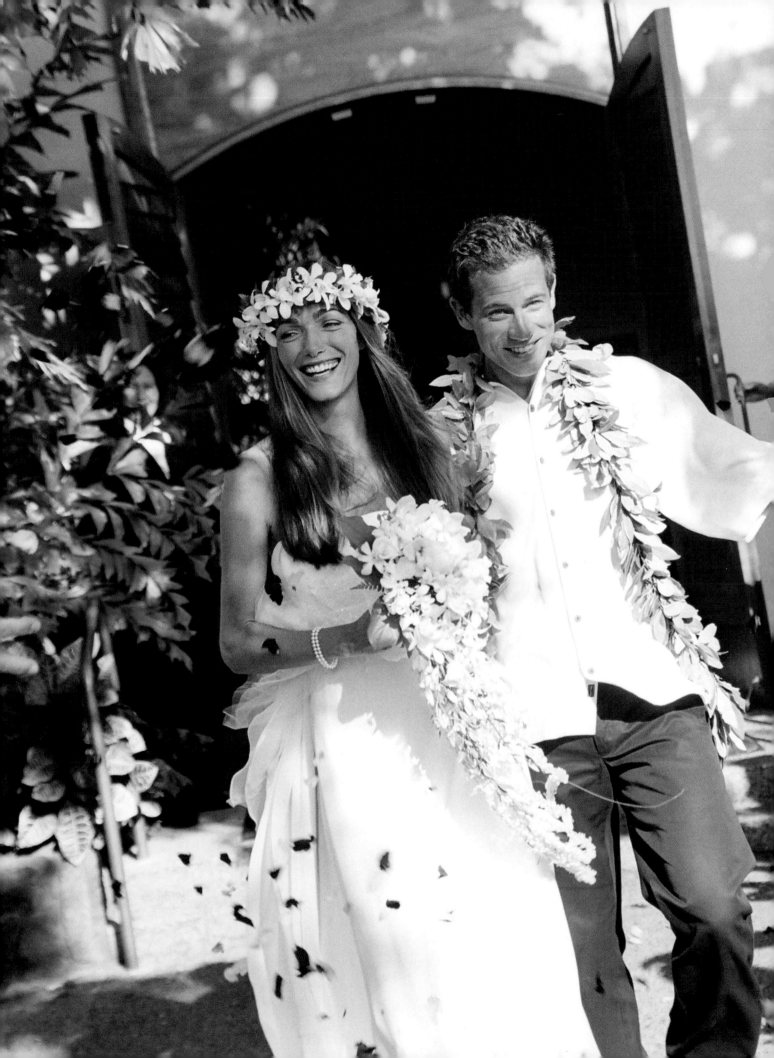

Mike Colón

LOCATION: Newport Beach, California
IN BUSINESS: Weddings since 1997
FILM OR DIGITAL: 100 percent digital (since 2001)
COVERAGE: Limits the number of weddings he personally shoots to fifteen per year, but his studio shoots more.

WEBSITE: www.mikecolon.com
KNOWN FOR: Digital wedding and lifestyle photography for high-profile and celebrity clientele. Colón's images embrace the spirit and emotions of a couple on their momentous day.

IN HIS OWN WORDS: "For me, photography is all about capturing life the way your heart sees it, and when you shoot from your heart, your work will always be your own—something no one else can copy."

BACKGROUND: Mike Colón's first real job in photography was doing general studio work, which gave him great experience working with people in groups. He shot sports teams, senior portraits, events, party formals, even group shots of Marines at Camp Pendleton. After working for a wedding photographer in California's Orange County, Colón started up his own business and has since traveled the world photographing some of the most extravagant and celebrity-driven weddings of the decade, including pop star Usher's wedding in September 2007. Colón's images have been published in numerous magazines, including on the cover of *People* magazine, *Essence, grace ormonde Wedding Style, Marriage, Studio Photography and Design, Rangefinder, Modern Bride, Photo District News, Popular Photography, American Photo, Shutterbug,* and *The Knot.* His work has been published in many books, including *The Best of Wedding Photojournalism,* and *The Best of Digital Wedding Photography.* In 2006, Nikon named Colón a "Legend Behind the Lens" and included his work in their permanent legends archive on nikonnet.com.

IN MIKE'S BAG: Nikon D3 camera bodies; Nikkor lenses—14–24mm f/2.8G ED AF-S zoom, AF-S 24–70mm f/2.8G ED AF-S. 200mm f/2G ED-IF AF-S VR; 70–200mm f/2.8G ED-IF AF-S VR zoom; 105mm f/2.8G ED-IF AF-S VR micro; 85mm f/1.4D AF; 50mm f/1.4 AF; 28–70mm f/2.8D ED-1F AF-S zoom; 17–55mm f/2.8G ED-IF AF-S DX zoom; 12–24mm f/4G ED-1F AF-S DX zoom, 10.5mm f/2.8G ED AF DX fisheye; TC-20E II (2X) AF-S, AF-I teleconverter. Also carries several Nikon SB-80 AF Speedlights. Portable theater: Epson Powerlite 1810P LCD projector, Epson 80-inch popup screen, MacBook Pro 17-inch laptop

DIGITAL DARKROOM: MacPros with Cinema displays, Epson Stylus Pro 3800, 4800, 7800; Mitubishi CP9550DW Dye-Sub

STORAGE: Model 692 Tamrac Big Wheels strongbox, Epson P5000 multimedia storage viewers, Lexar Pro 8GB 300x compact flash cards, 80GB Firelite mini external drives, 7.5TB Sonnet Sata Mirrored RAID enclosures.

CAN'T LEAVE HOME WITHOUT: "My D3 with my 85mm f/1.4 lens."

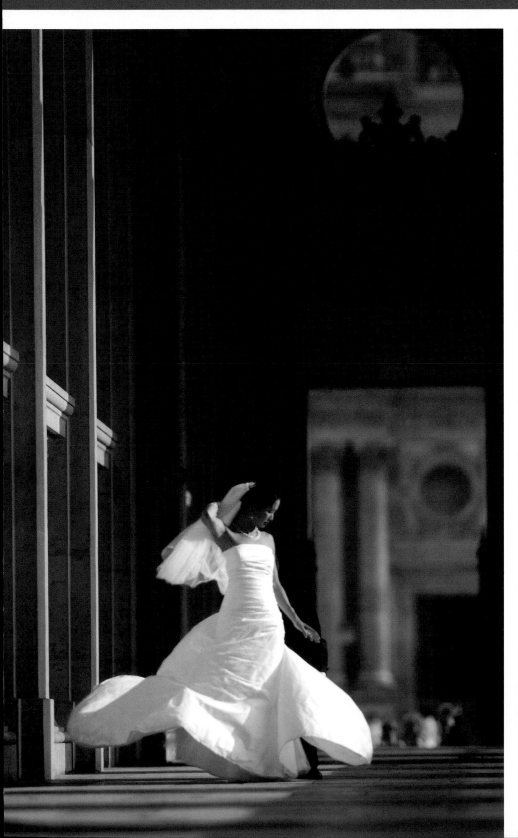
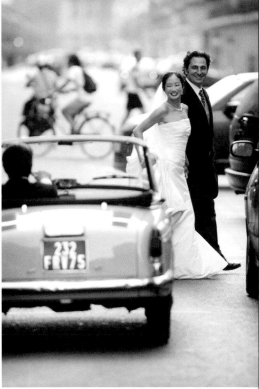
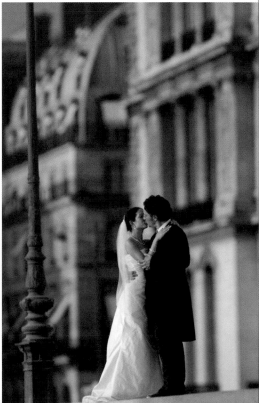

Amy Deputy

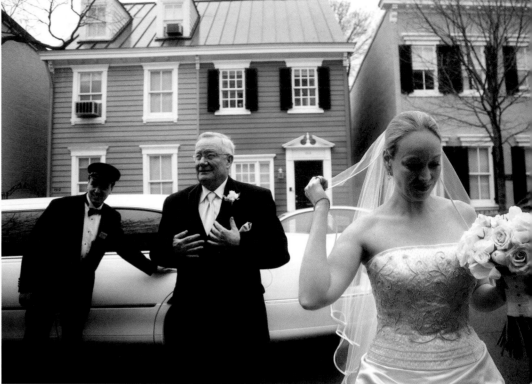

LOCATION: Sparks, Maryland
IN BUSINESS: Weddings since 2001
FILM OR DIGITAL: Digital
COVERAGE: Twenty-five to thirty weddings a year
WEBSITE: www.amydeputyphotography.com
KNOWN FOR: An evocative documentary style and use of available light.

IN HER OWN WORDS: "The most important role of the wedding photographer is to document the story from a place of stillness and to honor the immense courage to choose love."

BACKGROUND: Amy Deputy, a former award-winning photographer for the *Baltimore Sun* and the *Bremerton Sun*, got her photographic training at *National Geographic*, the *Sacramento Bee*, the *Chicago Tribune*, and the *Register-Guard* and was also a picture editor for the *Baltimore Sun*. After thirteen years in newspapers, she left the industry to launch Amy Deputy Photography LLC, her documentary-style wedding photography business. The switch came after she filled in last minute to shoot a friend's wedding—reluctantly—and she's been hooked ever since. Her wedding images have been featured in *Modern Bride, Washington Magazine, Baltimore Magazine, The Knot,* and *USA Today,* among others.

IN AMY'S BAG: Two Canon 5D cameras; 50 gigs of CF cards; 580 EX flashes; 35mm *f*/1.4, 70–200mm *f*/2.8, 50mm *f*/F1.4, 85mm *f*/1.8 17–25mm *f*/2.8, 24–105mm *f*/4, 135mm *f*/2 lenses; Lensbaby; radio remotes.

CAN'T LEAVE HOME WITHOUT: "Almond butter and blackberry jelly bagel sandwiches."

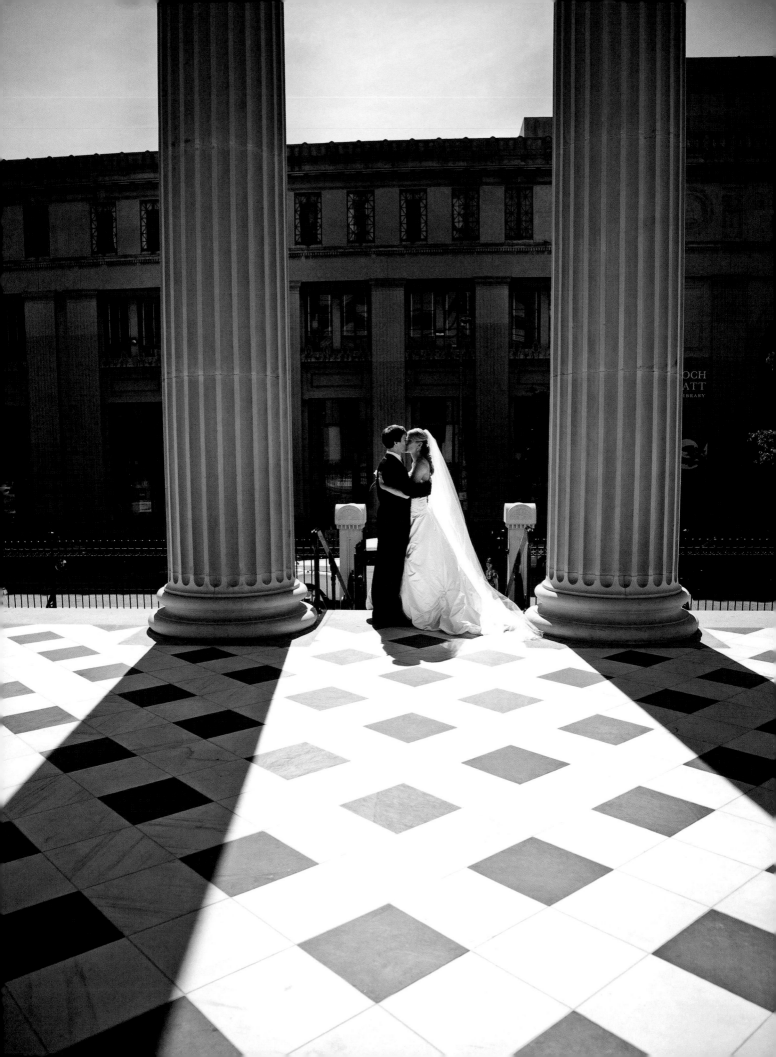

Shannon Ho

LOCATION: Norman, Oklahoma
IN BUSINESS: Weddings since 2002
FILM OR DIGITAL: Digital since 2002
COVERAGE: Twenty weddings a year
WEBSITE: www.shannonho.com
KNOWN FOR: Asking questions and developing a relationship and friendship with her clients and their families to elicit true emotions in her images. She also offers unique in-house custom-designed save-the-date cards, thank-you cards, rehearsal dinner cards, etc., all corresponding to the look and feel of the client's wedding day.

IN HER OWN WORDS: "A good wedding photographer can draw on his or her expertise of searching out beautiful light to capture beautiful images. That way, it doesn't matter if the location is unattractive or the most stunning of venues; you will still always be able to capture amazing images."

BACKGROUND: Shannon Ho was first introduced to photography with the help of an art teacher at an early age. She continued to pursue this passion throughout high school and college, where she received a degree in photography from Baylor University. Upon graduating, Ho moved to Dallas, where she assisted and worked with photographer Stewart Cohen for two years. She then returned to her hometown of Norman, Oklahoma, with her husband, Steve, who is also her business partner, and launched her documentary-style wedding and portrait photography studio.

IN SHANNON'S BAG: Canon 1D Mark III body, Canon 1D Mark II; Canon 85mm $f/1.2$, 50mm $f/1.4$, 24–70mm $f/2.8$, 70–200mm $f/2.8$ IS lenses; two 580EX Canon flashes, Lowel iLIGHT, California Sun Bounce reflector, Scrim Jim

CAN'T LEAVE HOME WITHOUT: "My Canon 85mm $f/1.2$ lens, since I enjoy shooting natural light as much as possible."

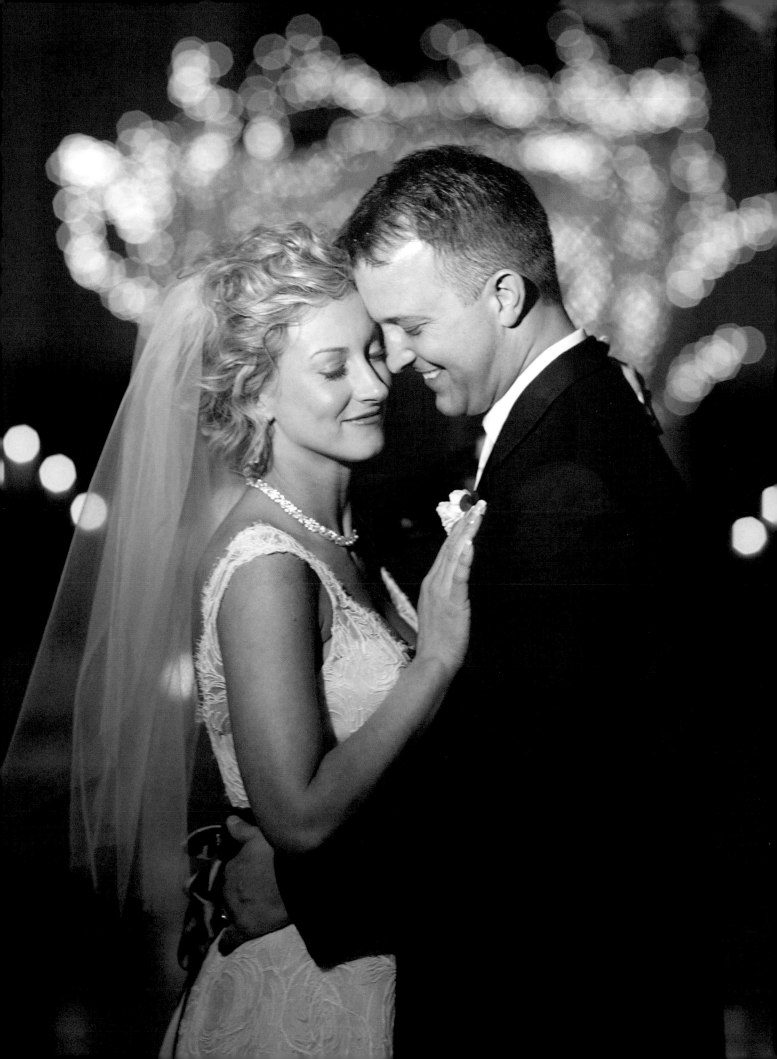

Jesse Leake

LOCATION: San Francisco

IN BUSINESS: Weddings since 2001

FILM OR DIGITAL: Both

COVERAGE: Thirty to forty weddings a year

WEBSITE: www.jesseleake.com

KNOWN FOR: Fresh, edgy, creative, fun, beautiful, warm, and innovative candid images.

IN HIS OWN WORDS: "My photography style consists of esthetically captivating, natural, comprehensive documentation sensitively expressed utilizing color, motion, composition, and light to accentuate what I see."

BACKGROUND: Jesse Leake lives in San Francisco and photographs weddings both near and far. He attended San Francisco State University and the Academy of Art (San Francisco), where he studied filmmaking. In 1999, he moved to Los Angeles for a year to get into the film industry. His photography career began in 1999 when a friend who was producing music videos needed a still photographer on the set. Leake eventually moved back up north and started assisting a few commercial photographers. After shooting several weddings for family and friends, Leake launched his wedding photography website, and the rest is, as he says, history. Leake's work has been published in *InStyle, PDN, Popular Photography, grace ormonde Wedding Style, Elegant Bride, Martha Stewart Weddings, The Knot, San Francisco* magazine, *Travel and Romance, Modern Bride, Wedding Bells, Here Comes the Guide, Digi Foto, Our Wedding Day, Destination Weddings & Honeymoons, Today's Bride,* and the book *Pottery Barn Photos.*

IN JESSE'S BAG: Four Canon EOS 35mm bodies, two Canon digital 5D bodies; Canon 16–35mm $f/2.8$, 24–70mm $f/2.8$, 70–200mm $f/2.8$ and 50mm $f/2.5$ macro lenses; two Canon 580 ex flashes, Sekonic 508 light meter; Manfrotto carbon fiber tripod with grip action head; step ladder.

CAN'T LEAVE HOME WITHOUT: "The 24–70mm $f/2.8$ lens gets the most use."

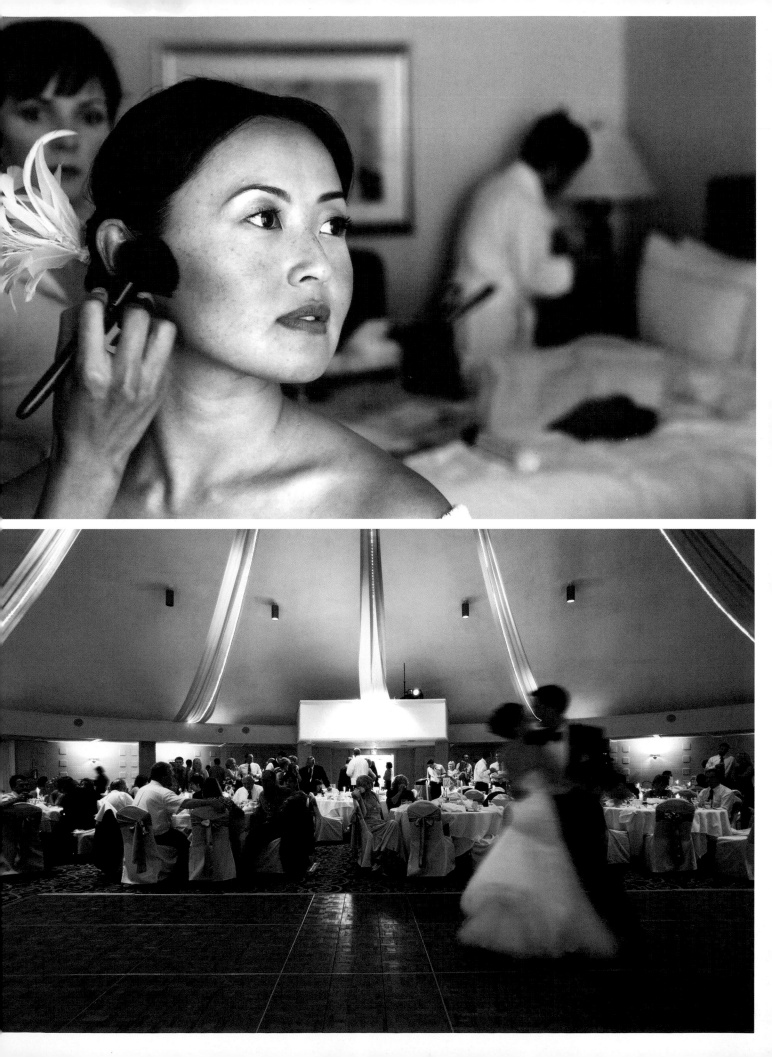

Kathi Littwin

© Joanna Wilson 2007

LOCATION: Brooklyn, New York
IN BUSINESS: Weddings since 1997
FILM OR DIGITAL: Both
COVERAGE: Twenty to thirty weddings a year
WEBSITE: www.kathilittwin.com
KNOWN FOR: Artistic, detail-driven imagery that evokes the mood and feelings of the wedding day.

IN HER OWN WORDS: "I approach each wedding more like a filmmaker. First, there is a story to tell about the two people and their friends and family coming together for a special occasion. Second, the story needs to have a sense of place, with a lot of attention paid to color and style elements. Finally, all the images must be edited together in a stunning and cohesive package."

BACKGROUND: Kathi Littwin received her degree in photography from the School of Visual Arts in Manhattan. She has been photographing weddings for over ten years and brings her artistic vision to each event: Eloquent visual narratives are primarily candids, complemented by formals, still lifes, and scenics in both black and white and color. She is an internationally recognized fine-art photographer with an extensive exhibition background. Her images have been published in *Elegant Bride, Modern Bride, Modern Bride New York, Bridal Guide, The Knot,* and *New Jersey Bride.*

IN KATHI'S BAG: Several camera bodies (Nikon F100 for film; Canon 5D for digital); 28–105mm, 85mm *f*/1.4, 80–200mm *f*/2.8, 17–55mm *f*/2.8 lenses; a video light.

CAN'T LEAVE HOME WITHOUT: "My 85mm *f*/1.4 lens and TMZ 3200 film."

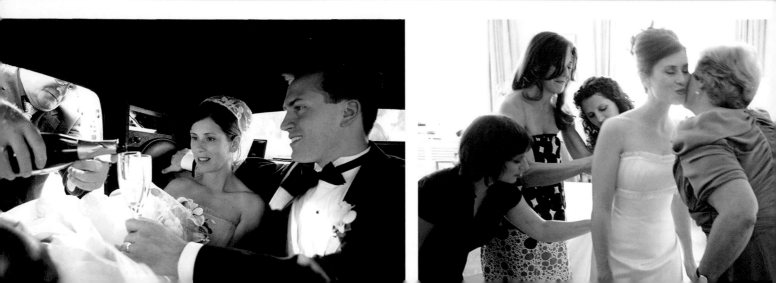

Charles and Jennifer Maring

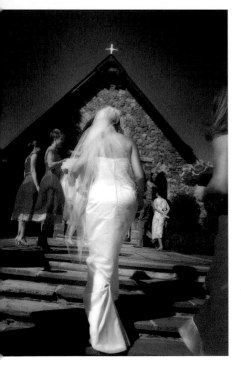

LOCATION: Wallingford, Connecticut, and New York City

IN BUSINESS: Weddings since 1989

FILM OR DIGITAL: Digital

COVERAGE: Forty-five weddings a year

WEBSITE: www.maringphoto.com

KNOWN FOR: Capturing some of the biggest celebrity weddings in history but at the same time offering their signature style and passion for photography to couples of all different budgets and from all walks of life.

IN THEIR OWN WORDS: "We call our style Photo-Expressionism. Just as artists like van Gogh and Matisse did by painting with stronger lines and colors to place emphasis on what the subject is feeling, we do with our photographs: We capture reality but enhance the imagery to showcase the inner experience of each fleeting moment."

BACKGROUND: Charles Maring is a second-generation photographer; his father was a serious amateur who turned pro later in life. Charles grew up with a darkroom in the house, always knowing that he would be a photographer in one genre or another. Celebrity photographer and lifestyle expert Jennifer Maring started her career in a small town in Connecticut, photographing one small, intimate wedding at a time. The two teamed up over fifteen years ago and are considered to be among the world's leading experts in wedding photography. They've been published in *People, Modern Bride, InStyle, grace ormonde Wedding Style, Inside Weddings,* and *Bridal Guide,* among many other publications. They have photographed several high-profile weddings, including Donald and Melania Trump's "Wedding of the Century" and Star Jones's and Al Reynolds's *InStyle* Wedding of the Year. In 2007, the Marings were part of *Brides* magazine's "Dream Team" as the photographers for a dream wedding of a lifetime at Walt Disney World in Florida.

IN THEIR BAG: Two Canon EOS 1D Mark 111 cameras; 16–35mm *f*/2.8, 24–70mm *f*/2.8, 85mm *f*/1.2, 70–200mm *f*/2.8, lenses; three 580EX Speedlights, Quantum Tfdr flash.

CAN'T LEAVE HOME WITHOUT: "The 85mm *f*/1.2 lens. We could photograph an entire wedding with it due to its low-light capabilities."

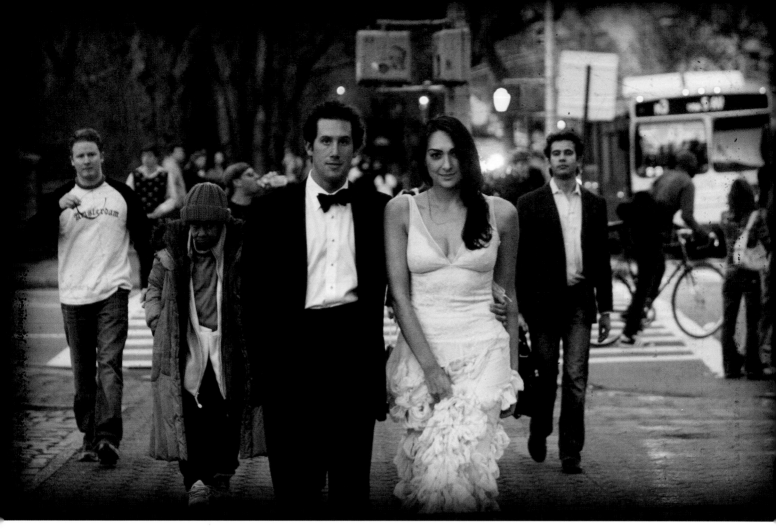

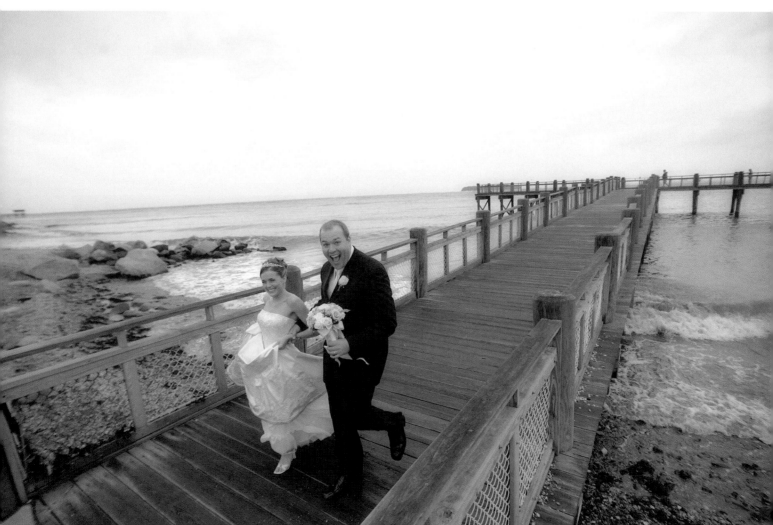

Melissa Mermin

IN HER OWN WORDS: "I love images that make people laugh and disturb the senses a bit, like great art does. I always walk a fine line at weddings of making images that please my client and making images that are personal to me. They are commissioning your vision."

BACKGROUND: Before photographing people professionally, Melissa Mermin was an in-house product photographer for a design company. In 1996 she was hired to shoot her first wedding and has since had a passion for capturing perfect moments through a camera. She received her BFA in painting from Massachusetts College of Art and soon after studied photojournalism under *Boston Globe* photographer Janet Knott. In 2003, Mermin partnered with Earl Christie to form the team of Mermin + Christie Photographers. She now works independently again, under the company name Melissa Mermin LoveStories.

IN MELISSA'S BAG: Two Canon 5Ds, 16–35mm *f*/2.8, 85mm *f*/1.4, 50mm *f*/1.4, 80–200mm *f*/4 IS, Canon 580 flash with a few diffusers, a few PocketWizards, wires and gizmos, lots of batteries and chargers, lots of 4-gig flash cards, an Epson 4000 storage viewer, and a 15-inch Macbook Pro laptop for editing. Stands and umbrellas for portraits using flash go in a separate bag. (For dark hotel weddings, Mermin rents Dyna-Lites with extra long cords or uses her Canon flashes on stands and slaves them.)

CAN'T LEAVE HOME WITHOUT: "The Canon 5D, my 16–35mm *f*/2.8 lens, and my 85mm *f*/1.4 lens. I could shoot an entire event with just those if I had to."

LOCATION: Boston and San Francisco
IN BUSINESS: Weddings since 1996
FILM OR DIGITAL: Digital since 2003
COVERAGE: Twelve to fifteen weddings a year
WEBSITE: www.melissamermin.com

KNOWN FOR: Withdrawing into the background to capture spontaneous and fun candid moments and telling a great visual story. Seeking out late afternoon sunlight on her subjects, or creating artificial "sunlight" using off-camera strobes in drab and dark places.

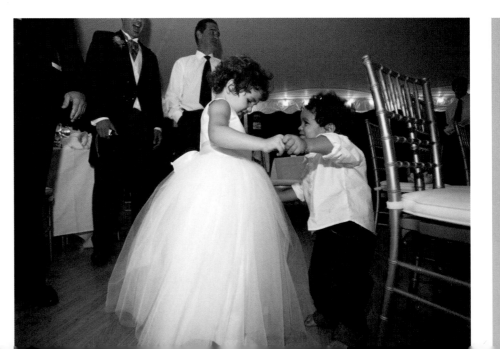

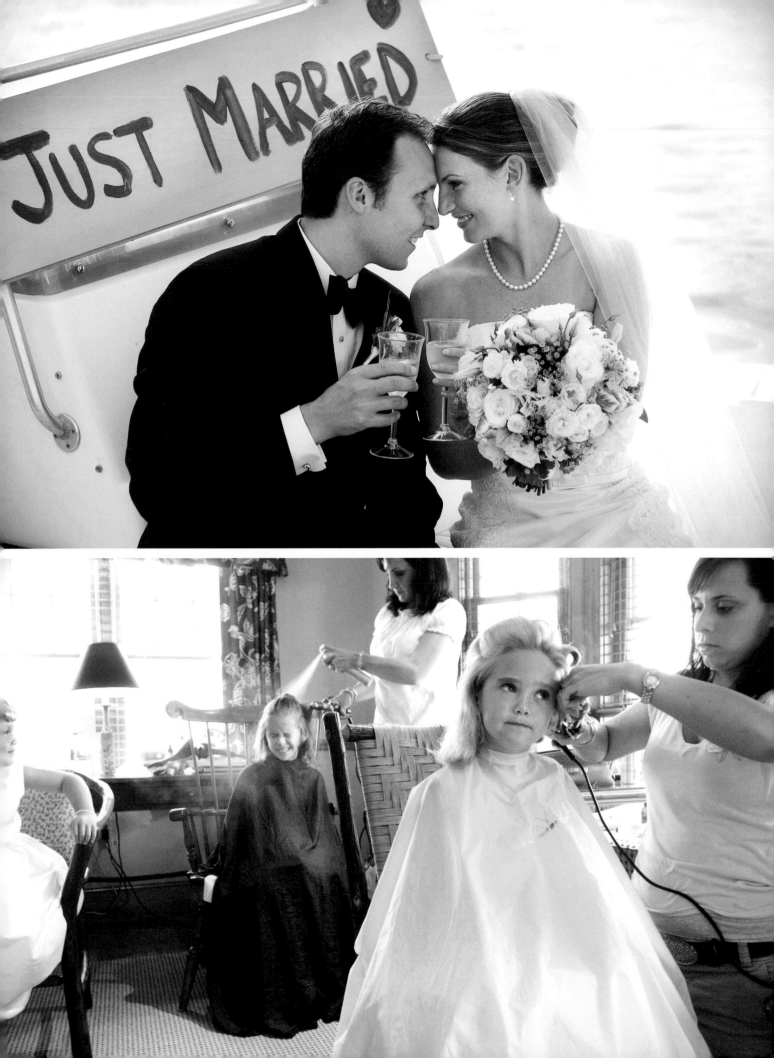

Elizabeth Messina

IN HER OWN WORDS: "Photography is the language of memories. Images are little time capsules that honor life's most beautiful moments and help preserve our memories. I love the intimacy of wedding photography. It's an honor to capture the emotion of a couple's unfolding love story."

BACKGROUND: Elizabeth Messina, who earned her BFA with honors from the San Francisco Art Institute, is now regularly sought after for her compelling wedding photographs. Her work takes her all around the world, and her images, both of touching, intimate weddings as well as high-profile celebrity nuptials, have graced the pages of countless magazines, including *Town & Country, Elegant Bride, InStyle, Santa Barbara* magazine, *Los Angeles Weddings, People* magazine, *grace ormonde Wedding Style, Martha Stewart Weddings,* and *Us Weekly.* Her images have been featured on *The Oprah Winfrey Show, Entertainment Tonight,* the Oxygen Channel, and the Fine Living Network.

IN ELIZABETH'S BAG: Contax 645, Canon EOS A2, Nikon FE2, and a couple of Holgas; Fuji Color NPZ 800, Ilford Delta 3200, Kodak Portra 400.

CAN'T LEAVE HOME WITHOUT: "My Contax 645 and film. My camera is more than a piece of equipment; it's an extension of me."

LOCATION: Southern California

IN BUSINESS: Weddings since 1999

FILM OR DIGITAL: 95 percent film; stores files digitally

COVERAGE: Twenty weddings a year

WEBSITE: www.elizabethmessina.com

KNOWN FOR: An innate sense of style and sensitivity that translates into sweetly sophisticated, elegant imagery.

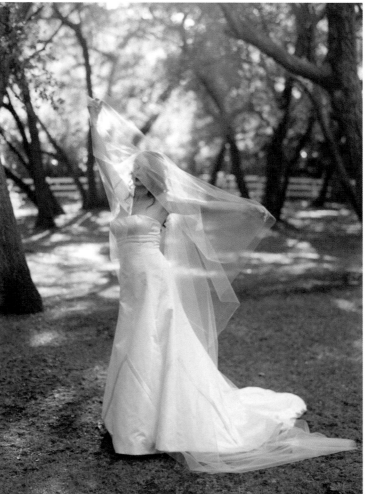

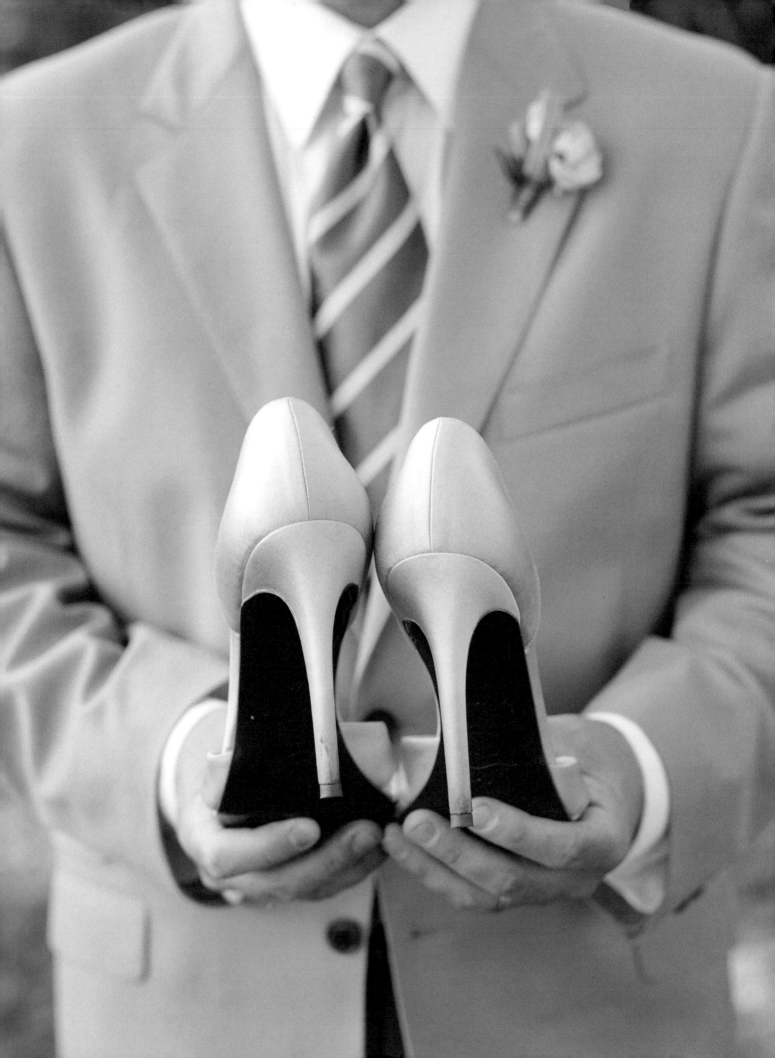

Melanie Nashan

LOCATION: Livingston, Montana

IN BUSINESS: Weddings full-time since 2001

FILM OR DIGITAL: Digital

COVERAGE: Fifteen to thirty weddings a year/five associate photographers operate out of California, Florida, and Montana.

WEBSITE: www.nashan.com

KNOWN FOR: Nontraditional wedding portraits that reflect a sense of place.

IN HER OWN WORDS: "When I'm looking through my camera, I'm always trying to create pieces of art that I would want to hang on my wall if I were the client. Photography is my passion, and I find great satisfaction in helping to create family histories."

BACKGROUND: Born in New Jersey and raised in Florida, Melanie Nashan used to flip through the pages of *National Geographic* magazine and dream of becoming a photographer. She eventually studied photography full time, earning her BFA from Cal State Long Beach and her MFA from Vermont College. She started shooting weddings sixteen years ago to earn supplemental income. In 2001, Nashan's first published wedding appeared in *Martha Stewart Weddings,* landing her on the "real weddings" editorial map. Her images have run in *Modern Bride, The Knot, Elegant Bride, Brides* magazine, and *Martha Stewart Weddings.*

IN MELANIE'S BAG: Canon 5D camera, Canon 20D (backup), Canon D60 (converted to infrared); Canon 50mm *f*/1.5, Canon 85mm *f*/1.8, Canon 20–35mm, Canon 24–70mm, Canon 70–200mm, Canon 180mm macro lenses; 580 EX, 550 EX (backup) flashes; twelve memory cards marked with name and phone number; Lexar FireWire card reader; Quantum Turbo Z batteries, extra rechargeable batteries for camera, flash, and computer; Swiss Army Card, manuals for cameras and flashes, business cards, peppermint breath drops, lipstick, and ibuprofen.

CAN'T LEAVE HOME WITHOUT: "My Canon 5D; I could cover a wedding with any lens on it. I always take my laptop and show slideshows during the reception of the images taken earlier that day."

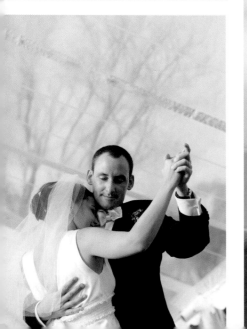

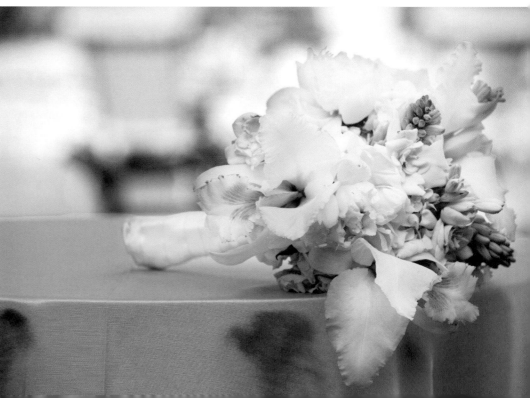

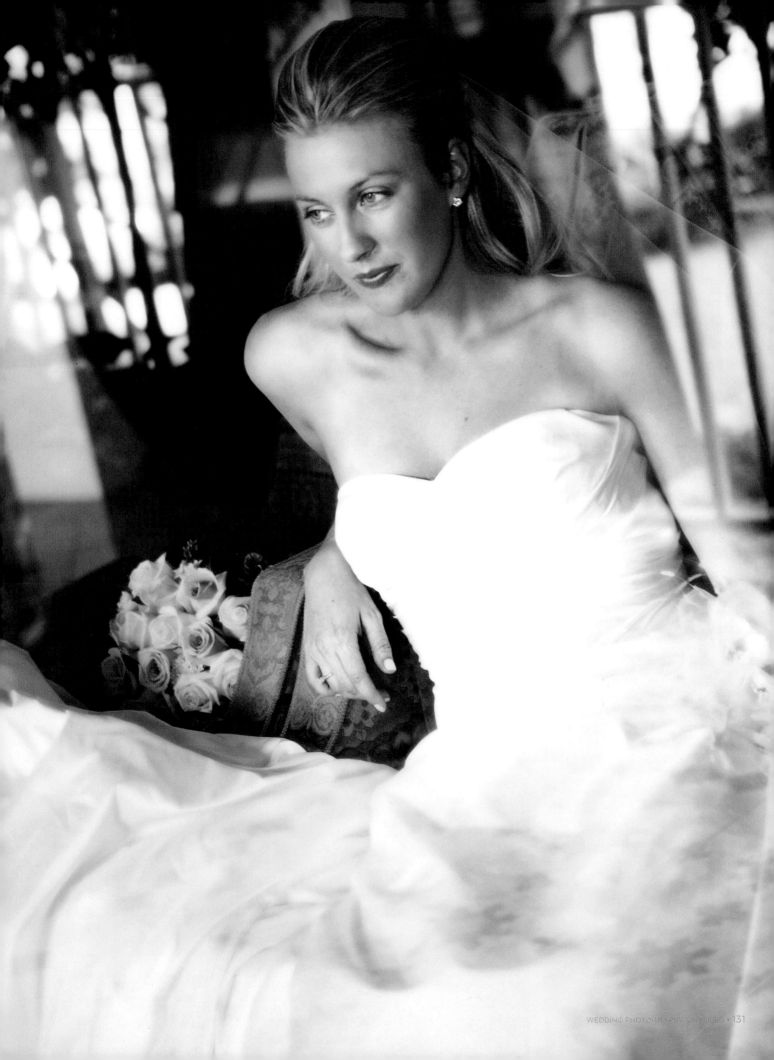

Christian Oth

© Brad Paris

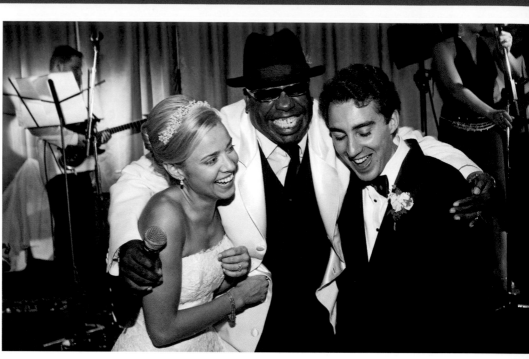

LOCATION: New York City
IN BUSINESS: Weddings since 2001
FILM OR DIGITAL: Digital
COVERAGE: Twenty-five weddings a year/Oth Studio, over 100 weddings a year
WEBSITE: www .christianothweddings.com
KNOWN FOR: Hip, edgy images captured with a roving, unobtrusive eye. Oth has worked in several photography genres over the years—photojournalism, portrait, fashion, still life—all of which have contributed to the development of his documentary-style wedding photography.

IN HIS OWN WORDS: "I have a natural shooting style that doesn't leave anything out. I watch the whole story unfold—the quiet times, the telling details, and the unique personalities."

BACKGROUND: Austrian-born Christian Oth studied photography at the International Center of Photography (ICP) in Manhattan in the early nineties. After starting his photography career, he quickly emerged as one of the city's top fashion and portrait photographers and became a regular contributor to the *New York Times* magazine. In 2001, Oth began photographing weddings and in 2005 opened his own boutique studio in New York City's Chelsea district. His images have been featured in *Martha Stewart Weddings, InStyle,* and *New York* magazine, and in 2007 *American Photo* magazine named him one of the "Ten Best Wedding Photographers in the World."

IN CHRISTIAN'S BAG: Canon 1Ds Mark III, Canon 1D Mark III cameras; Canon 24–70mm, 35mm *f*/1.4, 85mm *f*/1.2, 50mm *f*/1.4, 70–200mm *f*/2.8, 16–35mm *f*/2.8 lenses; 4GB SanDisk Extreme4 cards, two 580 EX2 flashes with Omnibounce, AA batteries, one extra battery for the Canons. Assistant bag & stand bag: One Profoto 600WS Acute battery power pack, one extra battery; one Profoto Acute head, one umbrella, one grid set; one stand tripod, one Frezzi light, two Bescor batteries; one reflector, one PocketWizard set, one Minolta4 light meter, one Super Clamp. On-site computer equipment in extra bag: One MacBook Pro, two SanDisk card readers, one backup drive, two FireWire 800 cables, one FireWire 800-400 cable, power supply for MacBook.

CAN'T LEAVE HOME WITHOUT: "My 24–70mm, my 35mm *f*/1.4—it allows me to shoot in any light and has a very beautiful shallow depth of field—and my 85mm *f*/1.2 lens for portraits."

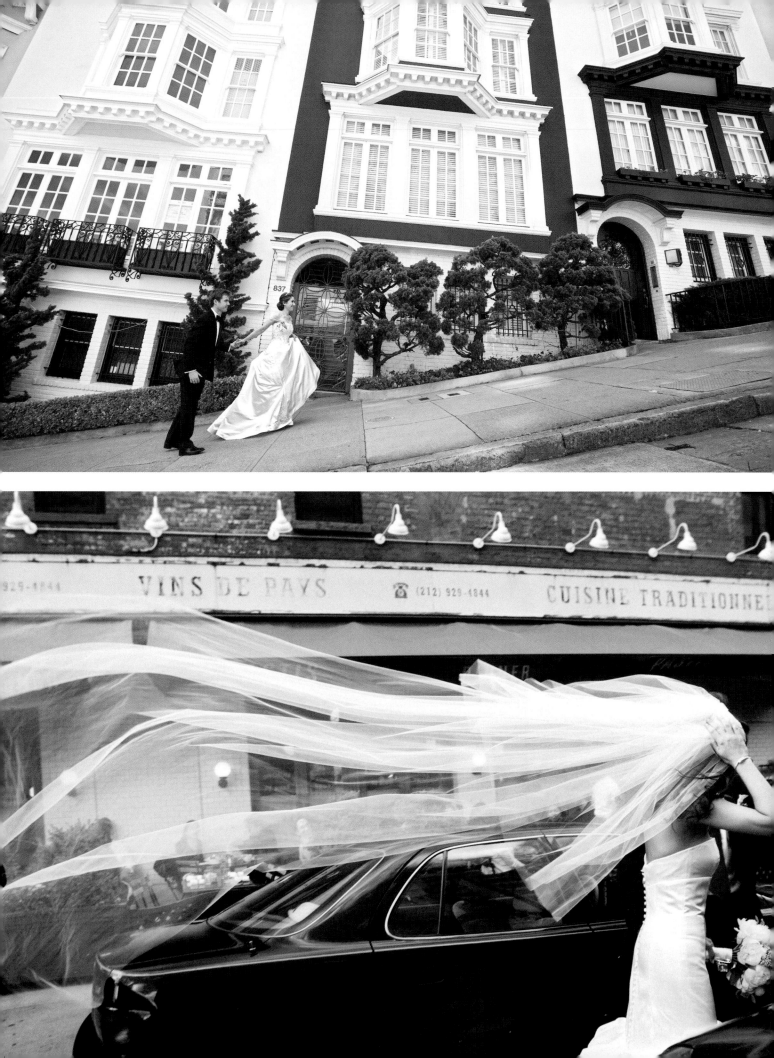

© Ryan Joseph

LOCATION:
Asheville, North Carolina
IN BUSINESS:
Weddings since 2000
FILM OR DIGITAL:
Mostly digital, but he still uses special film cameras like a swing lens panoramic and vintage RF film camera.
COVERAGE: Eighteen to twenty weddings a year
WEBSITE:
www.parkerjphoto.com
KNOWN FOR: Fine-art, photojournalistic, fashion, and avant-garde weddings with a vintage feel.

IN HIS OWN WORDS: "I am a photographer because I have to be. I photograph for my soul; my images have soul."

BACKGROUND: Parker J. Pfister shot his first wedding in 1984 when he was a sophomore in high school. After spending several years shooting weddings part-time with his dad, he decided it wasn't his bag because clients didn't like his "candids." Back then, he explains, clients still wanted the "standard smile-by-the-cake" shots. Seven years ago, Pfister returned to wedding photography, coming in with digital from a large-format background and with more of a fine-art approach. In July 2007, he photographed super-chef Wolfgang Puck's wedding on the Italian island of Capri. Pfister represents Canon's Explorer of Lights Program as well as their PrintMasters program. His wedding images have been published in several magazines, including *Modern Bride, Today's Bride, Rangefinder,* and *Studio Photography and Design,* as well as many photographic books.

IN PARKER'S BAG: Two Canon Mark11Ns and a 5D camera; lots of lenses—24mm $f/1.4$, 35mm $f/1.4$, 50mm $f/1.2$, 135mm $f/2$, 200mm $f/1.8$, 16–35mm $f/.8$, 24–70mm $f/2.8$, 70–200mm $f/F2.8$; and a couple of flashes.

CAN'T LEAVE HOME WITHOUT: "Glasses! And any of my fast lenses: 50mm $f/1.2$, 85mm $f/1.2$, 24mm $f/1.4$—that's all I need."

Ben Quillinan

© Rachel Richards

LOCATION: Phoenix, Arizona
IN BUSINESS: Weddings since December 2002
FILM OR DIGITAL: Digital
COVERAGE: Thirty weddings a year
WEBSITE: www.bqphotography.com
KNOWN FOR: Technically clean images that have a bit of an edge.

IN HIS OWN WORDS: "Through my background in photojournalism, I unobtrusively document each moment, capturing the essence and emotions of the day: the ceremony, formal portraits, and spontaneous moments that are too often forgotten or never seen. With each wedding, I tell an intimate and timeless story."

BACKGROUND: Ben Quillinan studied photography at Salt Lake Community College in Utah and then moved to New York City to further his career and develop his creative style. He assisted several editorial photographers, including Hugh Kretschmer and Nathaniel Welch, and took his first bridal portraits in December 2002. His work has appeared in *Arizona Weddings, Phoenix Bride and Groom, Arizona Bride, Wedding Chronicle,* and *AZ Society* (Arizona) as well as some national publications: the *New York Times, The Knot,* and *Professional Photographer* magazine.

IN BEN'S BAG: Canon 1D Mark III, Mark II, and 30D cameras; 24–70mm f/2.8, 70–200mm f/2.8 IS, 16–35mm f/2.8, and 50mm f/1.4 lenses; two 580EX II flashes with remote transmitter, two Quantum Turbo battery packs for the flashes, the Gary Fong Lightsphere ("love that thing"), and 20 gigs worth of CF cards. Also always bring 17-inch MacBook Pro and a portable lighting kit with two heads and umbrellas for formal portraits and reception lighting.

CAN'T LEAVE HOME WITHOUT: "Other than my camera, I have a pretty tight set of equipment, so I wouldn't want to leave home without any of it."

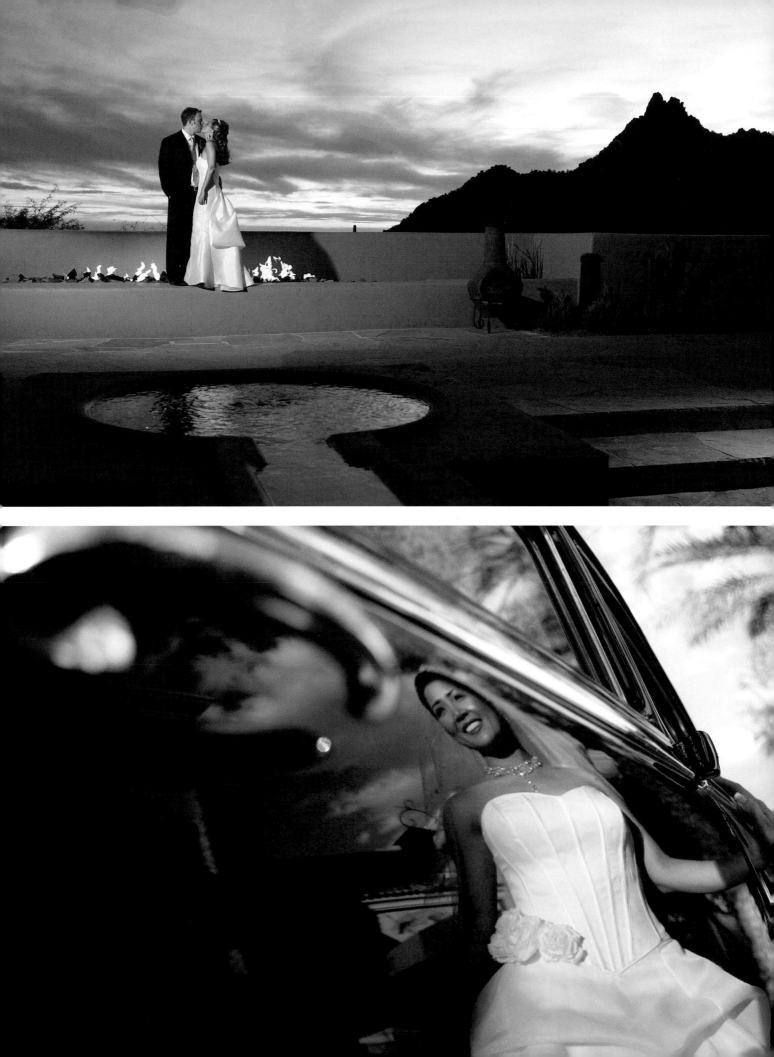

Meg Smith

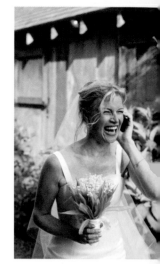

LOCATION: Napa Valley, California
IN BUSINESS: Weddings since 1995
FILM OR DIGITAL: Film, but she scans all of her negatives so she can submit work to magazines.
COVERAGE: Twenty to twenty-five weddings a year
WEBSITE: www.megsmith.com
KNOWN FOR: Candid photography using as much natural light as possible.

IN HER OWN WORDS: "I've been told there's a deceptive simplicity to my wedding photography. I'm not into gimmicks or special techniques. I just try to capture something special and do it without a lot of hoopla."

BACKGROUND: Born and raised in the Napa Valley in a winemaking family, Meg Smith started out doing documentary photography as an art history major at UC Berkeley, where her coverage included Gulf War riots, marches, and a project on sorority life. Smith credits her art history background with giving her "fluency" in the visual language of composition, lighting, contrast, and the decisive moment. She regularly contributes to *Martha Stewart Weddings, Town & Country,* and *Elegant Bride* and has photographed high-profile and celebrity weddings for *InStyle* magazine.

IN MEG'S BAG: Three to five Mamiya 645s and a variety of lenses; three to five Nikons, mostly F-100s, lots of 220 and 35mm black-and-white film, particularly Kodak TriX 400 and TMZ 3200 (for low-light); color film (Fuji NPH 400, ISO 800, or 1600 in low-light situations); titanium tripod; Mamiya macro lens for detail shots.

CAN'T LEAVE HOME WITHOUT: "My Nikon 85mm *f*/1.4 lens. You can be really unobtrusive with this lens and capture great candids with it."

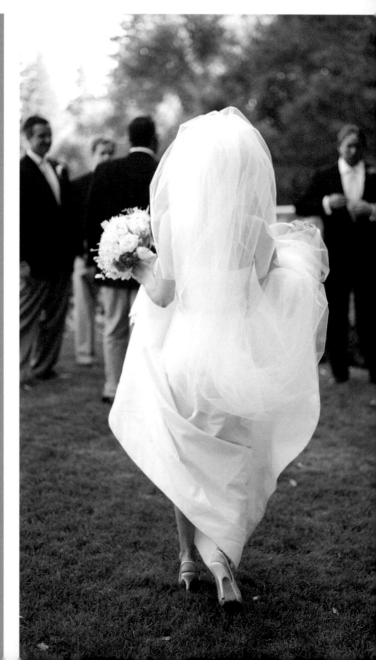

Amanda Sudimack

© Artisan Events, Inc.

LOCATION: Chicago
IN BUSINESS: Weddings since 1998
FILM OR DIGITAL: Both
COVERAGE: Fifteen weddings a year/Artisan Events, nearly 100 a year
WEBSITE: www.amandasudimack.com, www.artisanevents.com
KNOWN FOR: A fine-art esthetic, creative vision, and great attention to moments and details that capture the essence of the wedding day.

IN HER OWN WORDS: "My goal is for my clients to look at a picture of their feet and say 'that's so us,' or to see something else that sums up themselves or their relationship in the work in a very personal and real way."

BACKGROUND: Amanda Sudimack began her wedding photography business after receiving her BFA from the School of the Art Institute of Chicago (SAIC) and assisting for internationally acclaimed photographer Barbara Crane. In 1997, Sudimack opened her own studio, Artisan Events, and did corporate work and portrait sessions and photographed weddings for family and friends. She has been published in *grace ormonde Wedding Style, Inside Weddings, CS, Modern Bride, Brides, Chicago* magazine, *Wedding Bells, The Knot, The Knot Best of Weddings* magazine, and others.

IN AMANDA'S BAG: The shortlist: Canon 5D cameras; 16–35mm *f*/2.8, 24–70mm *f*/2.8, 70–200mm *f*/2.8, 50mm *f*/1.4, 85mm *f*/1.8 lens;, Lensbaby; CF cards, battery packs, extra battery clips, extra batteries, card reader, and cord; two tripods, five tripod plates, one monopod, PocketWizards, and cords; three Lightspheres, two umbrellas, two sets of umbrellas clips, one large fill/shade kit, one light reflector, two light stands, one digital color target. Medium format: Hasselblad 503CW body, one prism, two A12 backs; 50mm, 80mm, and 120mm lenses; 120 film; Holga toy camera.

CAN'T LEAVE HOME WITHOUT: "My 16–35mm *f*/2.8 lens; it's my gold standard. I can shoot 70 percent of the day with my favorite lens."

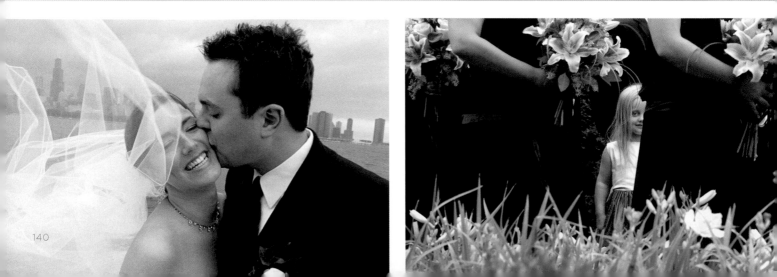

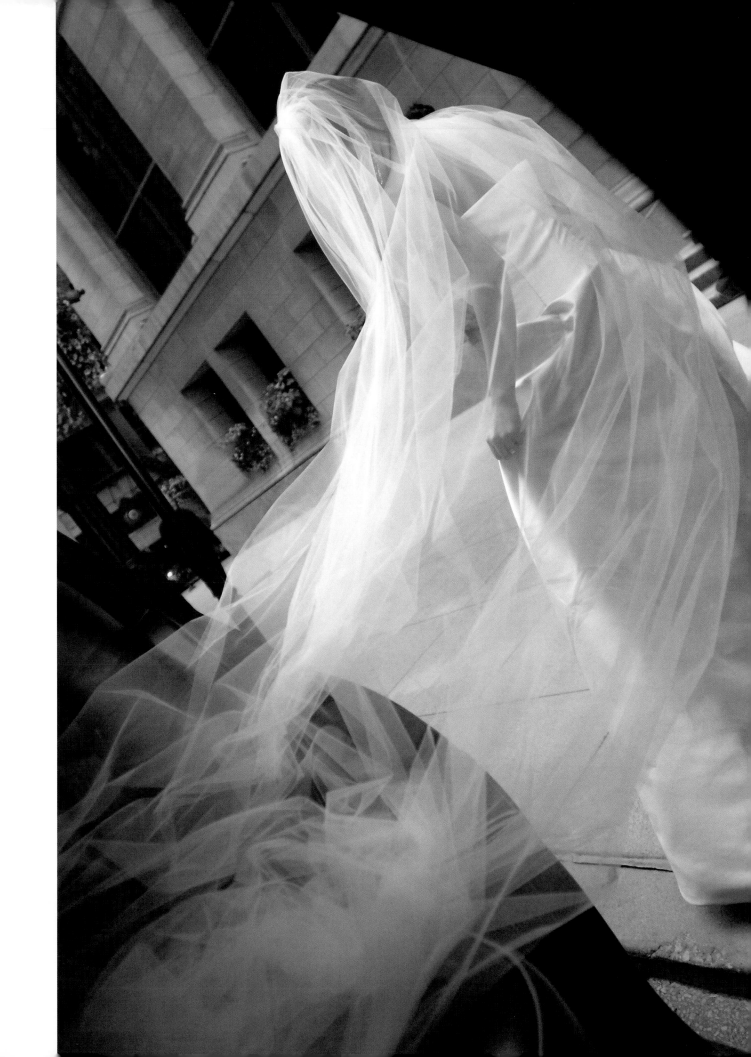

Jose Villa

LOCATION: Solvang, California
IN BUSINESS: Weddings since 2001
FILM OR DIGITAL: Film
COVERAGE: Sixty weddings a year
WEBSITE: www.josevillaphoto.com
KNOWN FOR: Artful wedding images fueled by his limitless energy, enthusiasm, and creativity.

IN HIS OWN WORDS: "Film is unique these days, which sets me apart right away. Film has a different look; it feels natural, especially the skin tones. I overexpose color film by a stop or stop and a half, which results in a beautiful, glowing, pastel lighting effect. The lab processes it normally, which really brings out the saturated colors, giving it more of a fine-art feel. I'm no stranger to digital, but film's workflow better suits my business."

BACKGROUND: After graduating from the Brooks Institute of Photography in Santa Barbara in 2001, Jose Villa fulfilled his dream of opening his photo studio in Solvang, California. His career immediately took off, so much so that studio revenues increased annually and Villa had to move his studio location three times to accommodate the ever-growing workload and additional clients (primarily weddings, kids, and fine art). Villa is more than willing to share his knowledge and expertise, offering workshops throughout the year both locally and abroad. His work has appeared in *Martha Stewart Weddings, grace ormonde Wedding Style, Pacific Rim Weddings, Brides, Modern Bride, Modern Bride Southern California, The Knot, Inside Weddings, InStyle Weddings, PDN, American Photo Wedding Issue, Your Wedding Day,* and *Santa Barbara* magazine.

IN JOSE'S BAG: Two Canon 35mm 1Vs, a Contax 645 medium format, and a variety of focal length lenses (Canon 16–24mm $f/2.8$, 70–200mm $f/2.8$, 100 macro $f/2.8$, and a 85mm $f/1.2$); a $15 Holga and a Hasselblad Xpan; a Canon 550EZ flash unit (only when absolutely necessary); Fuji Pro H 400 ISO, Fuji NPZ 800 ISO, and Fuji Press 1600 for color; Fuji Neopan 400, Fuji Neopan 1600 for black and white.

CAN'T LEAVE HOME WITHOUT: "My Contax 645, my 16–35mm zoom (for the Canons), and the 80mm $f/2$ lens (for the Contax)."

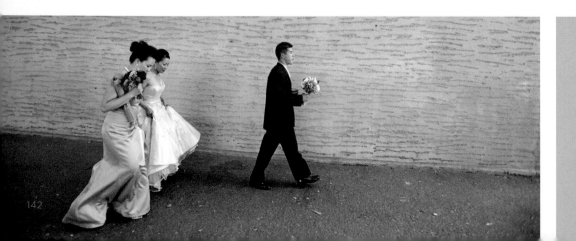

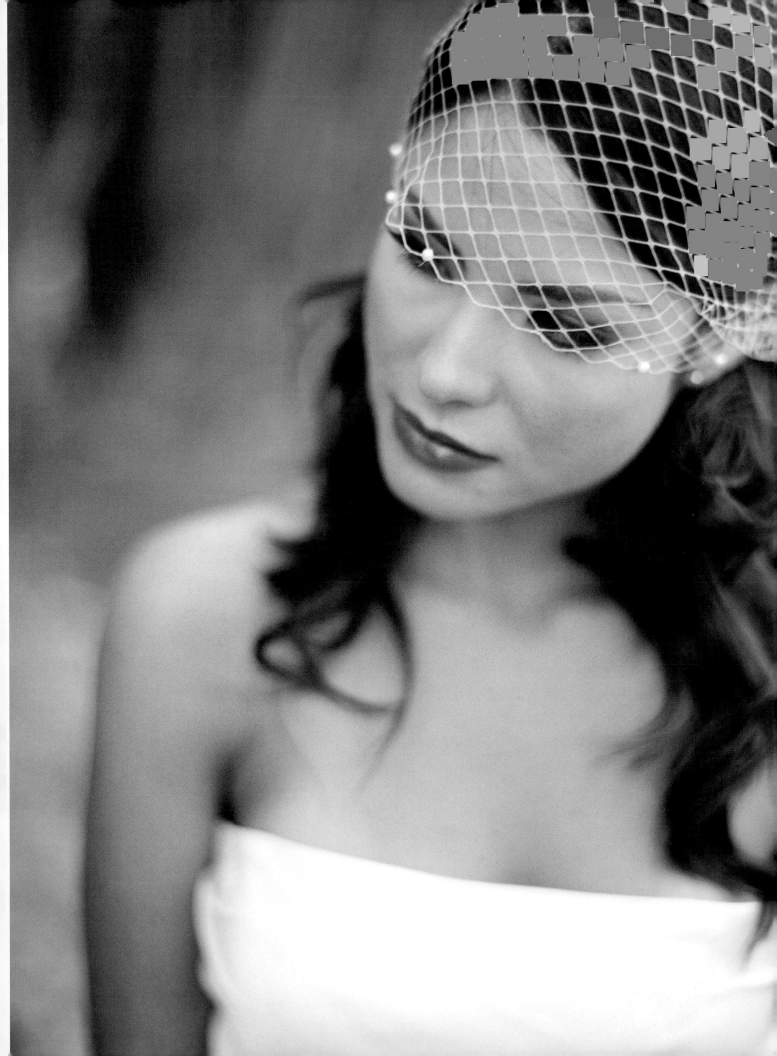

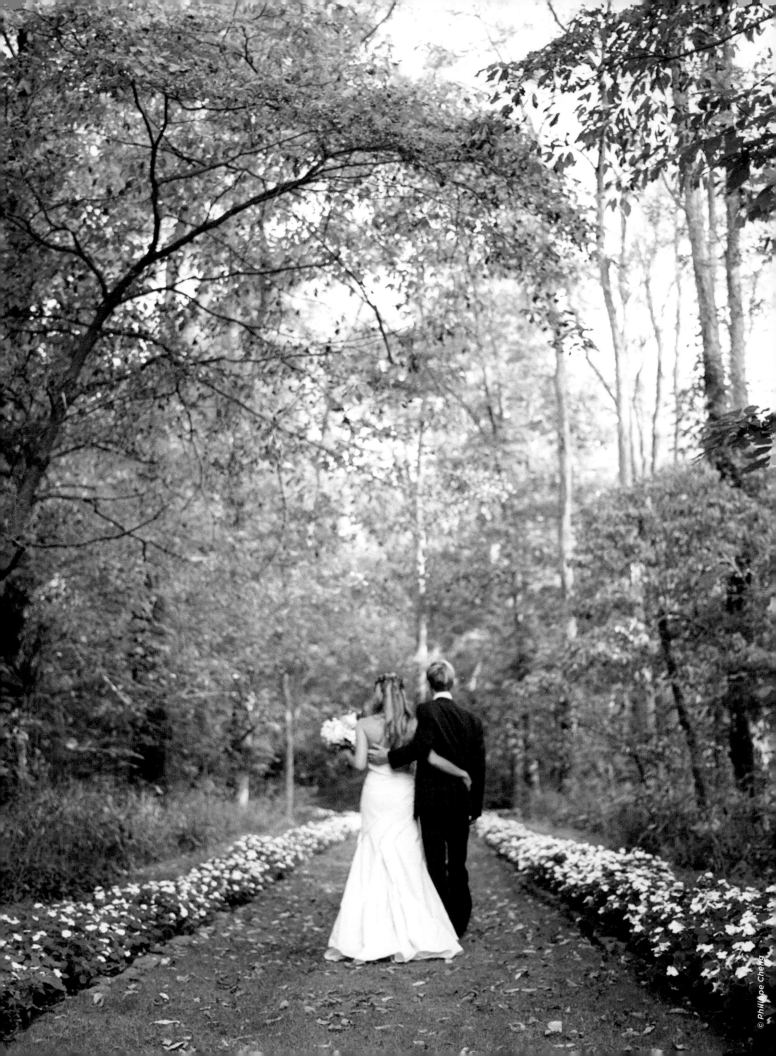

Note: Page numbers in **bold** refer to biographical sketches of featured photographers; page numbers in *italics* include photographs/captions of featured photographers.

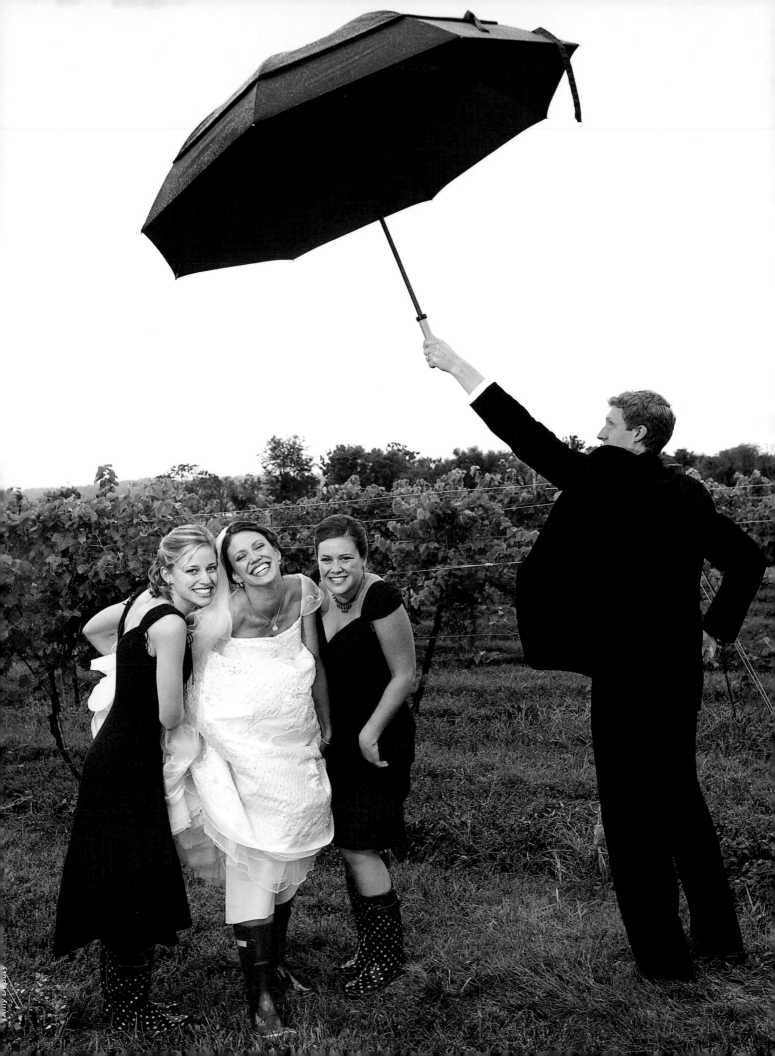

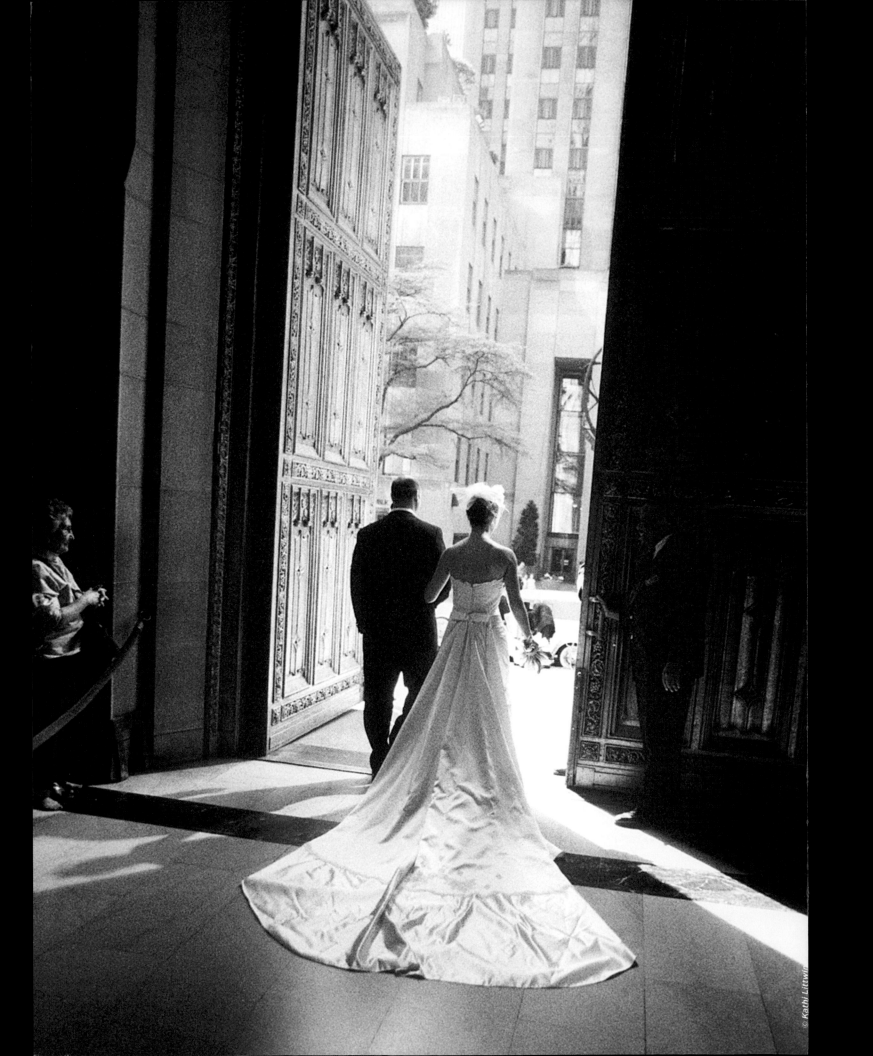

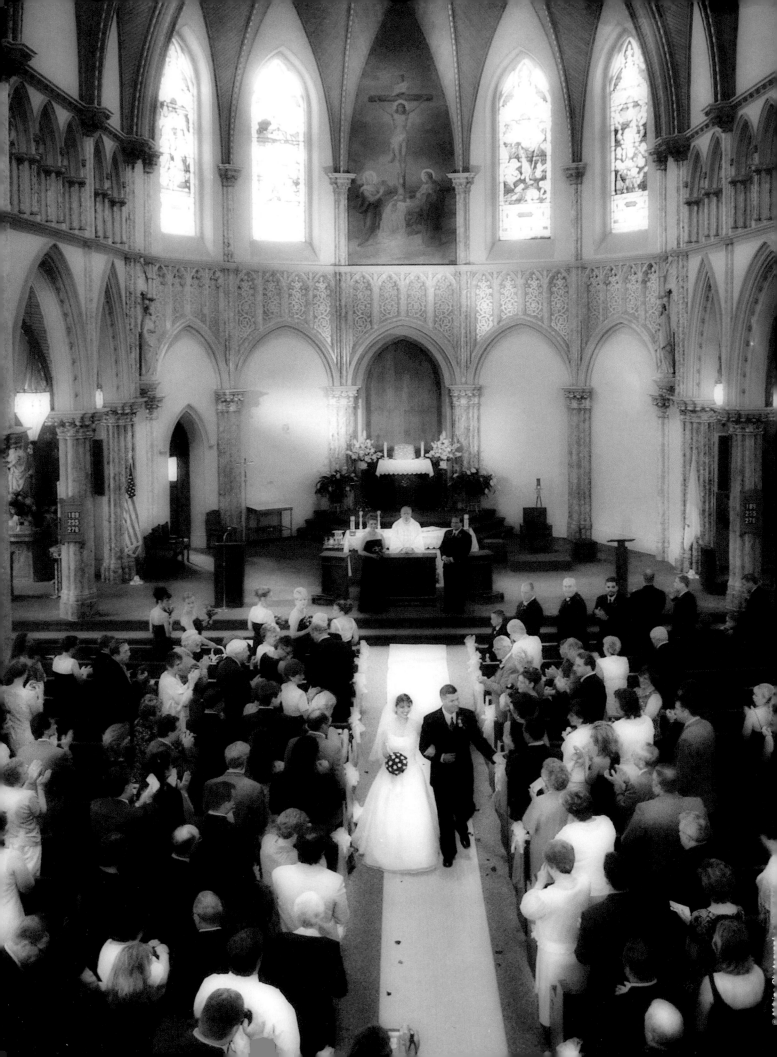